HISTORIC PHOTOS OF
NEW ORLEANS

MELISSA LEE SMITH

TURNER

PUBLISHING COMPANY

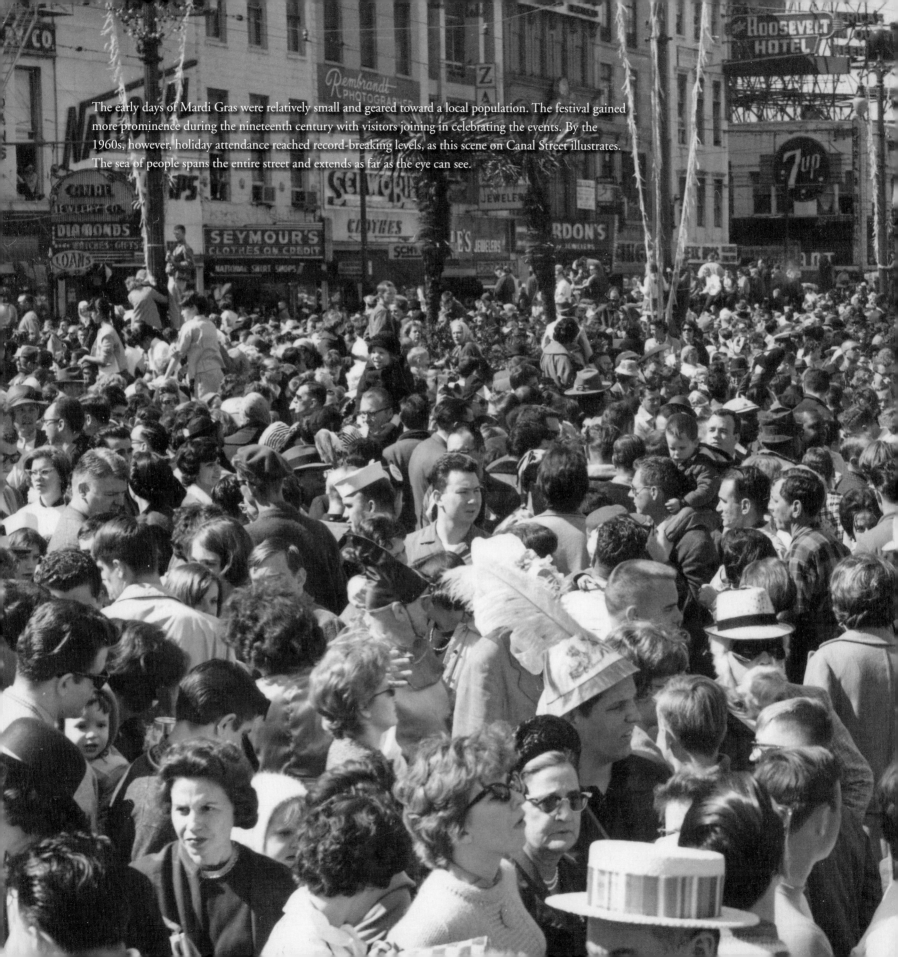

The early days of Mardi Gras were relatively small and geared toward a local population. The festival gained more prominence during the nineteenth century with visitors joining in celebrating the events. By the 1960s, however, holiday attendance reached record-breaking levels, as this scene on Canal Street illustrates. The sea of people spans the entire street and extends as far as the eye can see.

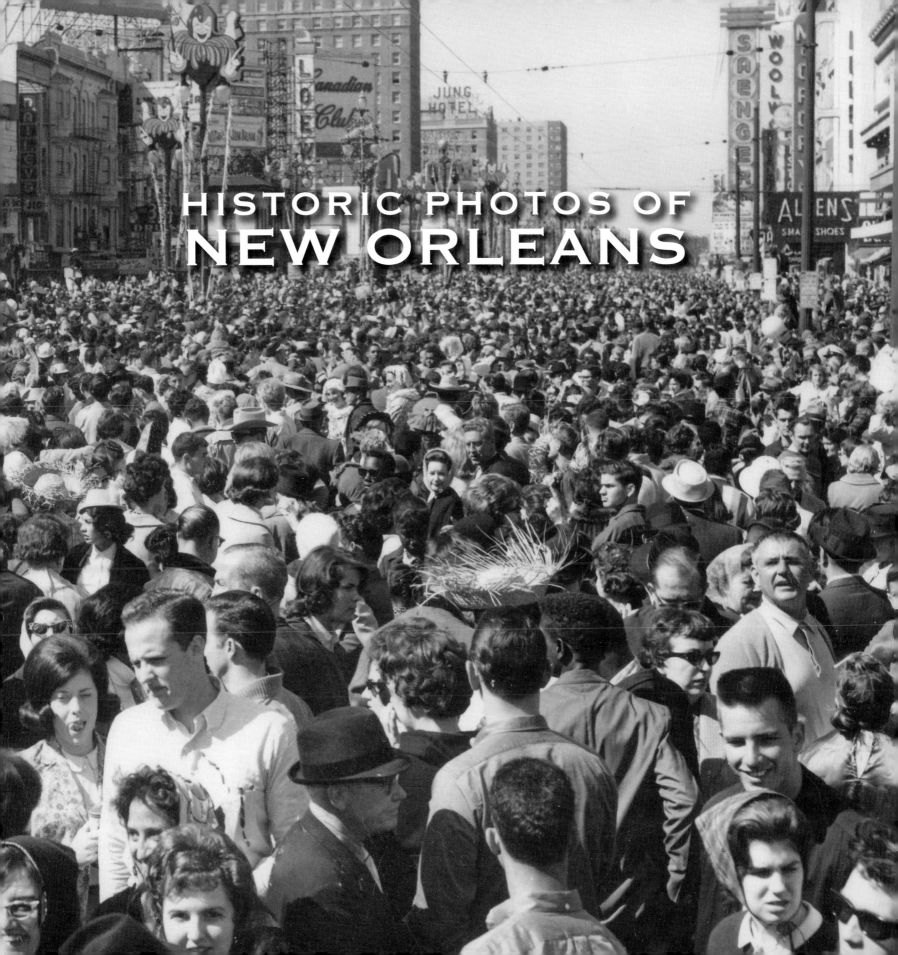

HISTORIC PHOTOS OF
NEW ORLEANS

Turner Publishing Company
200 4th Avenue North • Suite 950
Nashville, Tennessee 37219
(615) 255-2665

www.turnerpublishing.com

Historic Photos of New Orleans

Copyright © 2007 Turner Publishing Company

Library of Congress Control Number: 2007929645

ISBN-13: 978-1-59652-405-7

Printed in the United States of America

09 10 11 12 13 14—0 9 8 7 6 5 4 3

CONTENTS

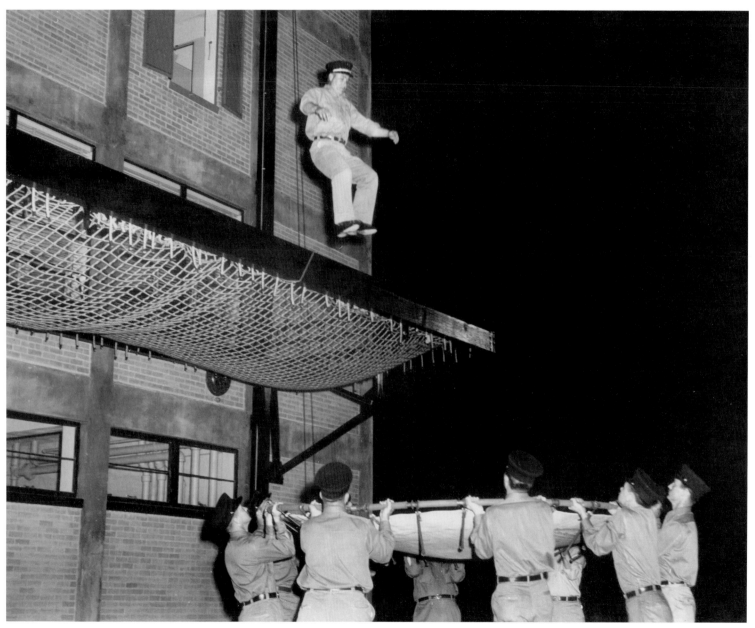

New Orleans, always susceptible to fires, prides itself on the New Orleans Fire Department. Here, local photographer Leon Trice captured a training session with a man jumping from a window onto a net. In addition to his photography business, Trice, along with Pops Whitesell and Clarence McLaughlin, formed the New Orleans Camera Club, a social organization that focused on photography.

Acknowledgments

This volume, *Historic Photos of New Orleans,* is the result of the cooperation and efforts of many individuals, organizations, and corporations. It is with great thanks that we acknowledge the valuable contribution of the following for their generous support:

Library of Congress
Louisiana Division/City Archives, New Orleans Public Library
Louisiana State Museum
Special Collections, Tulane University

We would also like to thank the following individuals for valuable contributions and assistance in making this work possible:

Irene Wainwright, Archivist, New Orleans Public Library
Wilbur Meneray, Assistant Dean, Tulane Special Collections
Lee Miller, Manuscripts Librarian, Tulane University
Ken Owen, Louisiana Collection, Tulane University
Greg Lambousy, Director of Collections, Louisiana State Museum
Tom Lanham, Assistant Registrar, Louisiana State Museum
Steve Maklansky, Director of Curatorial Services, Louisiana State Museum
The D'Antonio family of New Orleans from their private collection

PREFACE

New Orleans. The Big Easy. Crescent City. Many names have been given to this unique metropolis where cultures, music, architecture, and food blend to create a dynamic atmosphere unlike that of any other place in America. Several native tribes called what is now Louisiana home. At various times, both Spain and France claimed the region and introduced black slaves from Africa and from Caribbean colonies. Many runaway slaves found haven among the native people, and American Indian culture intermingled with African traditions. After the United States obtained the city as part of the Louisiana Purchase, other European and purely American influences joined the mix. At one time, the city even had a Chinatown on its outskirts. All of these peoples contributed to the creation of the grand city near the mouth of the Mississippi.

In January 1815, General Andrew Jackson defeated a British force at Chalmette plantation, in what became known as the Battle of New Orleans. His mixed force of frontiersmen, Indians, freemen of color, and French pirates dealt a disastrous defeat to Britain's professional soldiers in what would be the last invasion ever made on American soil.

The following decades saw New Orleans grow into one of the country's premier cities. Its ideal location along the river, close to the Gulf of Mexico, ensured it would become a major shipping point, with goods coming into the country for distribution up the Mississippi and thence the Ohio River, while cotton and other goods went out to world markets. Slave labor was a significant aspect of the city, but New Orleans and all of Louisiana also had a larger population of free blacks than could be found virtually anywhere else in the South.

The city was spared destruction during the Civil War when a Union fleet moved up the river and captured it bloodlessly. While residents chafed under Federal occupation—an infamous edict by Union General Benjamin Butler declared any woman who insulted a Federal soldier would be treated as a prostitute plying her trade—the magnificent architecture of New Orleans was spared the devastation visited on Atlanta and Richmond. Even the despised General Butler contributed to the city by beginning cleanup of garbage where disease-carrying mosquitoes bred.

Additional cultures came to New Orleans with a new influx of immigrants late in the nineteenth century. Italians

were especially prominent, and many became successful business leaders. Open-air markets that once provided produce to residents and income for immigrants grew into a tourist attraction. Many of these tourists discovered a new delicacy, a deep-fried pastry with confectioner's sugar, that went by the name beignet.

A new musical sound began wafting through the streets, incubated in the city's bars and brothels. It would give its name to the 1920s: The Jazz Age.

From all of these influences, the city continued to stir its own cultural mixing pot. Mardi Gras celebrations grew into fabulous events drawing hundreds of thousands of visitors. Famed writers including William Faulkner, Lillian Hellman, and Tennessee Williams called the city home; Truman Capote was born here.

The images within this volume—most rarely seen—capture the diversity and excitement of New Orleans while paying tribute to its storied history. The aim is to inspire, provide perspective, and evoke insight that might assist officials and citizens, who together are responsible for determining the city's future. In addition, the book seeks to preserve the past with respect and reverence.

With the exception of cropping where necessary and touching up imperfections caused by time, no other changes to these photographs have been made. The focus and clarity of some images is limited by the technology of the day and the skill of the photographer.

These historic images conclude with the 1960s. Events such as constructing the Louisiana Superdome and hosting the 1984 New Orleans World Exposition occurred after that time.

So, too, did Hurricane Katrina, the worst natural disaster ever to strike the city. At this writing, rebuilding is still under way, and will be for some time. But the residents of the Big Easy are resilient; they've faced and recovered from disasters in the past. Already, Mardi Gras parades have resumed. Jazz still floats on the breeze, from clubs where tourists and locals still rub elbows. The flowers in the Garden District still return in the spring, and like those flowers, New Orleans will bloom again. To the spirit of the city and its people, this collection of historic photographs is dedicated.

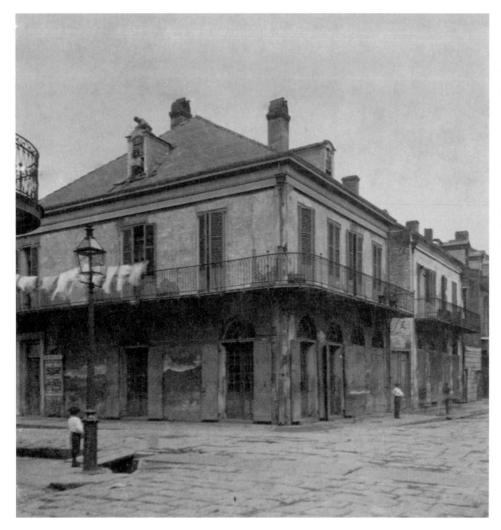

Due to the fires of 1788 and 1794 that for the most part destroyed the city, the architecture of the French Quarter developed from Creole architecture, an influence of French, Spanish, and Caribbean styles. Built in 1795, the Reynes House is one of the older buildings in the Quarter and one of the most Spanish-influenced buildings. Through the years, this building has been used for a variety of purposes: a storehouse, a grocery store, and today a restaurant.

Dawn of a New Era:
Recovery from the Postwar Period

(1870–1899)

Following the economic crises of the 1870s and Reconstruction, which ended in Louisiana in 1877, New Orleanians looked excitedly to the future. Unlike other Southern cities that suffered utter destruction during the Civil War, New Orleans had surrendered bloodlessly on April 28, 1862, and thus escaped physical devastation. The 1880s and 1890s brought in a period of realty development and expansion. Agricultural exports remained an economic engine for the port of New Orleans, as did the U.S. Mint stationed on the edge of the French Quarter. Immigrants from Europe flooded New Orleans, bringing with them their agricultural knowledge and love of food. Schools expanded along with the ethos of Victorian morality that maintained education was key to a successful life—mainly for white students, according to the city's political leadership, however. Benevolent societies and ethnic and cultural organizations popped up throughout the city. With people seeing a bit more money, leisure activities proliferated whether these pastimes took place at the racetrack, at the park, on a leisurely cruise, or on Carnival Day. As always, New Orleanians managed to enjoy themselves.

Political warfare, another pastime for Louisianans, never let up. Governor William Pitt Kellogg, whom many saw as a carpetbagger, faced armed rebellion that was quelled by U.S. troops. The 1880s closed with a momentous event for New Orleanians who had lived through the Civil War—the death of their beloved leader, Confederate President Jefferson Davis in 1889. In 1893, a special funeral train carried his remains from New Orleans to Richmond, Virginia, for reinterment.

For some groups, the future was a bit murkier. African American leaders in New Orleans maintained some of their old hegemony, and some were able to maintain their middle-class lifestyle for the most part. Yet, they faced an enormous task—finding the wherewithal to aid in the recovery of formerly enslaved people who flocked to the city following the Civil War looking for aid, education, and jobs. African American universities sprouted up and offered African Americans excellent courses of study in a variety of professions. Many locals enrolled at these institutions, such as Straight University and others, so that they could attain middle-class status at the end of the century and into the next. Yet, for those not as fortunate, manual labor on the docks and farms or as domestic servants were the only positions that some could find.

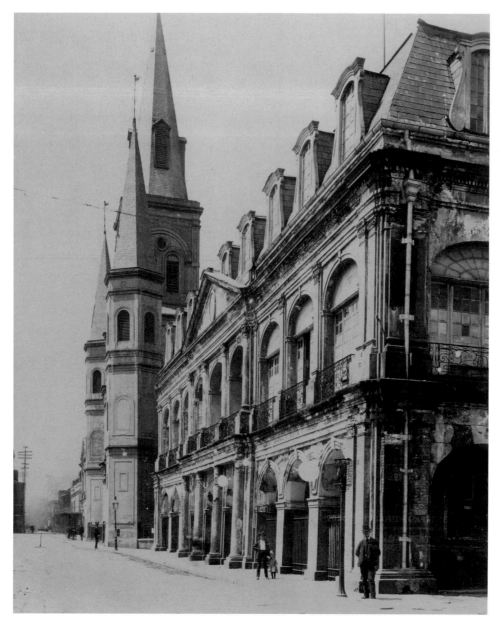

Located in the heart of the French Quarter, the St. Louis Cathedral and the Presbytere are among the architectural gems of the city. The oldest cathedral in North America, the St. Louis Cathedral was dedicated as the first permanent parish church in New Orleans in 1727, after three years of construction. The Presbytere, designed in 1791 and erected as the residence for Capuchin monks, became a courthouse in 1834 and remained so until 1911 when the Louisiana State Museum system took it over.

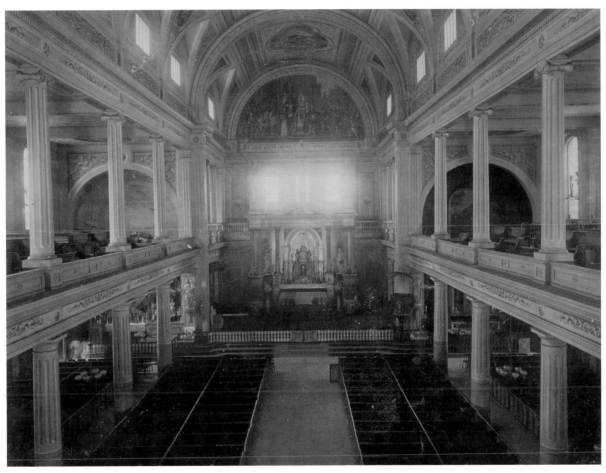

During the 1880s, the cathedral began to show some signs of wear. Father Mignot, the cathedral's pastor, received a donation from France's Society for the Propagation of the Faith to initiate renovations. He hired the New Orleans architect A. Castaing and the church painter Erasme Hubrecht to oversee the repairs. Each renovation not only preserves the masterpieces of the cathedral's earlier days but also adds new dimensions and new artwork.

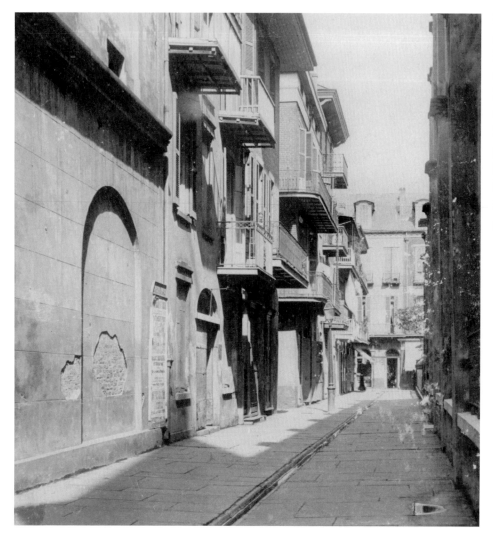

Until the 1960s, this strip on the side of the St. Louis Cathedral was known as Orleans Alley. Today, it is called Pirate (or in local vernacular, Pirate's) Alley. Home to the literary national landmark the Faulkner House, this area of the Quarter played host to writers such as Sherwood Anderson and William Faulkner, who wrote his first book, *Soldiers' Pay,* here in 1925, in his rented rooms on the first floor.

As two men meander along Exchange Alley, they come upon a tobacco shop. New Orleans during the latter half of the nineteenth century prospered from its local cigar industry. Many African American Creoles worked in this field, which led them to start their own fraternal organization, Societé des Jeunes Amis (Company of the Young Friends). Becoming well-known in African American circles, this organization eventually encouraged those outside the cigar-making field to join their ranks.

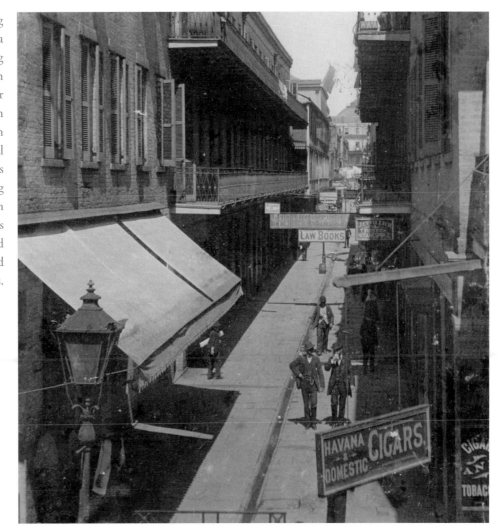

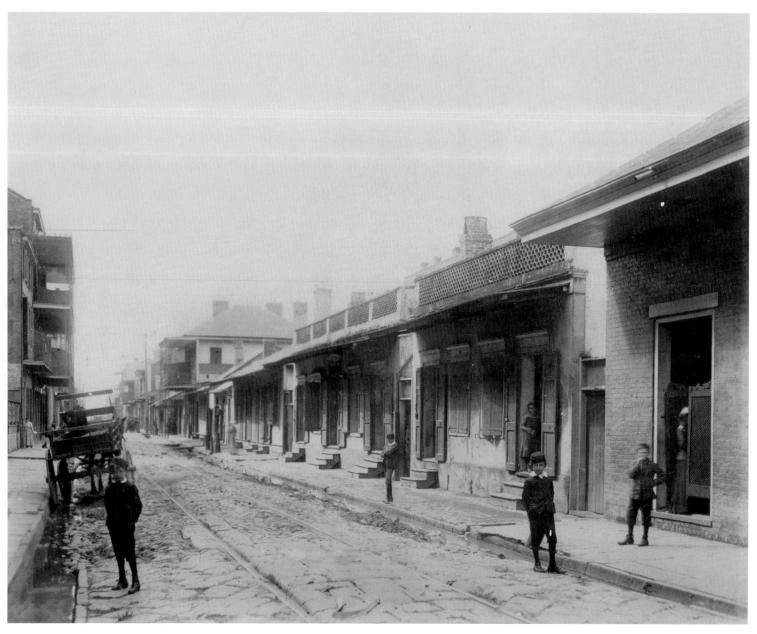

In 1884, George Mugnier entered the photography field after some time as a watchmaker. Noted for his images of New Orleans architecture and views, this photograph is a quintessential Mugnier shot: four boys on a street in the French Quarter, with a girl watching warily from a stoop in the background.

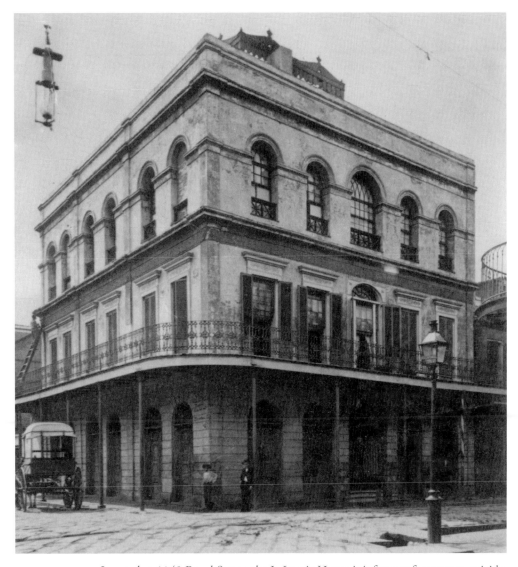

Located at 1140 Royal Street, the LaLaurie House is infamous for torture, suicide, and a deadly fire. Early on, Madame Delphine LaLaurie developed a reputation for torturing slaves. In April 1834, a deadly house fire engulfed the property. When firefighters arrived at the scene, they found a dozen slaves in various stages of torture, chained to the wall and to operating tables. Fearing a mob-like frenzy, Madame LaLaurie and her husband fled New Orleans for their lives, never to return.

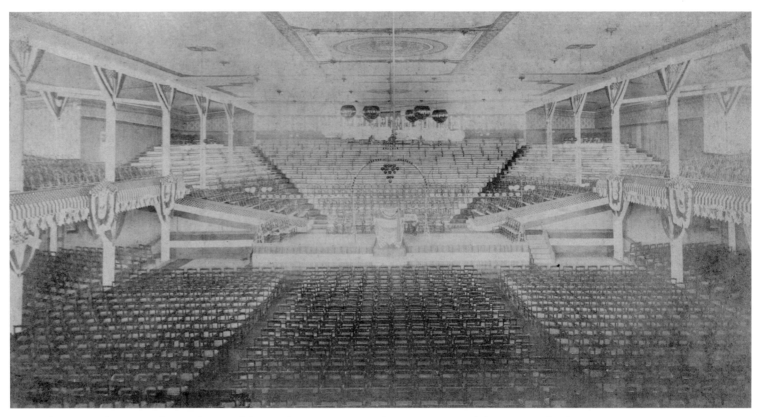

In October 1889, the New Orleans Chapter of the North American Singers' Union contracted the services of architect John Henry to build Saenger Halle in anticipation of the twenty-sixth Saengerfest, a four-day festival celebrating German music. Shortly after the event, the building was torn down and the site left dormant for fifteen years until the city built a public library. Today, K&B Plaza currently stands where this building was located.

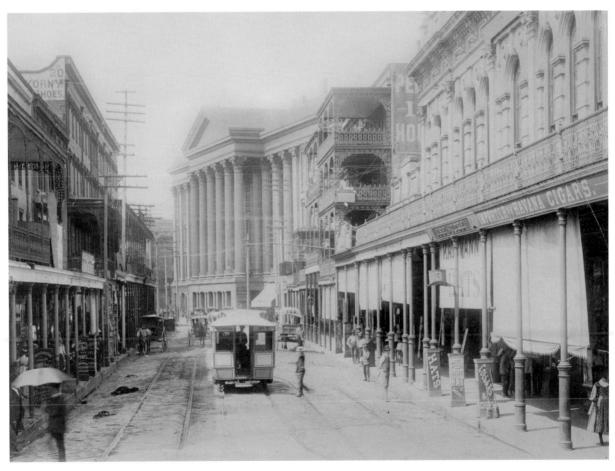

Heading out of the French Quarter, the "American" sector with regal St. Charles Street (now St. Charles Avenue) comes into view. Following Louisiana's statehood, the city expanded, and this area became a hub for business and government. Here, Mugnier's image shows a bustling St. Charles Street with streetcars and the famed St. Charles Hotel in the background. The hotel, located between Common and Gravier streets, fell victim to fires in 1851 and 1894. It was demolished in 1974.

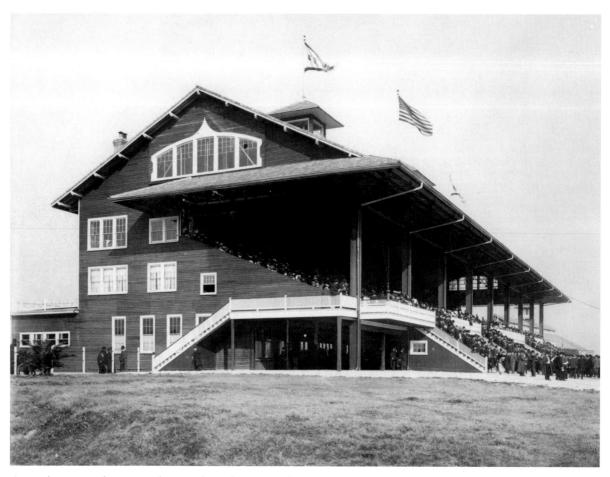

Opened in 1905, the New Orleans Jockey Club racetrack entertained New Orleanians with one of their favorite pastimes, horse racing. The brainchild of local developer George C. Friedrichs, who envisioned a world-class racetrack and winter resort hotel, its fate fell into the hands of anti-gambling forces in Louisiana, who shut it down in 1908. Today, it is the site of Tad Gormley Stadium, the Roosevelt Mall, and some baseball diamonds.

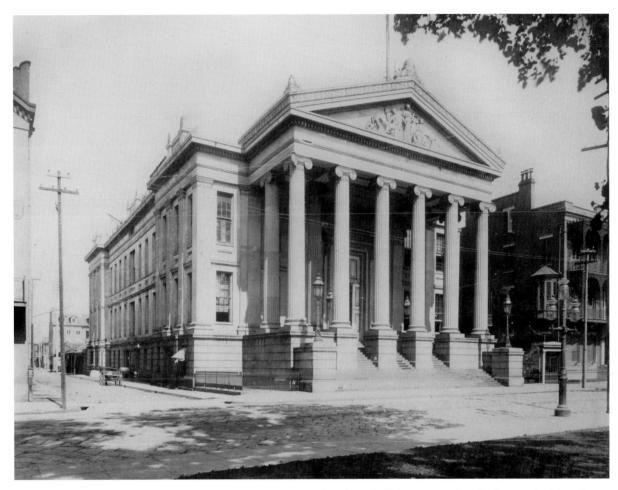

Gallier Hall served as New Orleans' city hall for over one hundred years. Architect James Gallier, Sr., oversaw its construction between 1845 and 1853. This commanding Greek Revival building boasts two rows of fluted Ionic columns made from Tuckahoe marble. Several prominent people have lain in state within it, including Confederate President Jefferson Davis, General P. G. T. Beauregard, and Ernie K-Doe, the famed R&B musician. Rex also toasts his queen and the mayor on Carnival Day here.

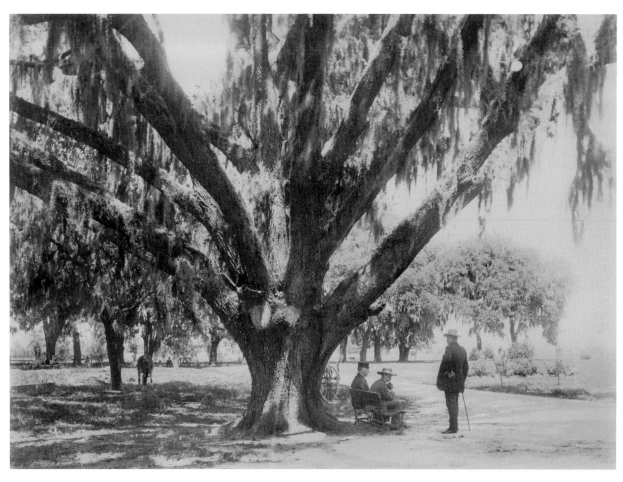

Audubon Park was originally the site of the plantation belonging to New Orleans' first mayor under the American regime, Jean Etienne Boré, who also first granulated sugar here in 1795. The city purchased the area in 1871 and used it as the site of the 1884 World's Industrial and Cotton Centennial Exposition. After the fair closed, Frederick Law Olmsted's nephew and adopted son, John Charles Olmsted, designed the park known today. It opened to the public shortly thereafter.

The term Rex can refer to one of the oldest Mardi Gras krewes (organizations) in New Orleans or to the King of Carnival on Mardi Gras Day. For the 1896 Carnival season, the Rex Organization chose the theme Heavenly Bodies and asked Charles Janvier, shown here, to serve as Rex, King of the Carnival. Born in 1857, Janvier served as postmaster, worked in the insurance industry, and was president of the Canal Bank & Trust. He joined the White League in 1874 and also served as president of the Citizens' League in 1896. In 1905, he chaired the Yellow Fever fund committee and subsequently received the *Times Picayune*'s Loving Cup award for this work.

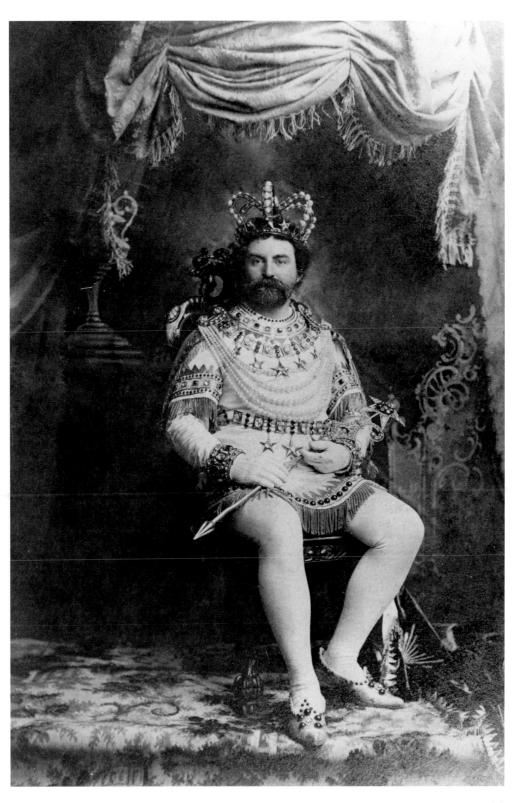

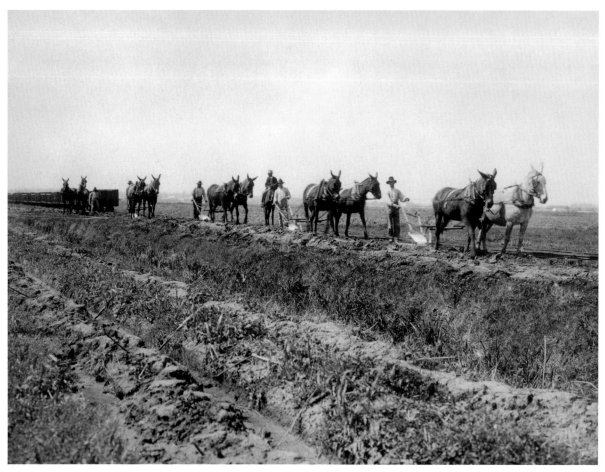

These workers are plowing the field in anticipation of planting sugar cane on the Godchaux Plantation in Raceland, Louisiana. Known as the "Sugar King of the South," Leon Godchaux also owned a sugar mill on this property and accumulated nearly 2,700 acres on this plantation alone. Godchaux was an immigrant in New Orleans who worked as a peddler, saved his money, and eventually opened Godchaux's, a New Orleans-based department store which served New Orleanians for generations.

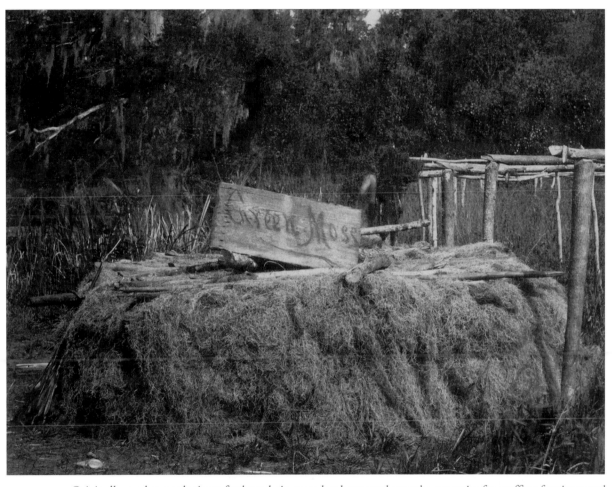

Originally used as a substitute for horsehair, moss has been used over the centuries for stuffing furniture and for making such diverse items as mortar, bricks, and saddle blankets. The curing process begins by submerging large amounts of moss in water and watering it on a daily basis for two to three months. The moss then must be turned occasionally during the curing process. Once this stage is complete, it is hung to dry, then it is separated from the chaff and constantly combed through until only the inner fiber is left.

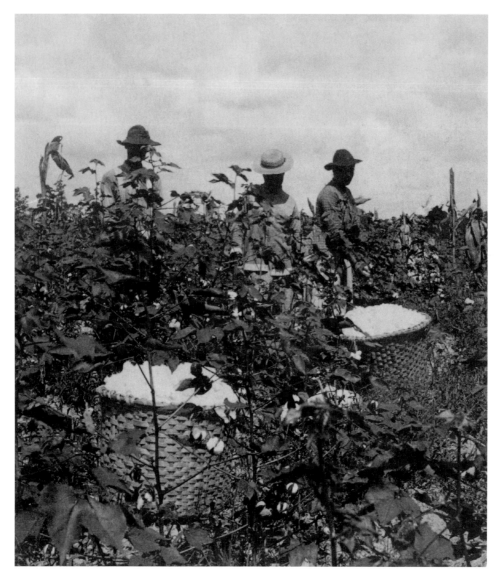

One of the more grueling positions on a farm was that of a cotton picker. While Eli Whitney's invention of the cotton gin in 1793 made processing cotton easier and more profitable, workers still had to hand-pick the boles. Folks of all ages and conditions participated in this time-consuming and physically painful work.

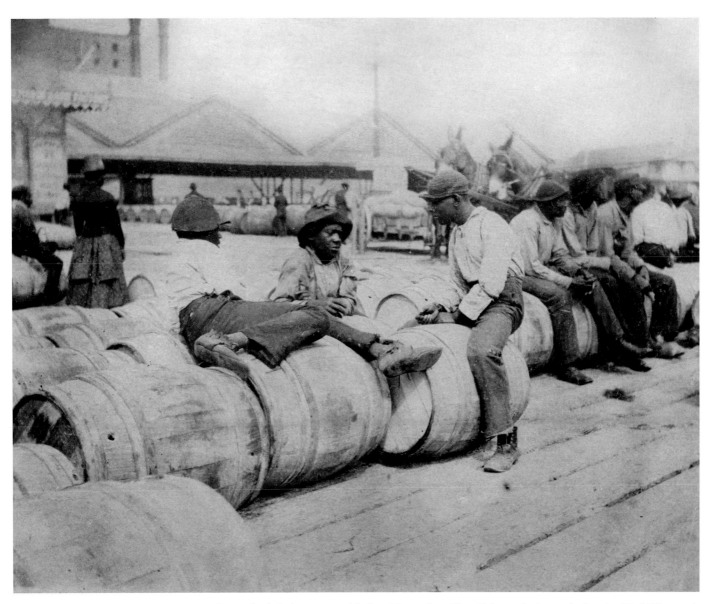

For those who left the countryside for cities such as New Orleans during and after the Civil War, work could be difficult to find at times. Most newly freed African Americans in New Orleans entered the work force as manual laborers on the docks. The hours were long, the work backbreaking. Here, a few men take a break and sit on sugar barrels waiting to be loaded.

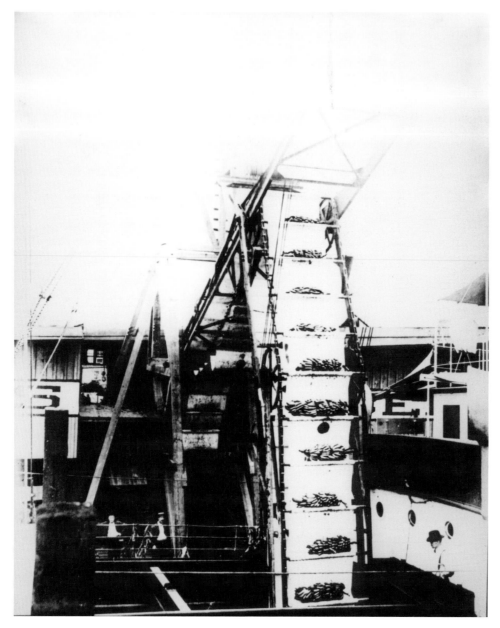

Banana trade between New Orleans and Latin America commenced during the mid–nineteenth century and reached its zenith in the twentieth century. An industry based on two companies run by two prominent Italian families, the Vaccaros and the D'Antonis, the banana trade opened New Orleans to a rich Latin American market for imports and exports. This image depicts the unloading of bananas on the docks. Much of the popular fruit ended up in the French Market.

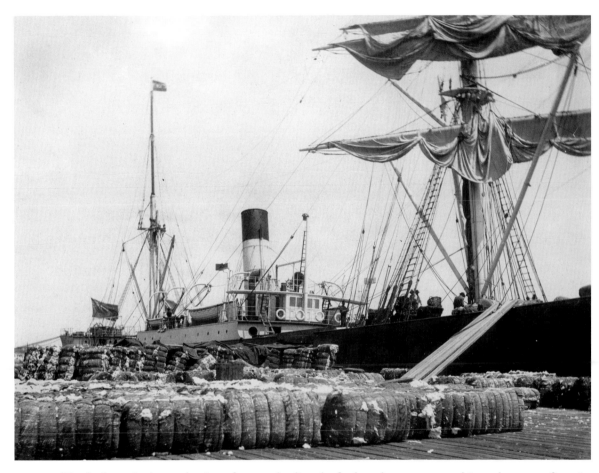

The final step in the production of cotton: loading the final product onto steamships to be sent to factories around the world, mainly Europe. New Orleans' rich history as an important port is clearly shown in this image. By 1860, Louisiana accounted for nearly one-sixth of the United States' total cotton production. In 1884, in honor of Louisiana's contribution to the cotton industry, New Orleans hosted the 1884 World's Industrial Cotton Centennial, its first world's fair.

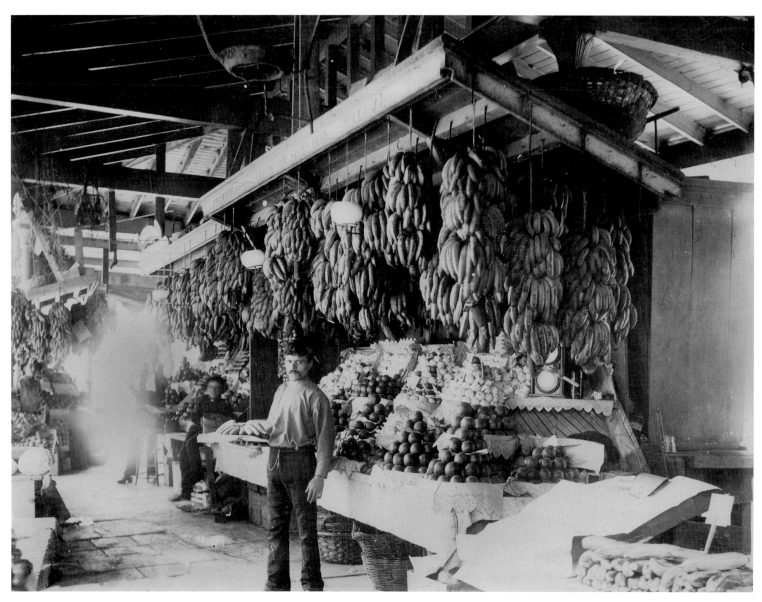

Peddlers, who had mainly come from Italy during this time period, sold their goods in the oldest open-air market in the United States, the French Market. The Spanish colonial government erected the first market in 1771, but the hurricane in 1812 destroyed it. In 1813, the city rebuilt the building which now comprises the length of Decatur Street from Jackson Square to Barracks Street.

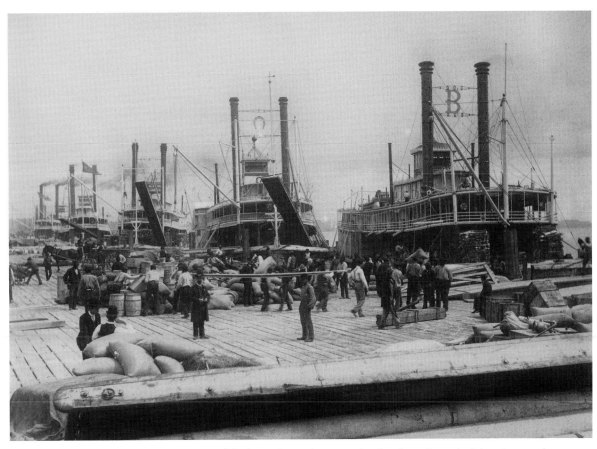

This impressive view of the levee shows the strength of trade at the end of the nineteenth century: workers loading and unloading goods, with a huge array of steamers lining the Mississippi River. Travel guides on New Orleans suggested that visitors should make time to visit the levee on the Mississippi, second only to the French Quarter in popularity.

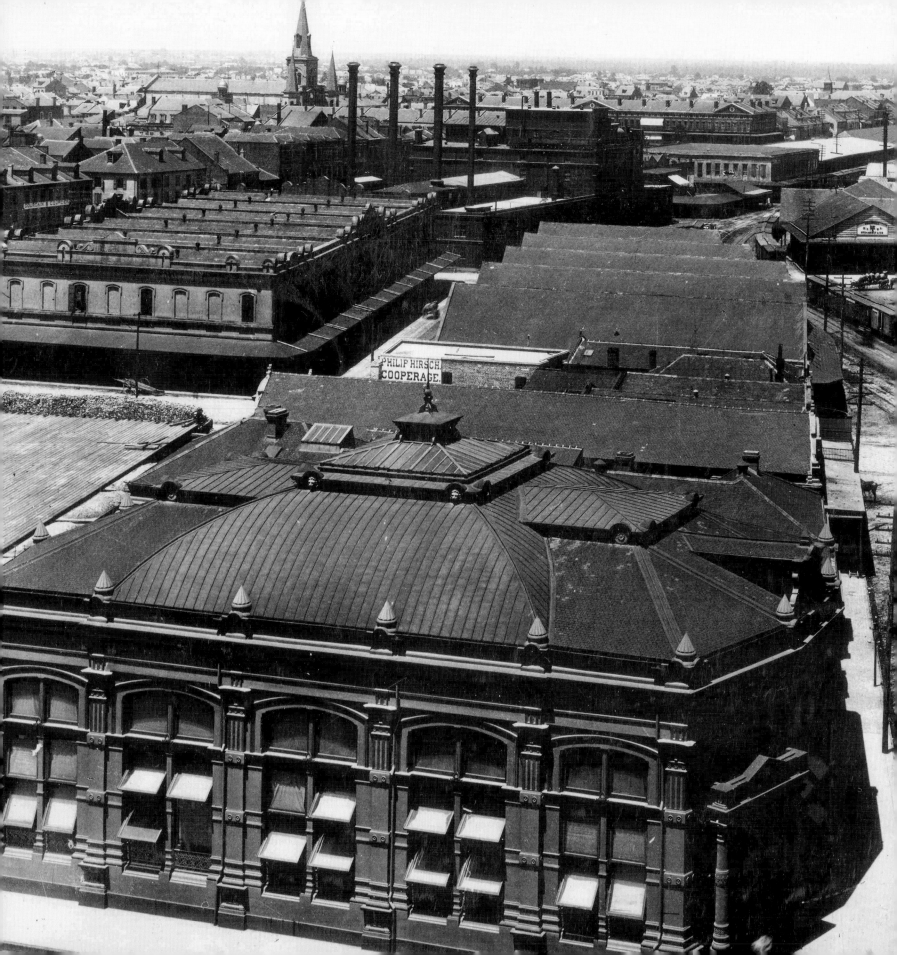

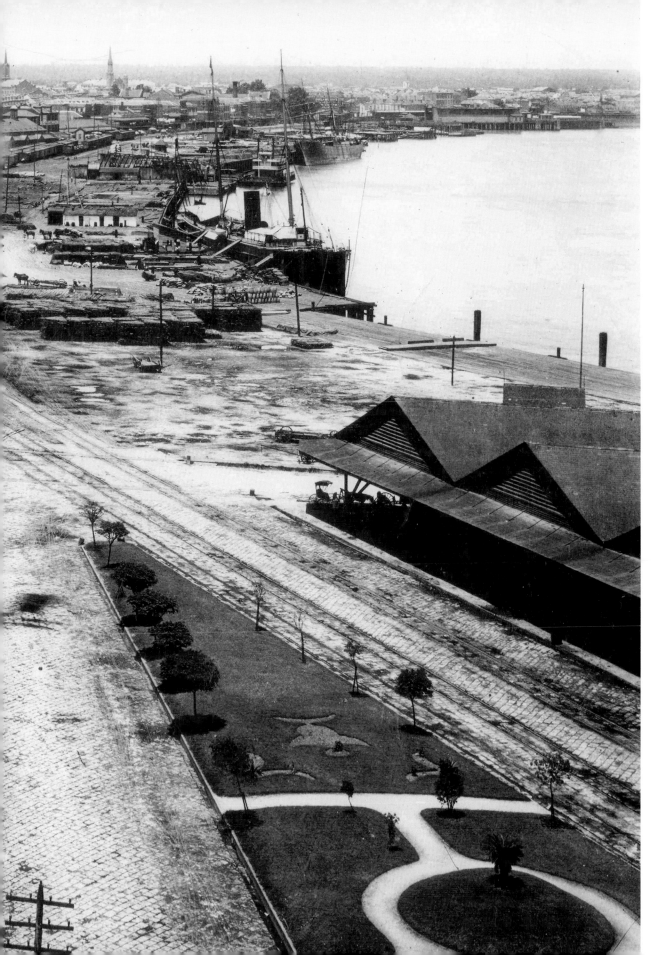

In this bird's-eye view of the city from the west, located in the present Warehouse District, numerous railroad tracks point the way from the warehouses and wharves toward the center of the city. St. Louis Cathedral sits at far left.

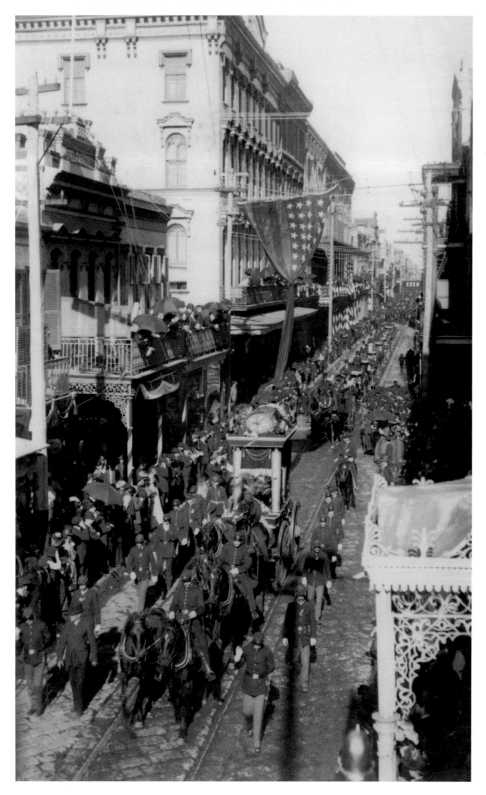

December 6, 1889, Jefferson Davis, former President of the Confederacy, died at the home of his friend, Judge Charles E. Fenner. After his body lay in state at Gallier Hall, a long procession accompanied it to his first interment in the Tomb of the Army of Northern Virginia at Metairie Cemetery. In 1893, his body was reinterred at Hollywood Cemetery in Richmond, Virginia.

A domestic servant with her charge along St. Charles Avenue in the Uptown section of New Orleans shows the limitations of positions offered to African American women. Many had little choice for work following the Civil War other than being domestic servants and laundresses. Working long hours raising the children of the white and privileged, without much time for themselves and their own families, they were mostly underpaid and unappreciated.

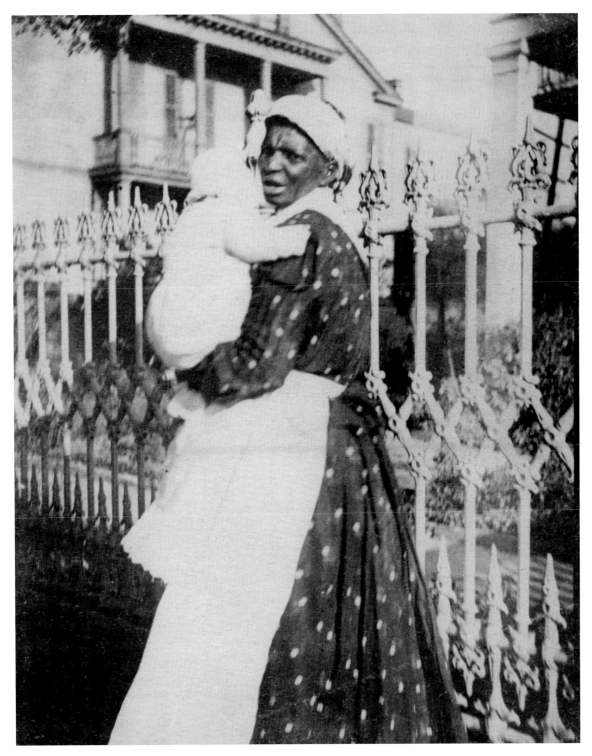

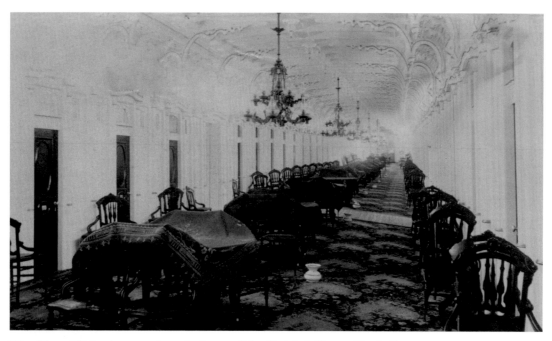

The *Edward Richardson* steamboat, built out of the *Katie* in Jeffersonville, Indiana, was 309 feet long, 49 feet wide, and 12 feet deep. The detail of this image shows how luxurious cabins could be on these "river palaces," with their chandeliers and carpeting. Captain J. M. White skippered the *Edward Richardson,* running cotton between New Orleans, Greenville, Mississippi, and Vicksburg, Mississippi. Dismantled in New Orleans in 1888, she was set on fire so that her iron could be salvaged.

A City at a Crossroads

(1900–1910)

Expanding on some of the gains made at the end of the nineteenth century, Mayor Paul Capdevielle (1900–1904) ushered in an era of reform and capital improvements which his successor, Martin Behrman (1904–1920), enhanced. New Orleanians saw an increased amount of industrialization, with a greater number of warehouses lining the river's busy port, and capital improvements to New Orleans' infrastructure. Streetcars and automobiles increasingly replaced the horse and buggy.

The new century also brought an important celebration to the state of Louisiana—its centennial, which reaffirmed the importance of the city and the state in the national perspective. Presidents William McKinley and William Howard Taft, visiting New Orleans at the beginning and the end of the decade respectively, understood and advocated the importance of the city's waterways to the national economy.

This era also introduced new amusements to the region and reinforced some old pastimes. Literary societies, private clubs, hunting organizations, horse racing, and yachting were all activities in which the wealthy participated. There was never a lack of recreational sporting in the city and its surrounding areas. In addition, civic and business leaders developed amusements geared to those not able to afford the private clubs, through its development of New Orleans City Park and the West End area of the city. With New Orleanians flocking to the lakefront to visit West End, visitors witnessed technological advances such as the first motion picture. Locals were also developing a new form of music and performing it at these amusement parks—jazz.

On the educational front, students received increased access to education, especially under the administration of Mayor Martin Behrman, who initiated a construction boom among the city's public schools. Yet, African American children and those from immigrant, underprivileged backgrounds still did not have as easy a time gaining access to education as did their white, native-born counterparts.

This period also brought in a time of reflection, shown in the number and variety of churches located in the city during this period. In 1905, residents faced a traumatic period, their last major bout with yellow fever. Improvements to the city's infrastructure and advances in medicine greatly reduced the risk of contracting this dreaded illness. New Orleanians such as Rudolph Matas and Quitman Kohnke, among others, were at the forefront of this battle.

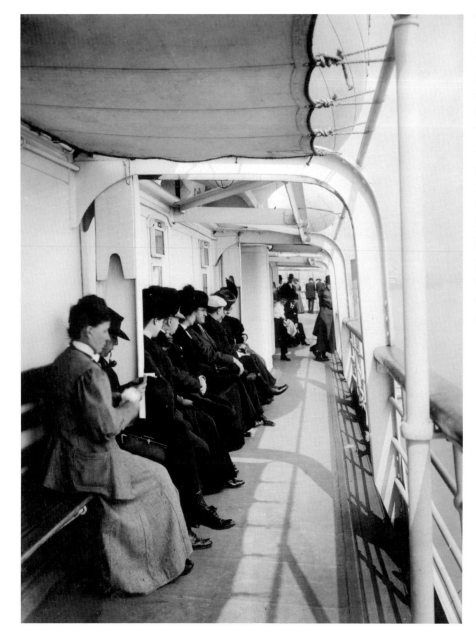

The SS *Momus* was a luxury steamer complete with suites, staterooms, promenade decks, library, and a wireless telegraph. Completed in 1906 by William Cramp and Son of Philadelphia, Pennsylvania, and owned by Southern Pacific Company, it ran between New York and New Orleans, offering the best in travel during this time. The Cramps named this steamer after Momus, the Greek god of laughter, mockery, and ridicule.

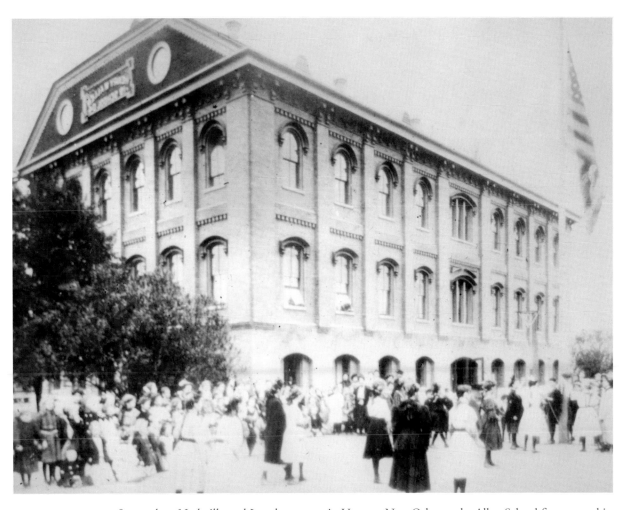

Located on Nashville and Loyola avenues in Uptown New Orleans, the Allen School first opened in 1904 and was named after former Confederate officer and governor Henry Watkins Allen (1820–1866), who served in the latter role from 1864 until 1865. During his time as governor, he ordered the printing and distribution of books throughout the state to combat illiteracy.

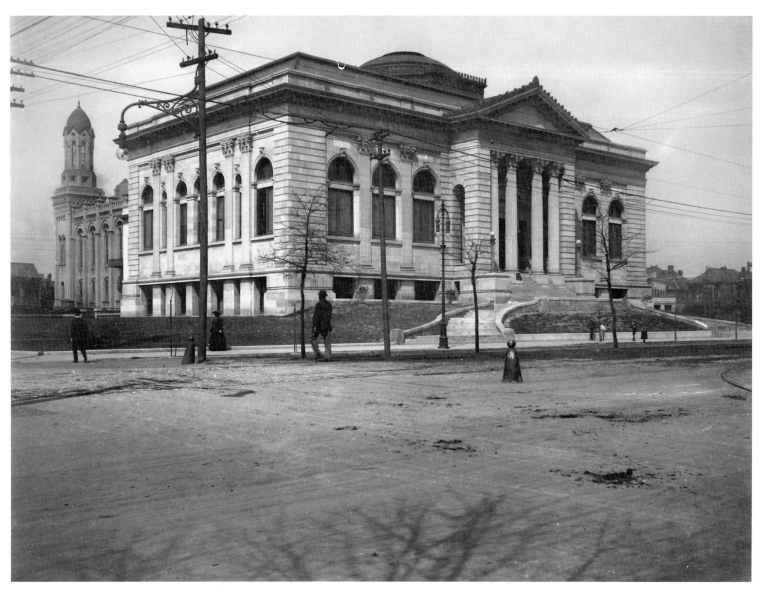

In 1843, a local philanthropist, Abijah Fisk, bequeathed his house on Customhouse Street to the city to be used as a public library. The Fisk Collection remained the bulk of the library's holdings until 1881, when the forerunner of Tulane University unofficially assumed responsibility for the holdings. In 1895, Mayor John Fitzpatrick suggested the City Council establish a free library, thus merging the Fisk Collection with a private library and beginning the New Orleans Public Library. This branch of the New Orleans Public Library was located at Lee Circle from 1906 until 1956.

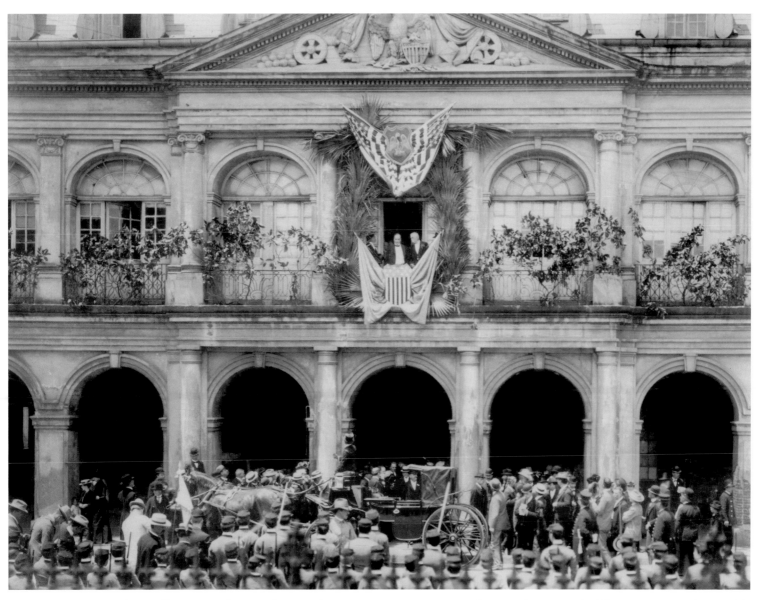

President William McKinley visited New Orleans in 1901 to commemorate Louisiana's centennial of the Louisiana Purchase. While the actual anniversary did not take place until 1903, the Louisiana Historical Society, the host for the event, decided to celebrate two years early so that the president could attend, as he was booked for 1903. Here, President McKinley is seen with New Orleans Mayor Paul Capdevielle on the balcony of the Cabildo, the building where the Louisiana Purchase transfer took place. Its name comes from the governing body that met there under Spanish rule, the "Illustrious Cabildo," or city council.

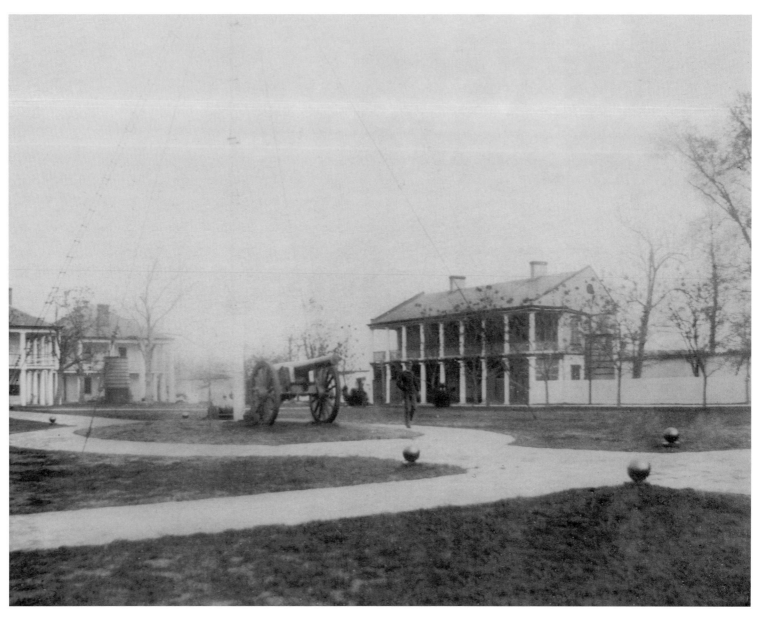

In 1833, the federal government purchased the site where Jackson Barracks stands, to house federal troops. They chose the land for its proximity to New Orleans and to the four outlying posts that protected the city. Building construction began in 1834 and finished in 1835, with the first troops to be housed there arriving in 1837. Originally called New Orleans Barracks, in 1866 it was renamed Jackson Barracks in honor of President Andrew Jackson, hero of the 1815 Battle of New Orleans. Fourteen of the original buildings still stand today.

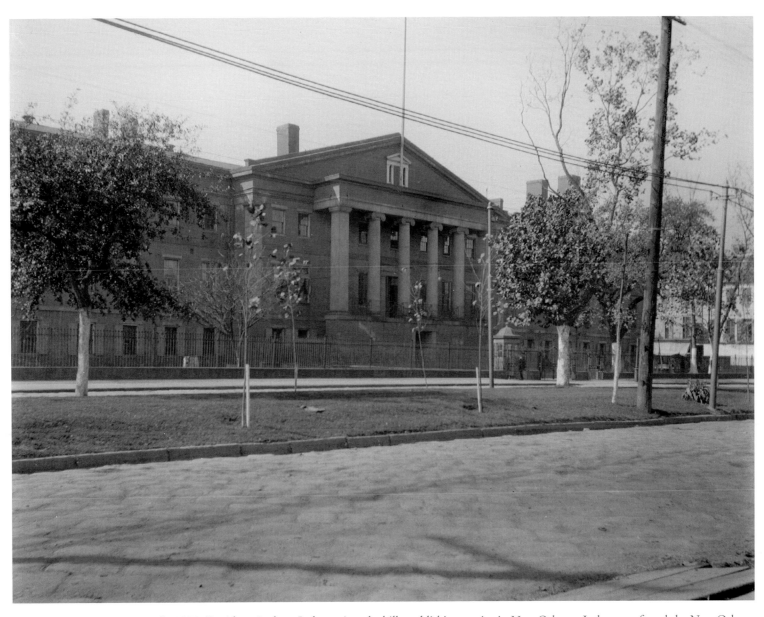

In 1835, President Andrew Jackson signed a bill establishing a mint in New Orleans. Jackson preferred the New Orleans site because of the Mexican gold that entered the city's port. William Strickland, a student of Benjamin Latrobe, designed the building. Completed in 1839, it was the only mint that produced coinage for the Confederacy during the Civil War. Today, the Louisiana State Museum houses its jazz museum there.

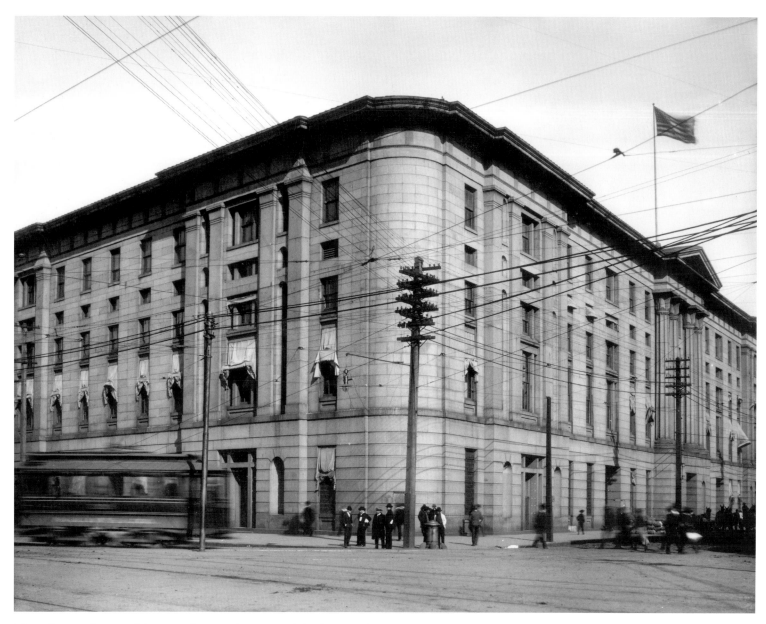

The collection district of the port of New Orleans served the shores and waters of the Gulf of Mexico, the Mississippi River, and, beyond that, the Ohio River. Construction of the customhouse shown here did not commence until 1848, and it was not functionally complete until the 1880s. During its illustrious history, Confederates created weapons there during the Civil War; under Union control, the building served as a prison for Confederate soldiers.

Created in 1871, the New Orleans Cotton Exchange was the epicenter for the cotton industry until it closed its doors in 1964. In 1884, due to the prestige of this industry in New Orleans, the city hosted the 1884 World's Fair, the World Cotton Centennial. French impressionist Edgar Degas spent much time in New Orleans and one of his most famous paintings, *The New Orleans Cotton Exchange,* shows the interior of the building with men busy at work.

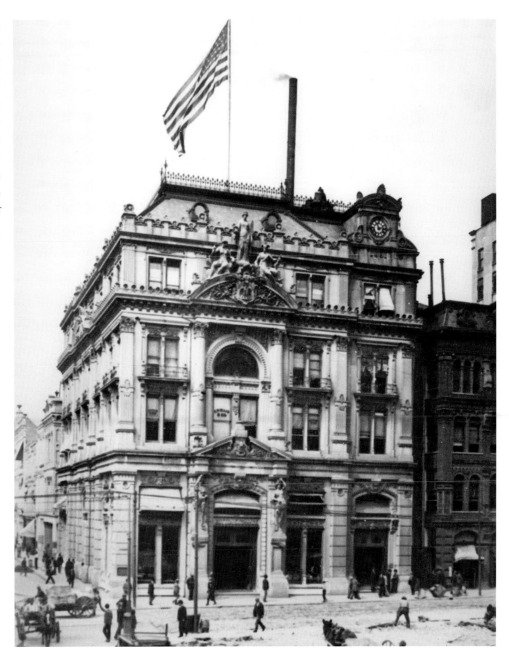

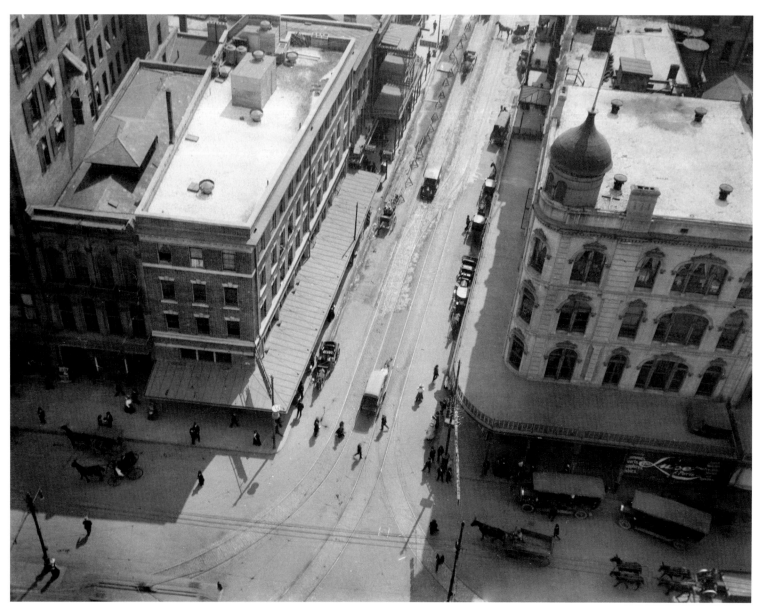

At the turn of the century, the Maison Blanche building on the 900 block of Canal Street held the ranking as the tallest building in the area and was a landmark department store for generations. Isidore Newman opened the store in 1897; after buyouts, Maison Blanche ultimately closed in 1998. This view, overlooking Baronne Street, shows a city at a crossroads: streetcar tracks, horses and carriages, and the motorized car, a mix and a transition from the old world to the new.

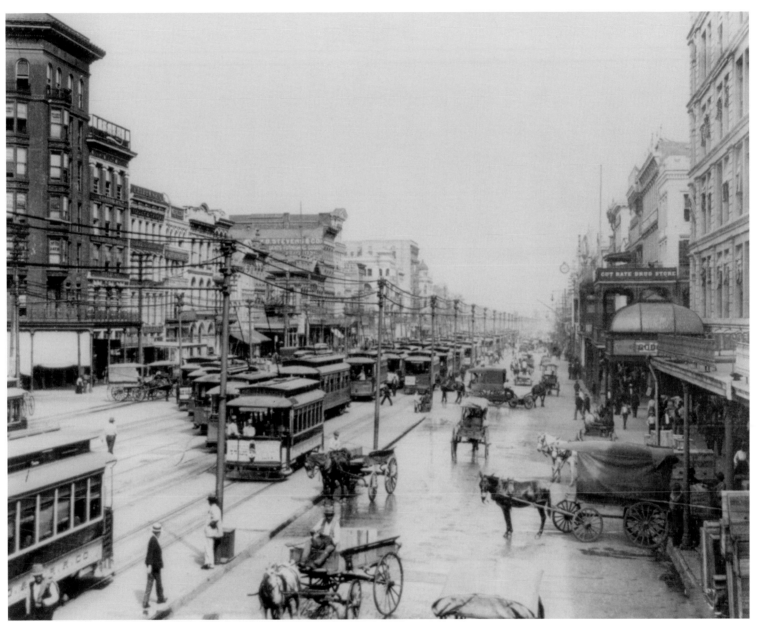

A closer view of Canal Street during the same time period shows the bustling activity of New Orleans' widest and most prominent thoroughfare. Lines of streetcars and electrical poles extend down the entire street. At the turn of the century, the city had over 173 miles of street railway, and all of them converged onto Canal Street. Theaters proliferated, and Canal Street beckoned locals and tourists alike with its amusements and businesses.

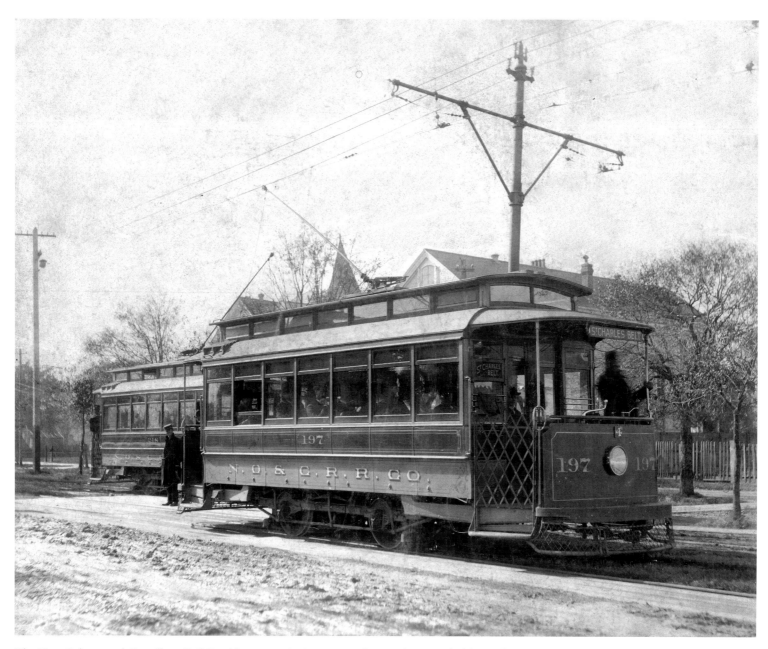

The New Orleans and Carrollton Rail Road began service in 1835, making it the second-oldest railway in the city, with the eldest being the Pontchartrain Rail Road. The New Orleans and Carrollton Rail Road Company introduced electric-driven streetcars in the 1890s, as depicted in this image of the transfer station on Willow Street. In 1922, New Orleans Public Service, Inc., bought the company and consolidated the city's streetcar lines.

Rex, which began parading in 1872, is one of the city's most famous and storied krewes, the groups that organize parades. Each year, members of Rex choose the krewe's king, a prominent business and civic leader, and the queen, a debutante from New Orleans society. Both are to remain unknown until Mardi Gras Day. In this 1901 image, Rex's stand-in, a tradition during this time in order to have a public representative prior to Carnival Day, enjoys his reception.

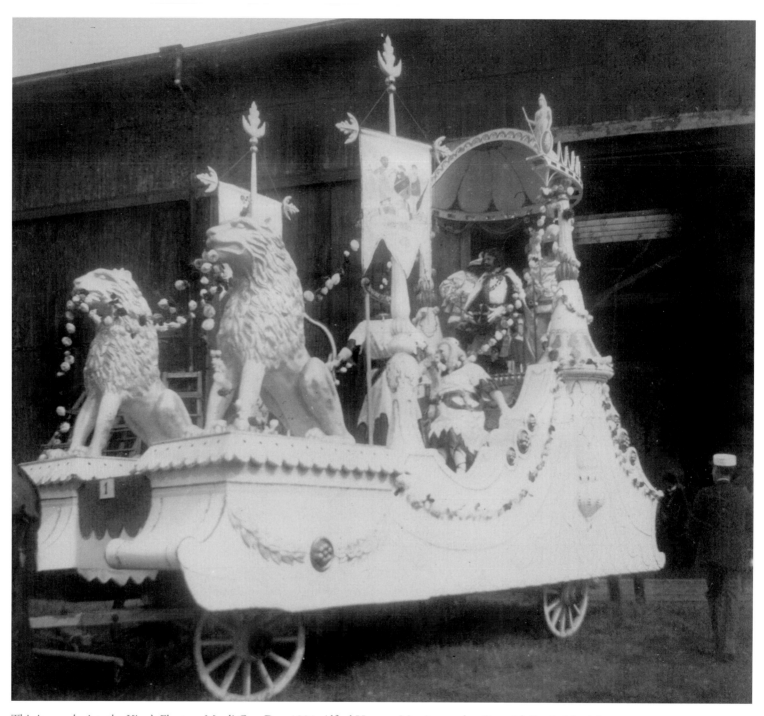

This image depicts the King's Float on Mardi Gras Day, 1901. Alfred Hennen Morris served as Rex with Bessie Merrick as his queen. The 1901 Rex theme was Human Passions and Characteristics, which led to floats with the following traits and passions: Indulgence, Religion, Art, Folly, and Hope. This season also marked, for the first time since 1871, the absence of the beouf gras, an ox clad in garlands and flowers and paraded through the streets during the Rex parade.

40

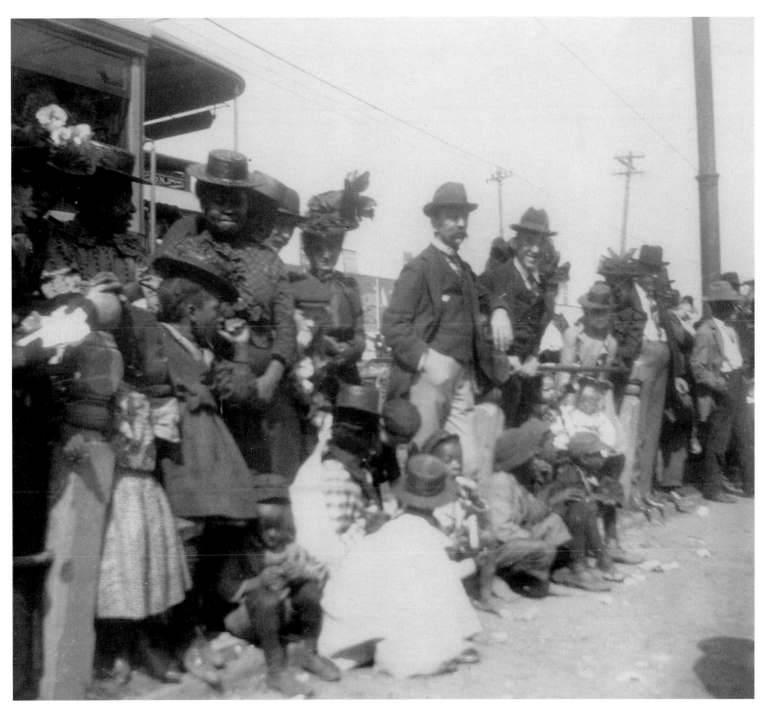

The 1901 season offered Cornelius Durkee, a visitor from New York and the photographer of this image, a rare opportunity to document Carnival throughout the day. Here he records children sitting on the ground, having a snack, and patiently waiting for the arrival of Rex on St. Charles Avenue, with the adults in tow standing on the "neutral ground"—the median.

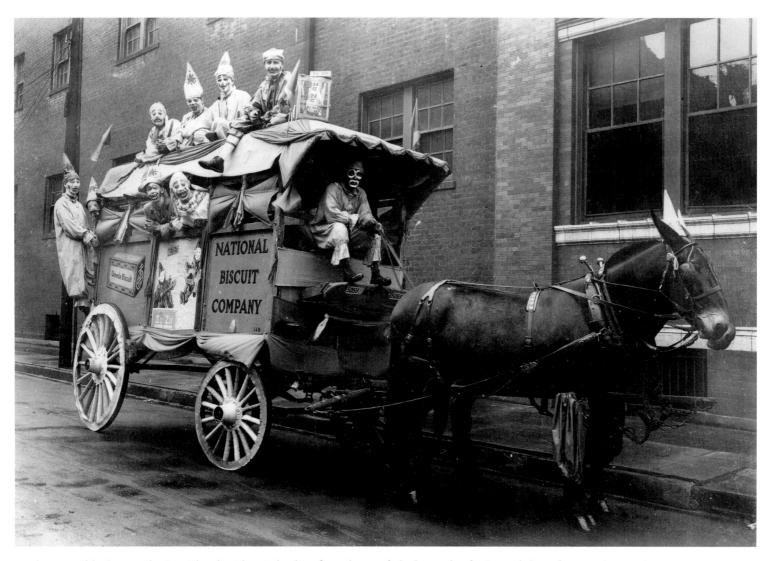

Masking possibly dates to the Spanish colonial period; edicts from that era forbade people of color and slaves from masking and mimicking whites during the Carnival season. Accounts from the 1820s report costumed people walking on the streets, apparently on their way to masked balls, and young men organizing a procession of maskers. By the 1830s, reports of parades of maskers could be found in local newspapers. The city directories of the early twentieth century, however, frowned upon the tradition as promiscuous.

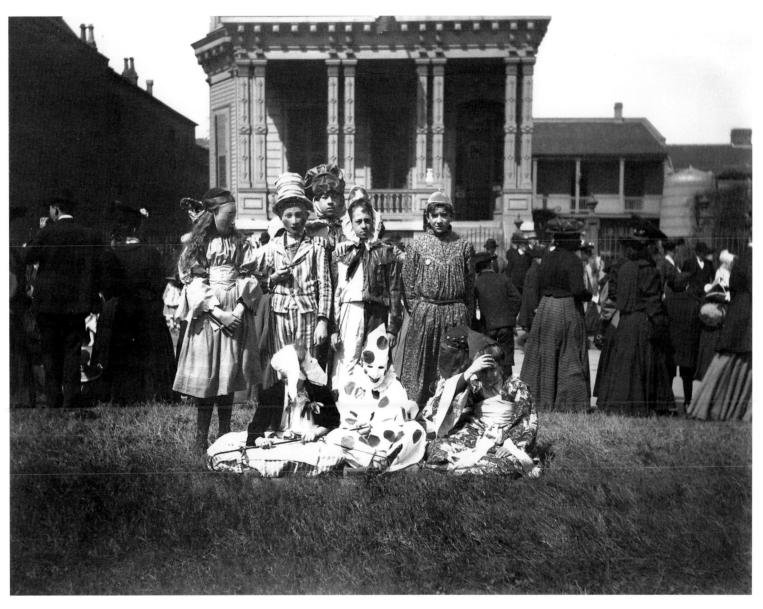

Society took a different take on children masking, as they did not consider this as threatening. Here, a group of masked children pose on St. Charles Avenue. Children always looked forward (and still do!) to Mardi Gras Day, with the hopes of catching treats like sugared peanuts or one of Rex's famous doubloons.

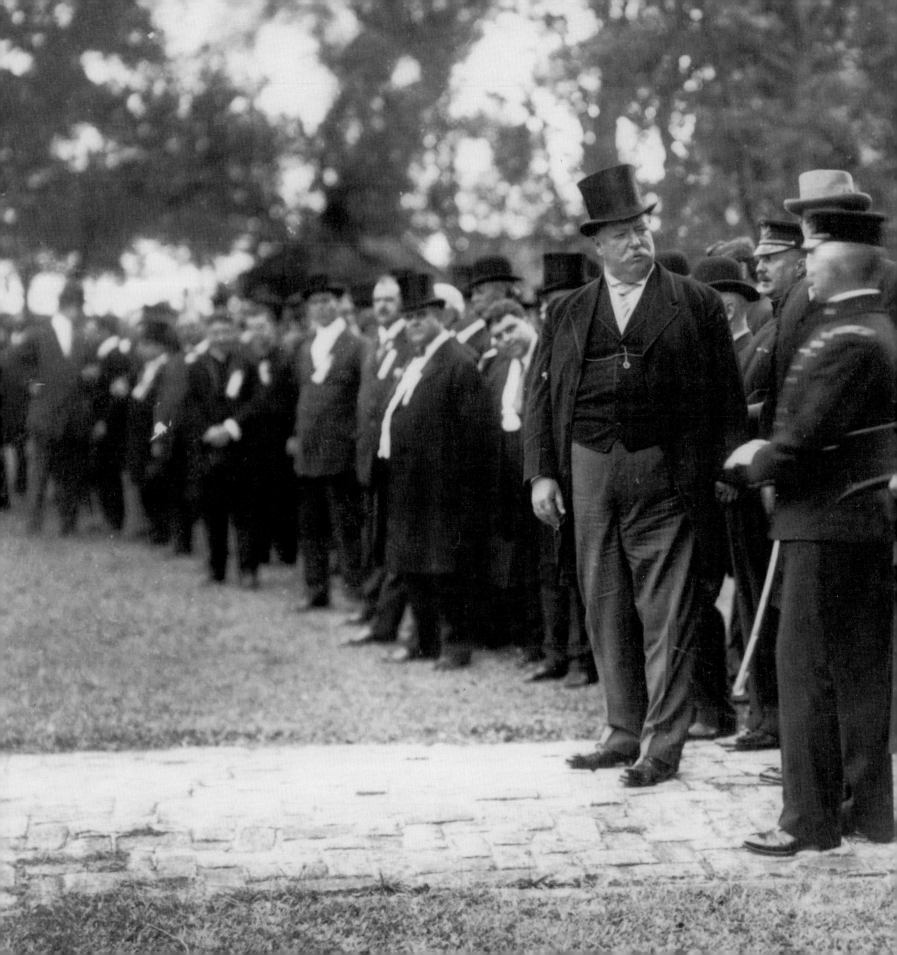

President William Howard Taft visited New Orleans twice in 1909, the first time as president-elect in town to visit Mardi Gras and the second to address the Waterways Convention held at the Antheneum the following October. In his address, he detailed the need to develop the Ohio and Mississippi rivers as commercial waterways for exports and imports so that the United States could compete with foreign powers.

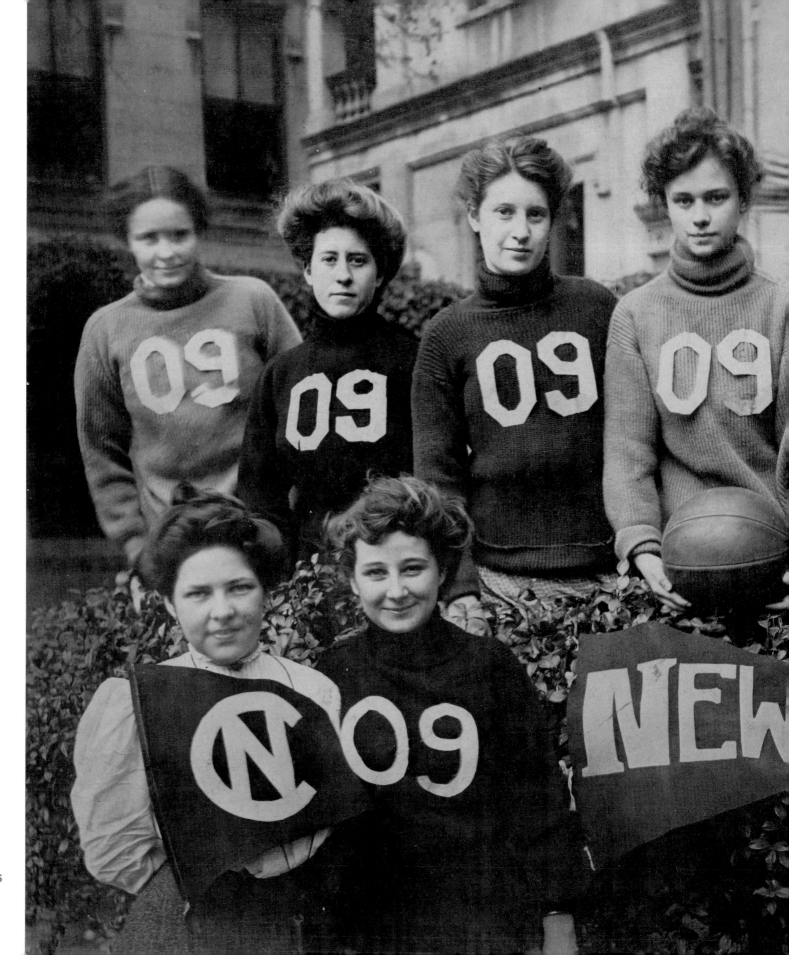

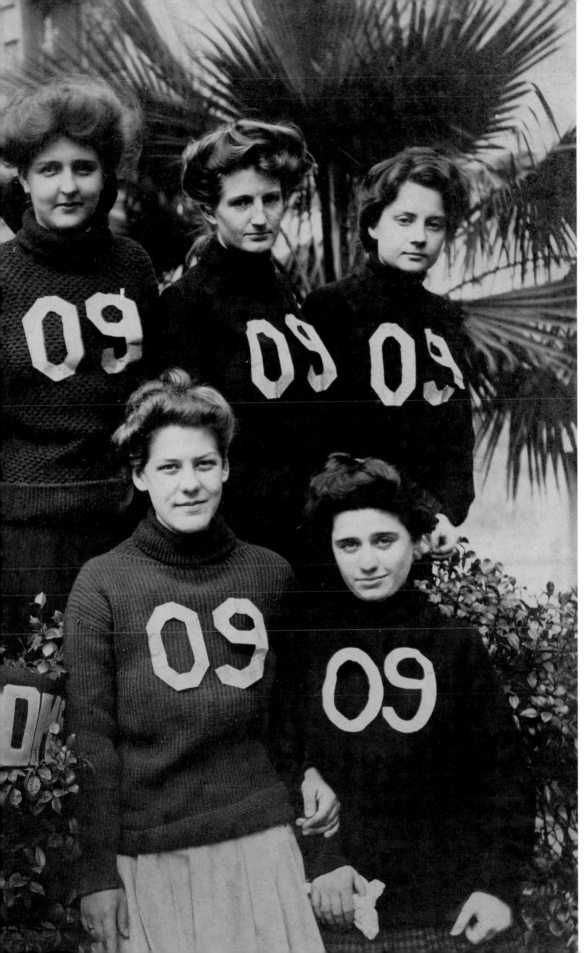

Newcomb College opened in 1886 with an endowment from Josephine Louise Newcomb in honor of her daughter, H. Sophie Newcomb. Women from all over New Orleans and the Gulf South flocked to this school as educational opportunities increased for women in the early years of the twentieth century. Internationally known for its art department, Newcomb students left their mark in the pottery world. Another critically acclaimed program during this time was the Department of Physical Education. Its first chair, Clara Baer, published *Basketball Rules for Women and Girls*.

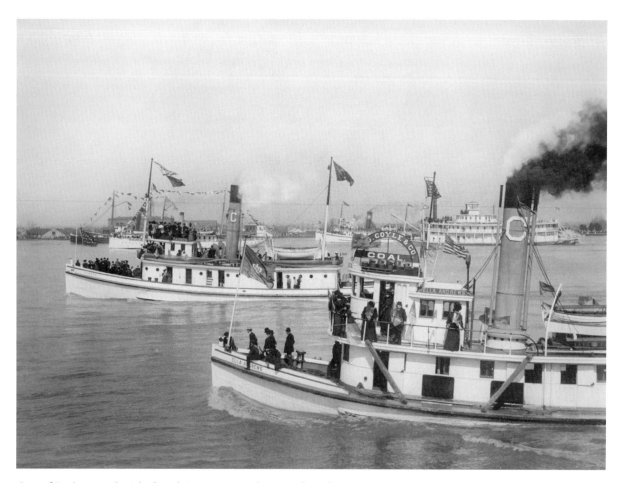

One of Rex's most cherished traditions concerns his arrival on the Mississippi River the day before Mardi Gras. For some years, he arrived on the SS *Robert E. Lee* with tugboats leading the way. The *Picayune Guide to New Orleans* called it a "magnificent display" with the King of Carnival and his entourage of dukes and peers, forming his escort to lead him on his way to receive the keys of the city.

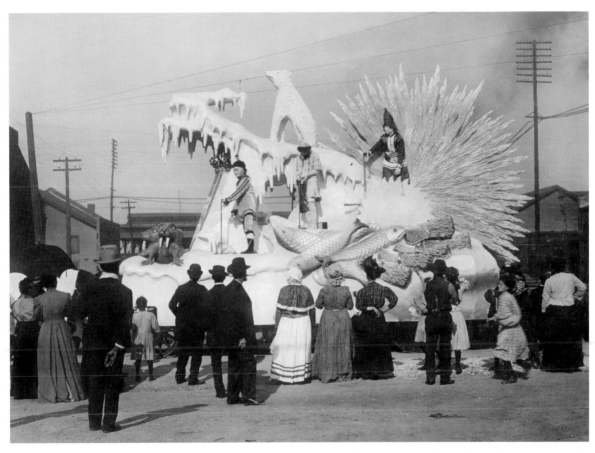

The Rex krewe, noted for the intricate design of its floats, started the float-making process early in the year. Designs for both the floats and costumes were first shown as watercolors. Once approved, papier-mache artists and other artisans set to work on physical construction of the float in utmost secrecy, starting usually on July 1 in abandoned warehouses. Here, Rex shows off its Canadian float for the 1907 theme Visions of the Nations.

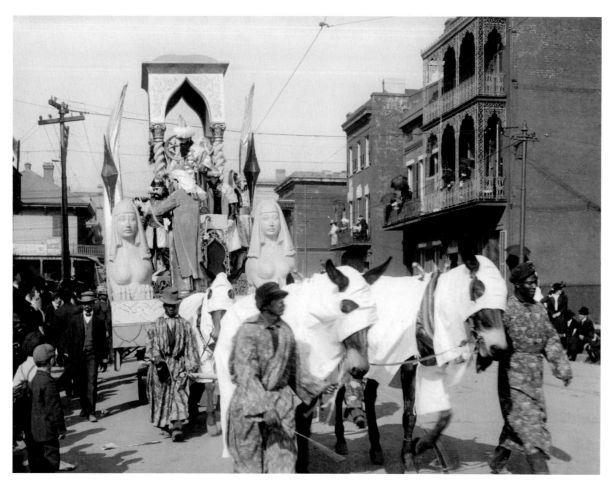

The Egyptian float, from the Visions of the Nations theme in 1907, rambles down a street to the joy of the crowds. Rex usually began around noon with the captain ensuring that the streets were free of obstacles and ordering the floats to head out. The King's float leads the parade with the themed floats, like this one, following behind.

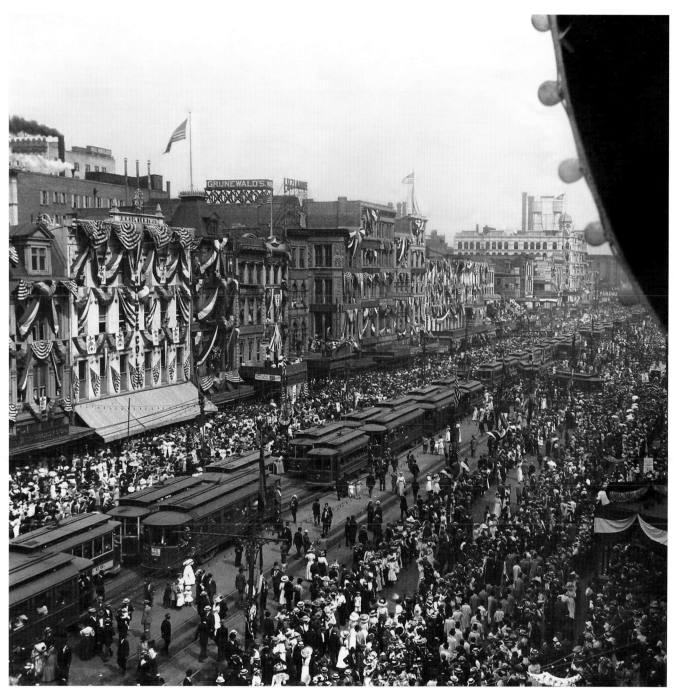

This is a view of Canal Street from the Chess, Checkers, and Whist Club after the Rex parade in 1910. Crowds throng the streets on the one day of the year when all commerce ceases and revelry reigns. Notice all the buildings decorated in anticipation of the city's most famous festival and holiday.

James DeBeneville Seguin, Charles Buck, and Charles Maurian first organized the Chess, Checkers, and Whist Club in 1880 and received the first charter in 1882. At one time, the club, with its headquarters at 108 Baronne Street, boasted a membership of 1,000 people but later restricted it to 800. This club served as a chess club, a literary society, and a social outlet for its members, composed mainly of business and social elites.

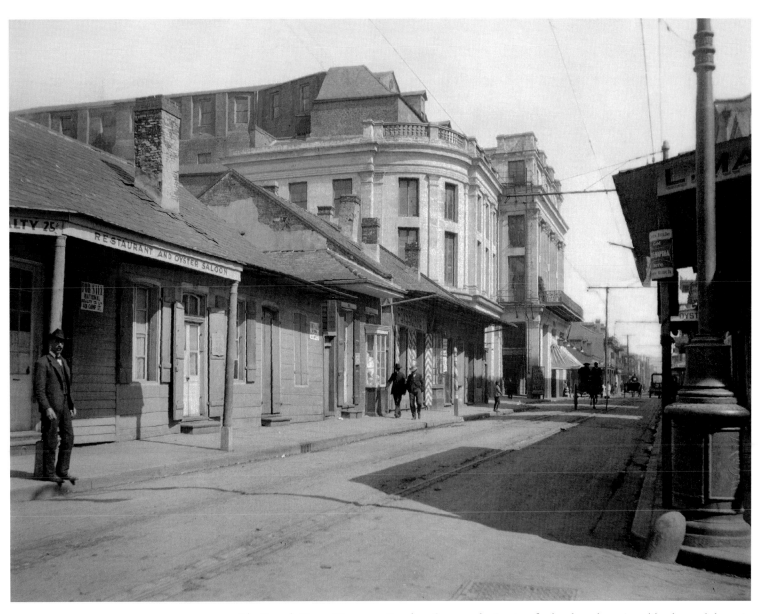

The French Opera House on Bourbon Street, a destination for locals and tourists alike, burned down in 1919. Noted New Orleans architect James Gallier, Sr., designed the building and oversaw its construction in 1860. It held 2,800 seats and was the site of many Carnival balls. Among the notable operatic singers from the turn of the century who performed there were Adelina Patti and the Madame Frezzolina.

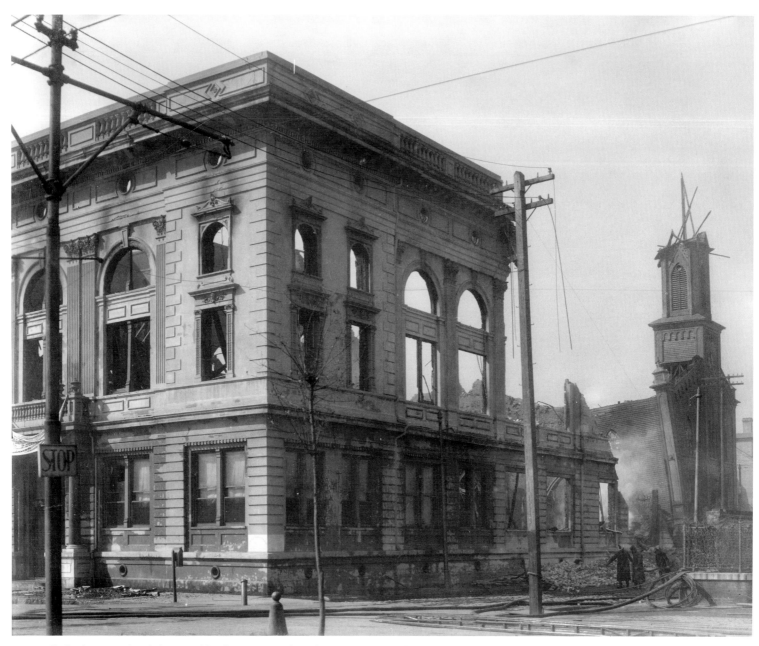

Originally built in 1896 and destroyed by fire in 1905, the Athenaeum on St. Charles Avenue made an imposing landmark. The Young Men's Hebrew Association had occupied this building since its inception. In addition to organizational activities, the Athenaeum also held concerts, plays, lectures, art shows and balls. Another Athenaeum replaced the original in 1907 and burned 30 years later.

Formerly the site of the Metairie Jockey Club and racetrack, Metairie Cemetery opened in 1872. The Tomb of the Army of Northern Virginia stands around fifty feet high. Atop the shaft of its column rests an eight-foot, nine-inch statue of Confederate general Thomas Jonathan "Stonewall" Jackson. The members of the Louisiana Division, Army of Northern Virginia, commissioned the tomb and held its dedication ceremony in 1881. Jefferson Davis, upon his death in 1889, was laid here before his remains were reinterred in Richmond, Virginia, in 1893.

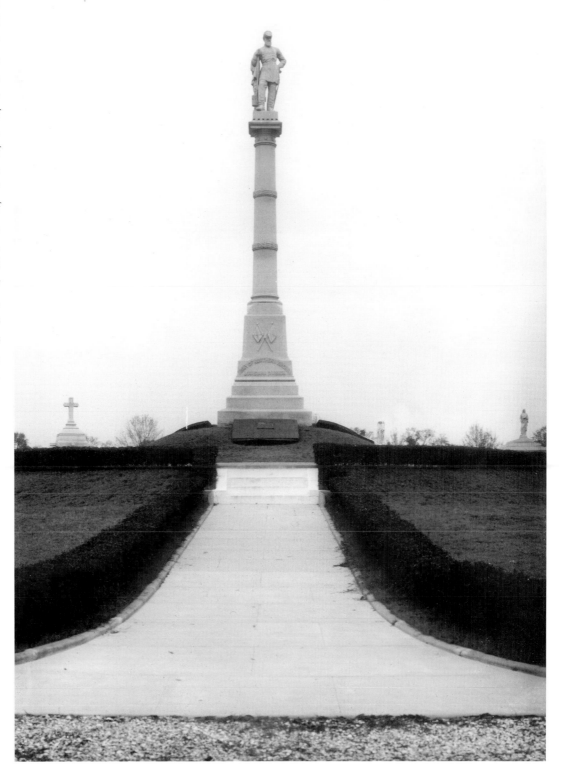

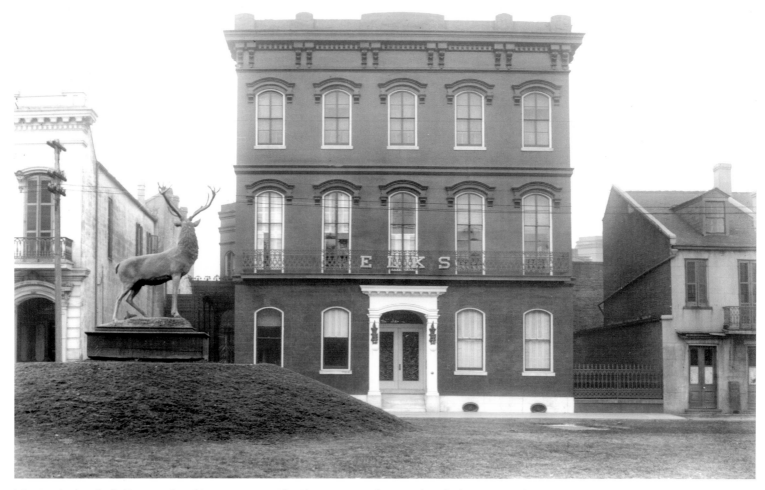

The Brotherhood of Elks moved to this structure on Elks Place in 1897 after spending $14,000 to purchase and renovate the building. Up till this time, this organization had not had the best of luck with their structures; they moved numerous times and fell victim to fire once. This building boasted a billiards room, smoking room, writing room, reading room, and an indoor swimming pool and baths.

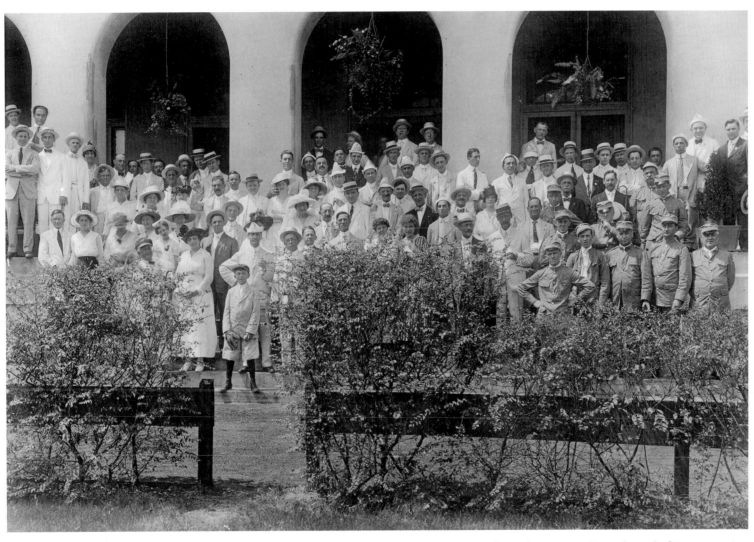

Fraternal organizations have enjoyed a long and storied career since the city's inception. From the end of Reconstruction up through the early years of the twentieth century, these groups sprouted throughout New Orleans. Here, the members of New Orleans Lodge No. 30, B. P. O. Elks and their families stand for a group picture. The Elks, on a national level, received its charter in 1868 and organized in New Orleans in 1884.

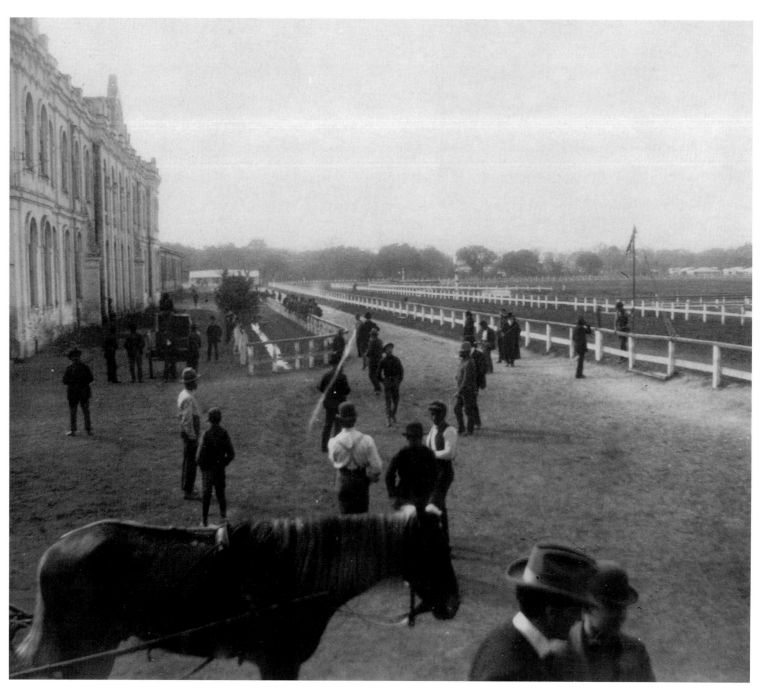

In April 1873, the Fair Grounds opened to the Crescent City Jockey Club. Horseracing had been a popular pastime in New Orleans since the 1850s and at the turn of the century, it became more popular than ever with the growth of this club and the New Louisiana Jockey Club. By 1908, the state made racing illegal, but reversed that law again in 1915.

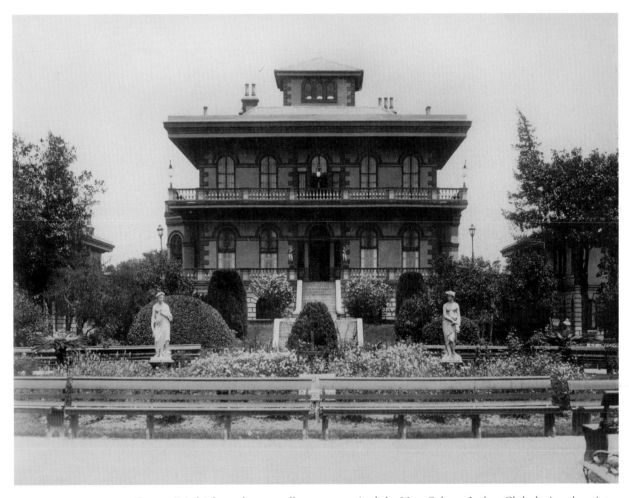

George Friedrichs and some colleagues organized the New Orleans Jockey Club during the winter season of 1904–1905. Their racecourse at the back end of City Park on Metairie Ridge took up over one hundred acres, with the Grand Stand holding about 5,000 people. This image depicts the clubhouse for the New Orleans Jockey Club on Esplanade Avenue, which later became a private residence.

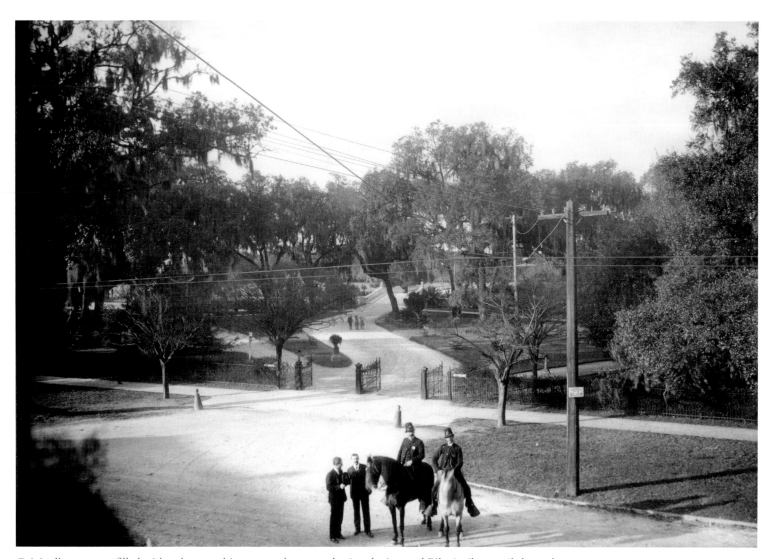

Originally a swamp filled with oak trees, this area was home to the Accolapissa and Biloxi tribes until the early French period. Eventually, the land became the property of Joseph Allard whose plantation was sold at sheriff's auction to John McDonogh in 1845. McDonogh, a local philanthropist, donated the land to the city upon his death, with the specific intent to convert the land to a park. It opened to the public in 1854. While the original bequest only had one hundred acres mentioned, today City Park encompasses over 1,300 acres.

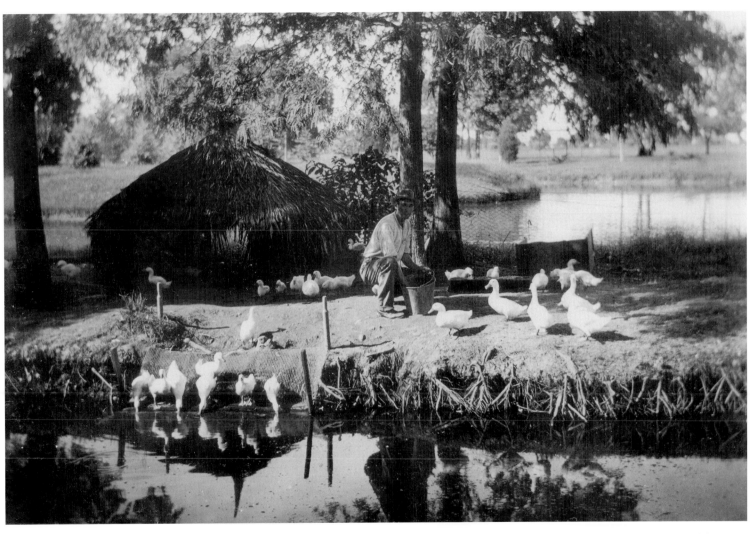

Ducks, geese, and egrets can be found on Bird Island at City Park, an oasis for local wildlife. Here, a caregiver hands out some bread to hungry customers. Generations of New Orleanians have taken part in feeding the different varieties of fowl that make this area their home.

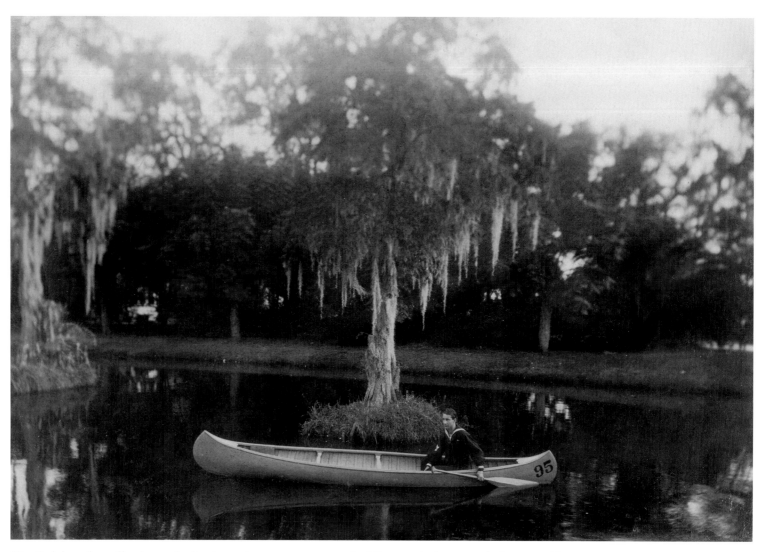

City Park has often offered a respite for those who want to escape and while away the hours on the lagoon, with the magnificent backdrop of a live oak draped in Spanish moss. During the first decade of the twentieth century, under an improvement campaign on the part of Mayor Paul Capdevielle, a golf course and racetrack were built and opened to the public. Pony rides began and the mechanical carousel also opened.

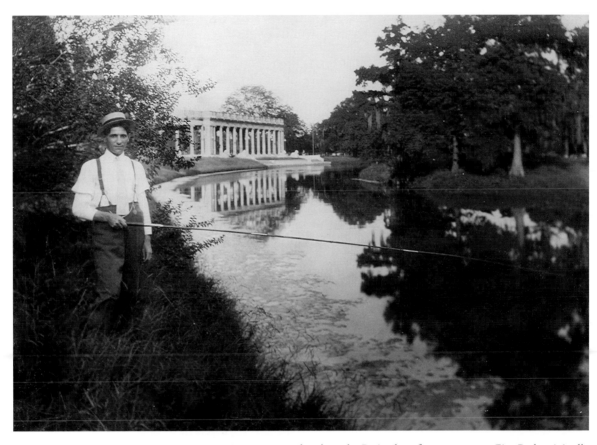

In 1907, construction was completed on the Peristyle, a famous spot at City Park originally used for outdoor dances. The Ionic columns, the four lions, and the steps touching upon the edge of the bayou give the site an almost regal, other-worldly atmosphere. Many people can be seen even today fishing from its bottom steps for delicacies such as bass.

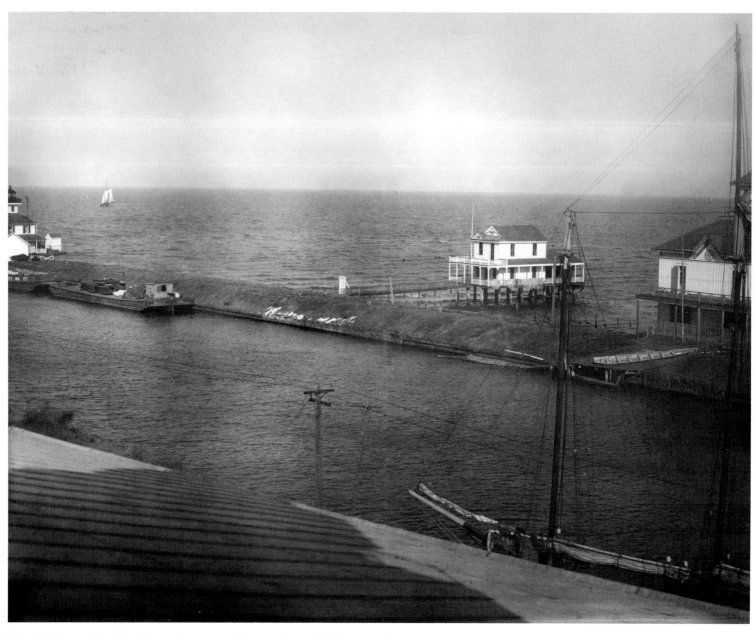

West End was originally a famous resort named New Lake End. The name changed in 1880 when a hotel, restaurant, and amusements were built on stilts over Lake Pontchartrain.

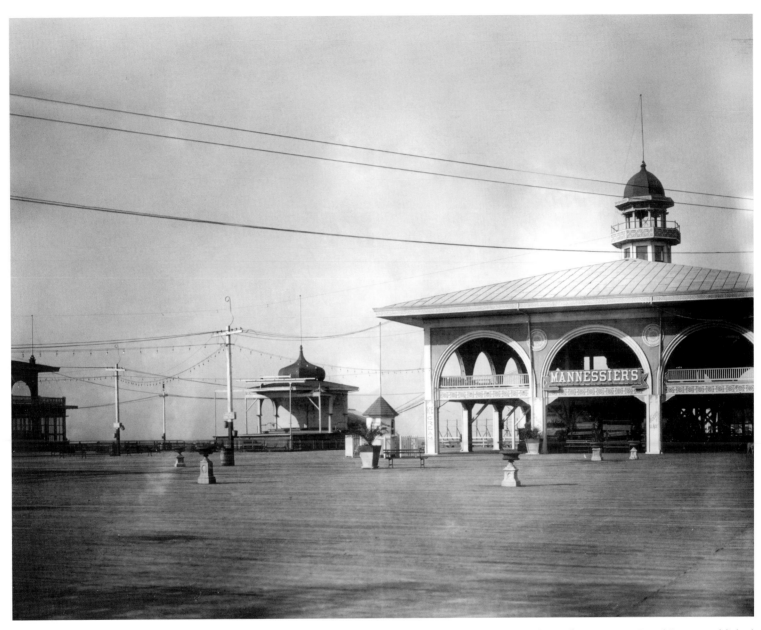

The famous ice cream, pastry, and coffee shop, Mannessier's Confectionery on Royal Street established a new restaurant at West End in 1889, Mannessier's Pavilion. Here, between the two pavilions, the first movie played in New Orleans in 1896. Also, musicians performed in this area and all along Lake Pontchartrain during the early days of jazz. The Pavilion operated until about 1911.

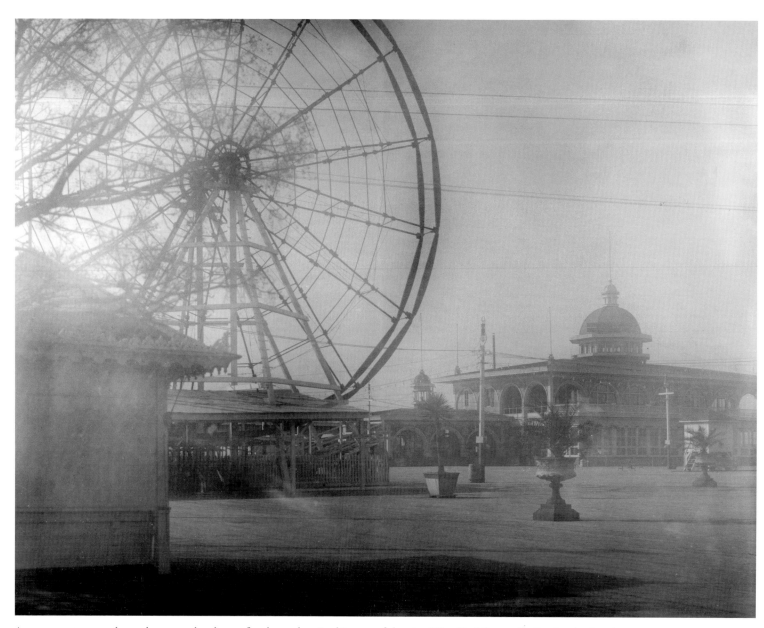

Amusement centers have always made a home for themselves in this area of the city. West End featured a Ferris wheel and roller coaster; across the way were Mannessier's and Spanish Fort, with a resort hotel and amusements of their own. New Orleans boosters tried to promote this area as the "Coney Island" of the South. Eventually, both these parks would be supplanted by Pontchartrain Beach at the site of Spanish Fort in the 1920s and closed in 1983.

The second-oldest yacht club in the country, the Southern Yacht Club opened in 1849 in Pass Christian, Mississippi, and relocated to New Orleans in 1857. One of the oldest regattas in the country, the Race to the Coast, stretches from Lake Pontchartrain to the Mississippi Sound. This building, constructed in 1899 under the direction of Commodore Albert Baldwin, received major renovations in 1920, but it was in such bad condition by 1949 that it was replaced with a more modern building, which Hurricane Katrina destroyed in 2005.

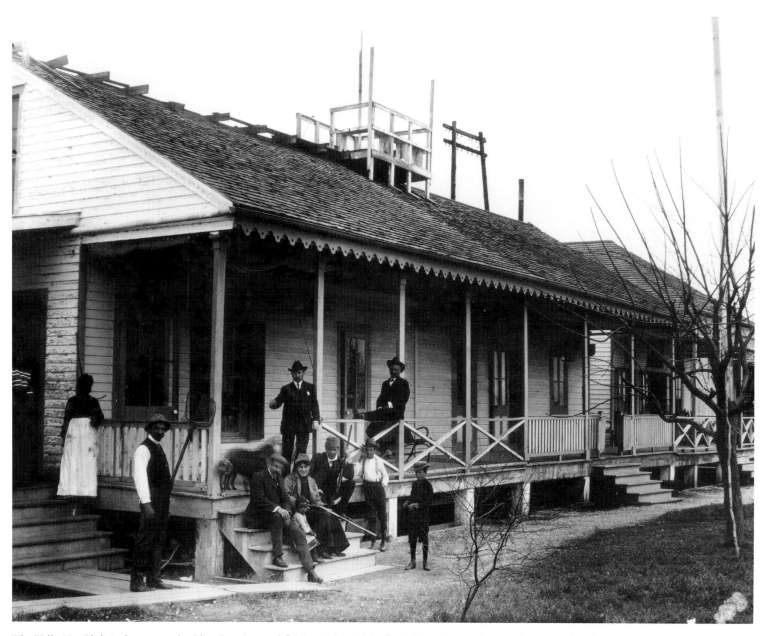

The Tally Ho Club is the country's oldest hunting and fishing club. Originally built on Bayou Sauvage in 1815, shortly after Andrew Jackson defeated the British at the Battle of New Orleans, the club moved to its location across the Chef Menteur Pass in 1869. A part of the original building still stands and is now used as the club's dining room.

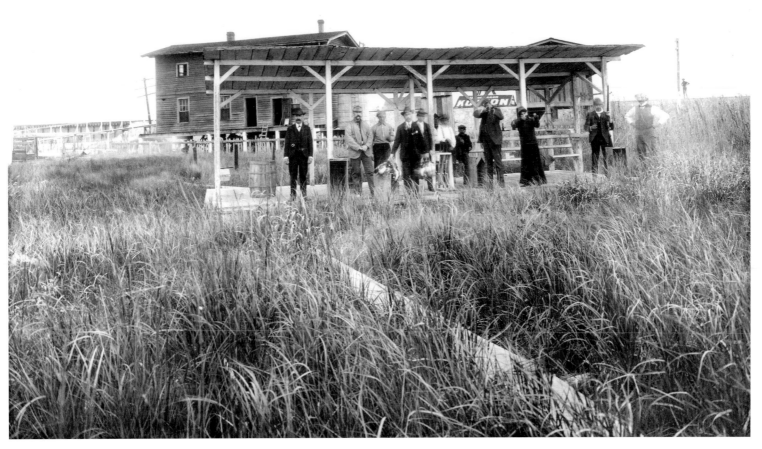

Members of the Tally Ho Club set up at the shooting box. This area is renowned for its teal, mallard, black duck, dos gris, poule d'eau, and other birds. Today, the club is still close to thousands of acres of virgin marshes and bayous.

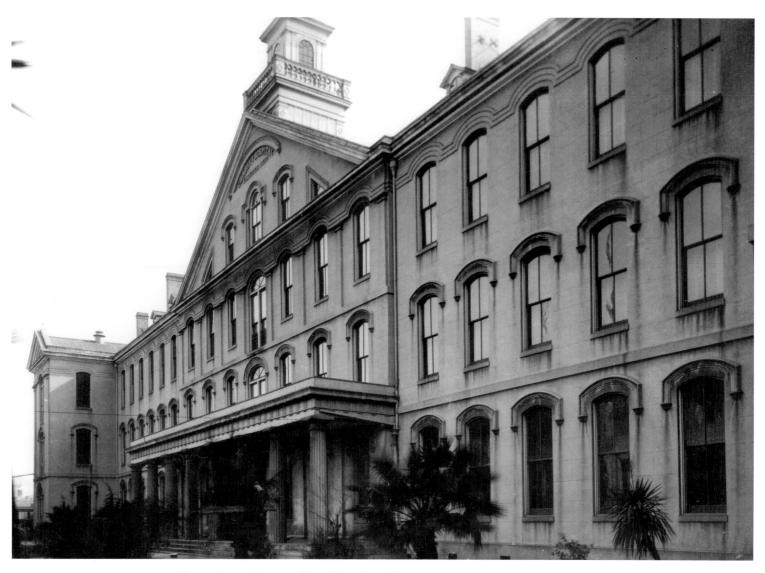

Charity Hospital is one of the oldest charitable institutions in the United States. In 1737, Jean Louis, a French sailor, left 10,000 livres to the Ursuline nuns to establish a hospital to aid the indigent. Through that generous donation, generations of poor have been able to receive access to health care in New Orleans. This building, constructed in 1832, stood on Tulane Avenue and handled about 7,000 cases yearly at the turn of the century.

During the early twentieth century, New Orleans had six markets, with the French Market being the oldest and most famous. With the influx of immigrants during this time, many found work in agriculture and as vendors in the market. For the most part, those who worked as butchers came from the Gascon region of southwestern France, as shown here in the meat market of Roman D'Artois.

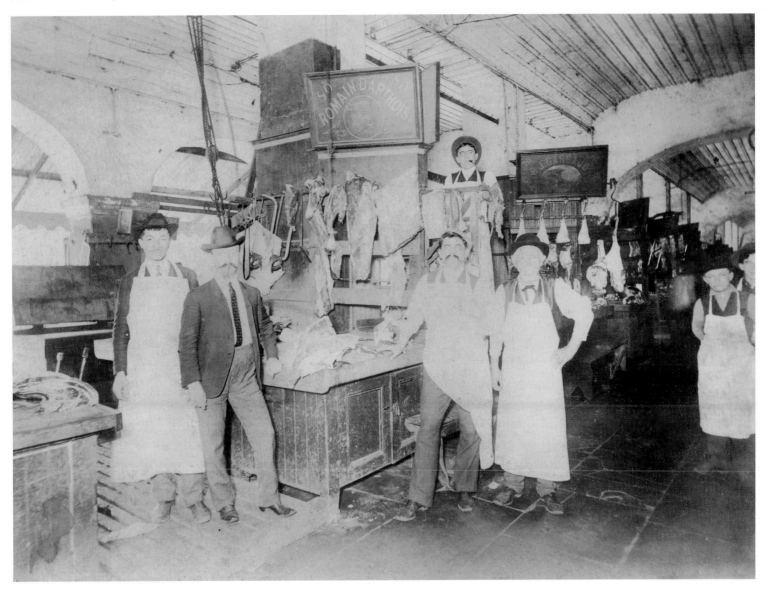

Following Spread: Vegetable and fruit peddlers normally came from Italy, Germany, and Spain. Here, children wait in front of the market and Masich's Grocery. Tangipahoa Parish to the north and Plaquemines Parish to the south of New Orleans were home to many of these immigrants who opted for agricultural work versus selling in the market. There, they raised a variety of citrus crops such as lemons, oranges, and strawberries, in addition to other produce to be sold in the city.

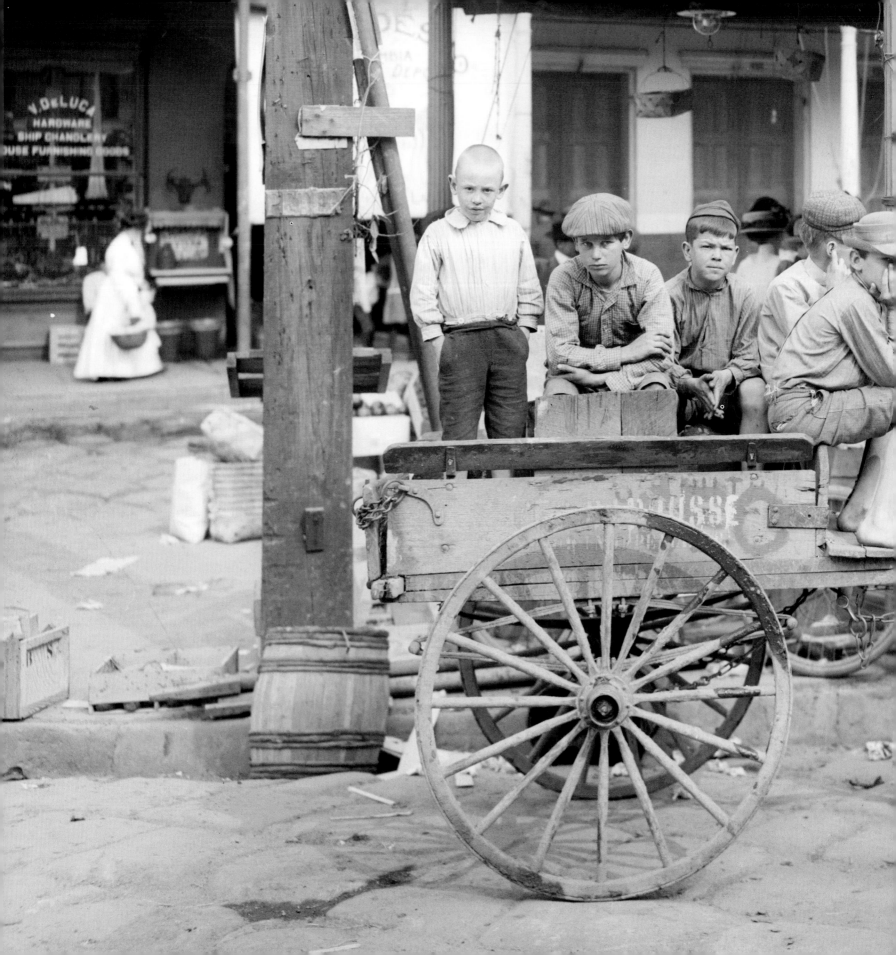

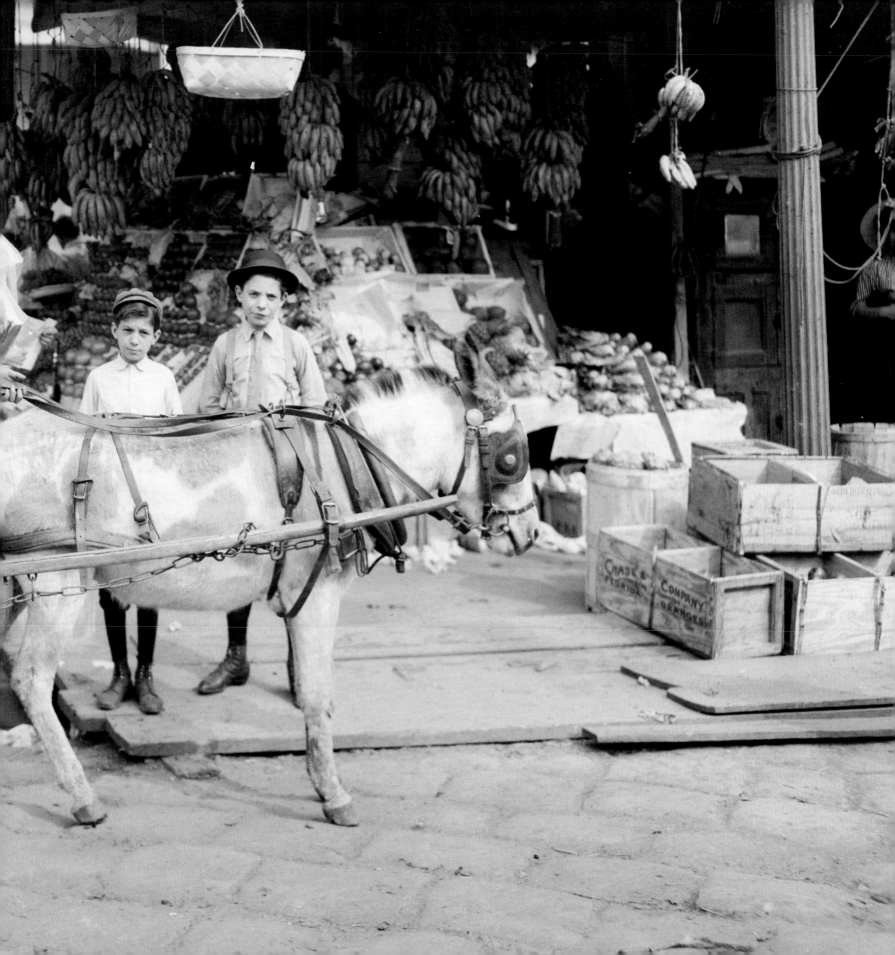

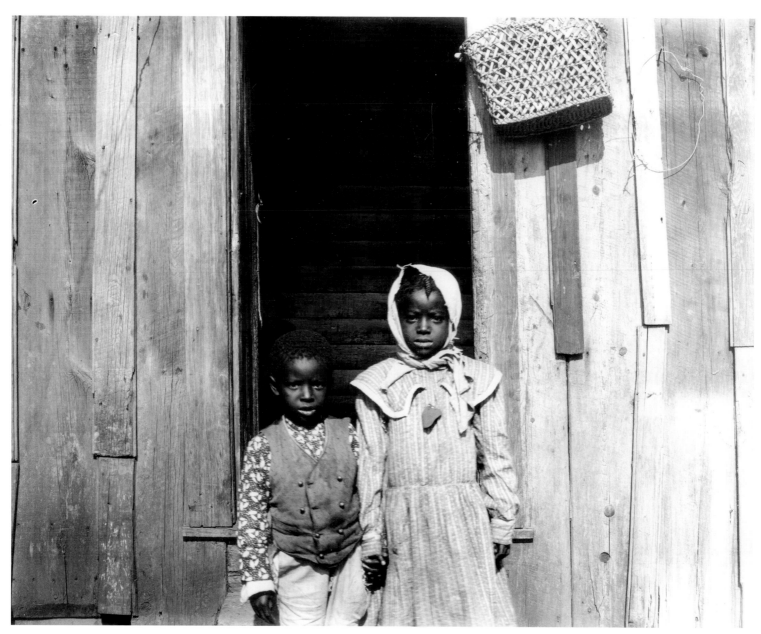

In some ways, African American children did not have as many resources at their disposal as foreign-born children in New Orleans. For families who left the plantation and moved to New Orleans following the Civil War, life at the turn of the century could be described as bleak at best. While there was some access to education, the Orleans Parish School Board continually put off educating African American children.

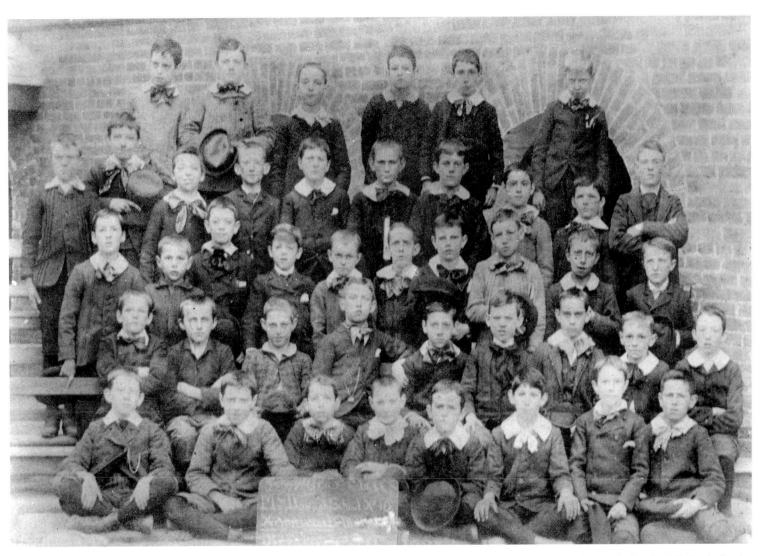

In John McDonogh's will that left land for a park where City Park currently stands, he also left funds for the public education of children. Today, in New Orleans, many public schools are named "McDonogh" schools in honor of this man, who in essence established free public education in the city. While he never asked for any accolades, he did request that the schoolchildren of the city throw flowers on his grave once a year.

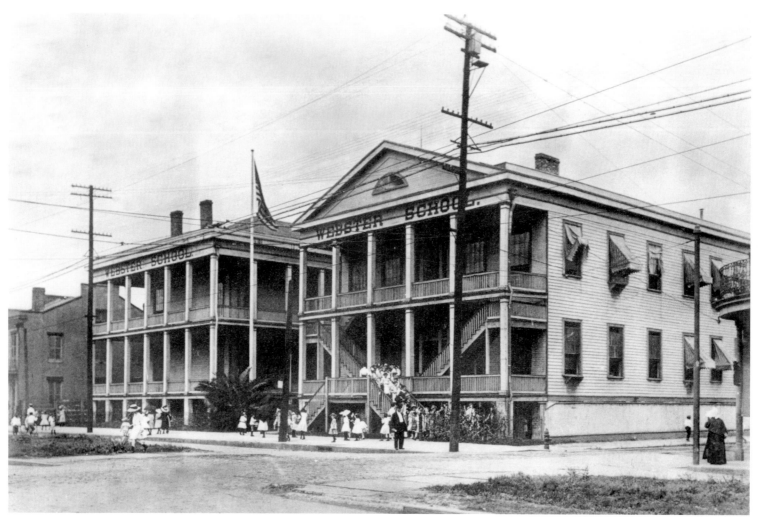

The Orleans Parish School Board educated roughly 32,000 out of 75,000 educable children in New Orleans at the beginning of the new century. With 16,000 students educated in the parochial system, nearly one-third of New Orleans' children received a private education. The Webster School for girls, directed by Miss Kate Eastman on Dryades and Erato streets, served the education needs of girls in the American sector.

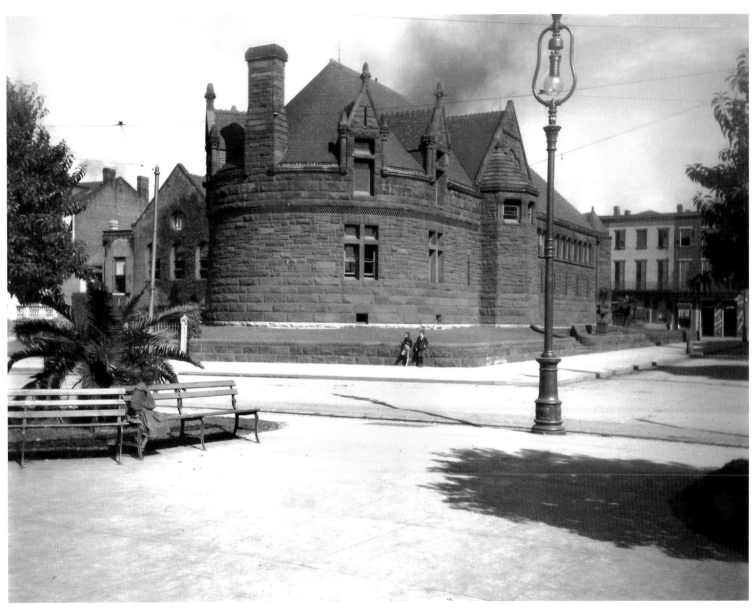

On March 4, 1889, Annie Turner Howard established the Howard Memorial Library, situated between Camp Street, Howard Avenue, and Lee Circle in memory of her father, Charles T. Howard. William Beer was appointed the first librarian. The library held 35,000 volumes in addition to a significant rare book and map collection, as well as John Audubon's prints. Eventually, Tulane University's Tilton Library absorbed Howard Library, becoming the Howard-Tilton Memorial Library.

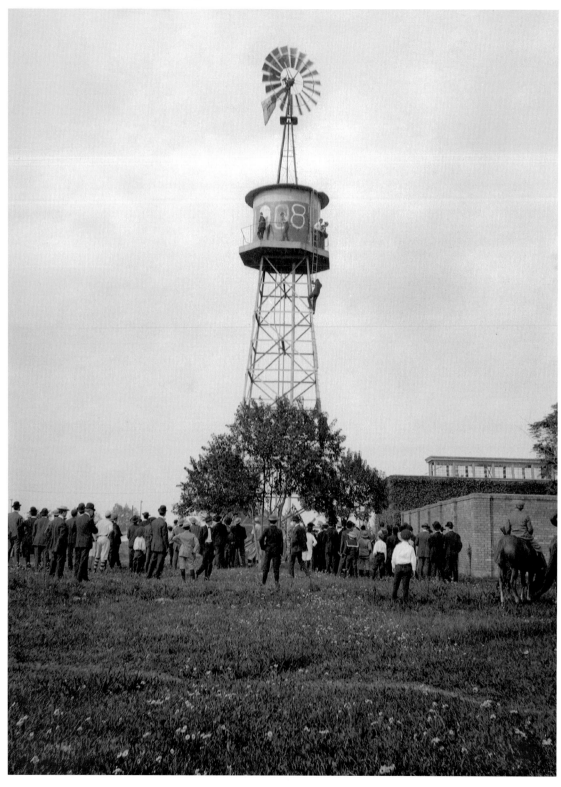

This image captures people looking at the windmill prior to a Tulane football game. In 1908, the year painted on the water tower, the team went 7–1, outscoring opponents 103–23. Louisiana State University was not on their schedule that year. In 1905, when John Tobin was the head coach of Tulane, the season had consisted only of one game—against LSU, which won 5–0. Subsequently, Tulane complained that LSU used ineligible players. Due to the discord, the two teams did not play against each other again until 1911.

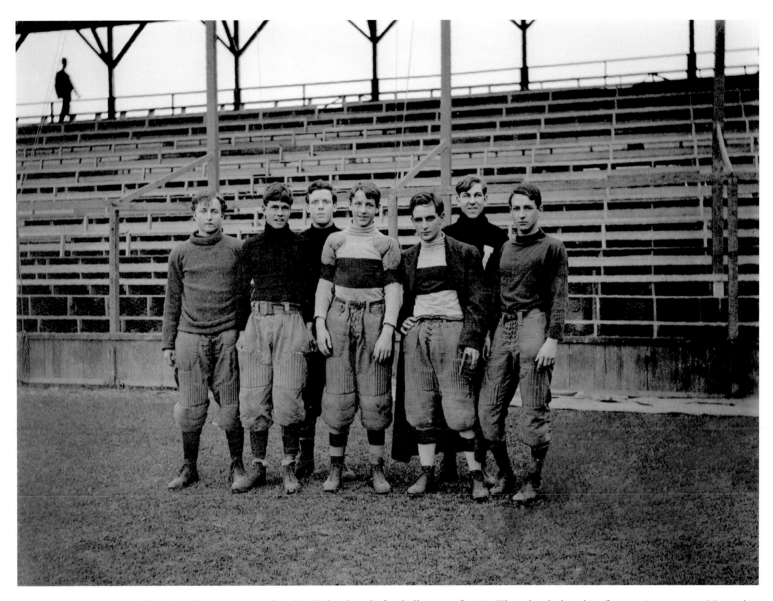

These hardy young men played in Tulane's only football game of 1905. The school played its first varsity game on November 18, 1893, losing to the Southern Athletic Club. Modern standards had not been set at that time, so Tulane's coach, T. L. Bayne, also played in the 1893 game—on the opponent's side! Seven days later, his brother Hugh scored Tulane's first-ever touchdown, against LSU, a team Bayne also helped coach. From 1900 to 1907, Tulane had seven different head coaches.

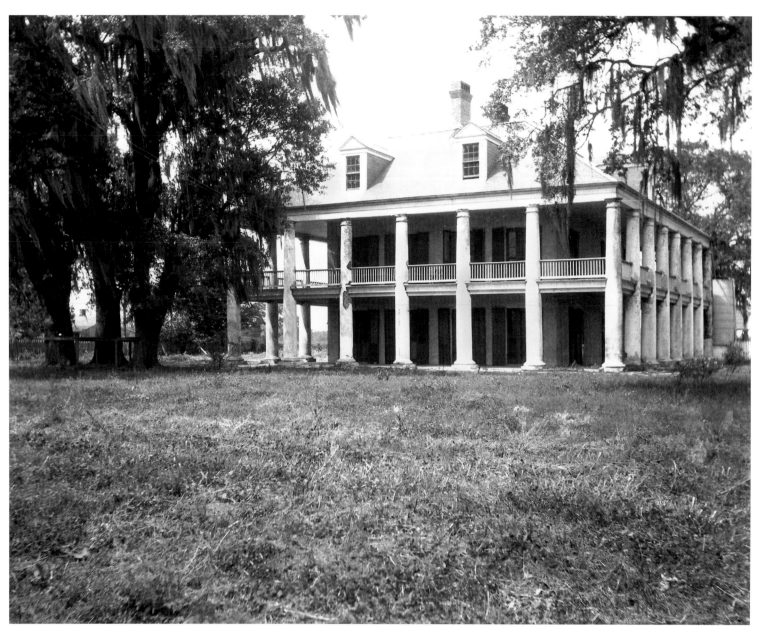

One of the older plantation homes in the area, Three Oaks Plantation in St. Bernard Parish sustained a bit of damage during the 1815 Battle of New Orleans, when a shell pounded one of the solid brick columns of this beautiful Greek Revival building. In 1966, in order to build a canal, the American Sugar Company demolished the Three Oaks Plantation in a swift, unpublicized move.

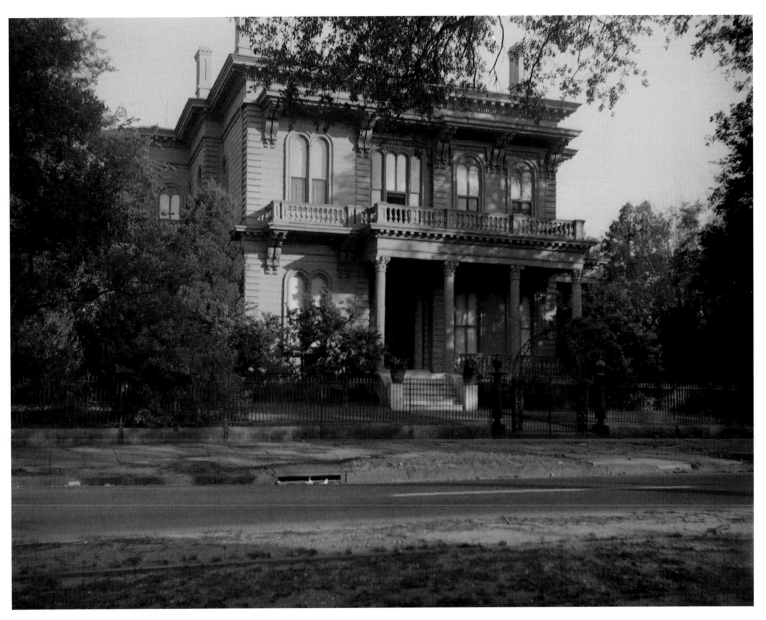

First developed as residences for Americans not wanting to live in the Quarter with the French Creoles, development in the Garden District began in the 1830s and 1840s, a time period known as New Orleans' golden age. The area borders St. Charles Avenue, Magazine Street, Louisiana Avenue, and Jackson Avenue. The sumptuous mansions, with their cast-iron gates, are surrounded with large gardens, giving the area its moniker.

Prior to the modernization of the city's utilities around the beginning of the twentieth century, cisterns, like the tall, circular one shown here, served as residents' main water source. These large containers collected rain water. Drinking it increased the chance of contracting the yellow fever that plagued the city until the first decade of the twentieth century. With the establishment of the Water and Sewerage Board under Mayor Paul Capdevielle's administration, cisterns were eventually removed.

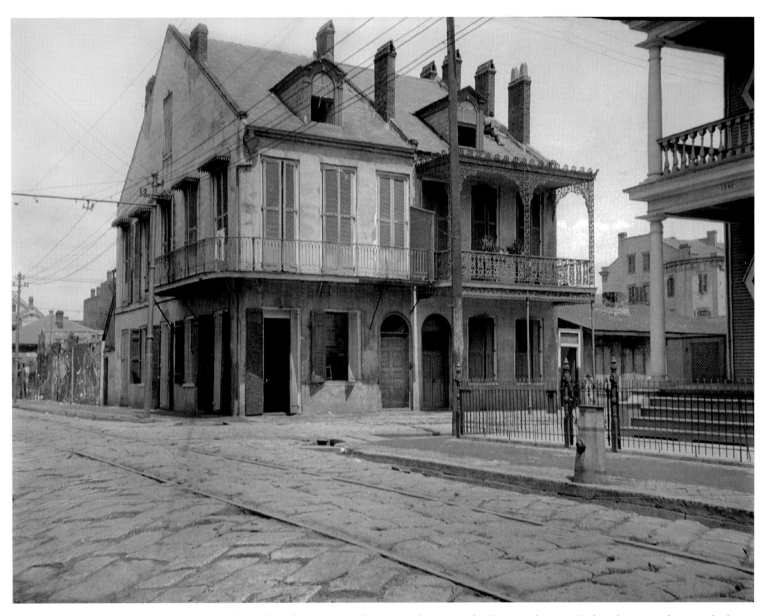

During the mid- to late-nineteenth century, the area in the Quarter closer to Esplanade Avenue became the home of the indigent and of newly arrived immigrants. Former residences, such as these buildings on Barracks and Royal streets, were split up into apartments. These two buildings did not follow the predominant style of retail spaces on the bottom and living quarters on the top, however. Somewhat ironically, it was the immigrants who preserved the architectural integrity of the French Quarter. When city leaders considered tearing down vast portions of the Quarter in the twentieth century, the residents successfully fought against the idea.

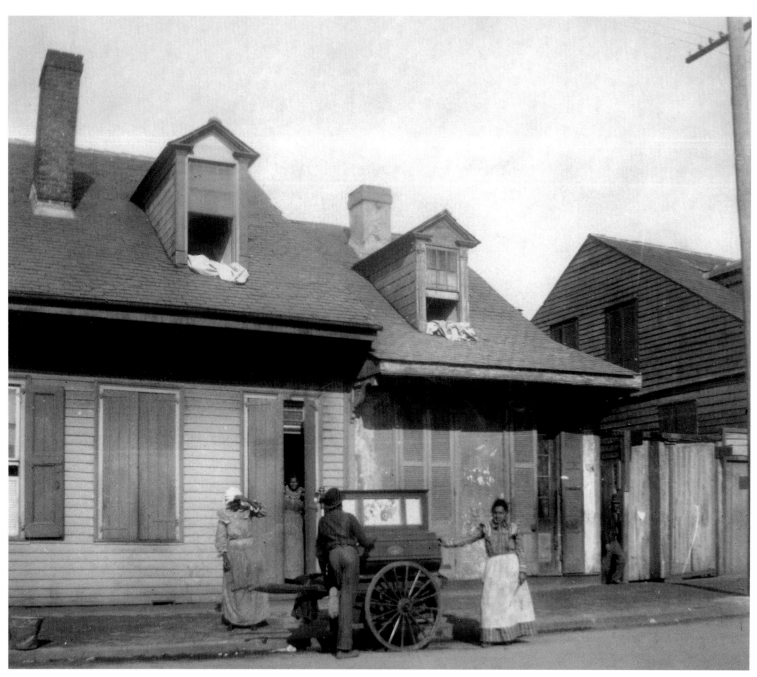

North Rampart, which bridged the French Quarter with parts of Treme, housed mainly African American families and Italian immigrants at the turn of the century. Treme is the country's oldest African American neighborhood, but during this time, newcomers flocked to this area and to the Quarter for the cheap rent and proximity to work. The influx forced out some of the older white and black Creole families, who eventually moved to Esplanade Ridge and other areas of New Orleans.

THE GREAT WAR, THE JAZZ AGE, AND THE DEPRESSION

(1911–1939)

New Orleans' music, cuisine, and culture make it one of the most distinctive cities America ever produced. Louis Armstrong and his jazz trumpet innovations; Huey Long with his populist politics; the exotic characters of Storyville—these people and countless others have made this city a magical place.

The years between 1910 and 1920 ushered in a time of changing attitudes to replace the pervading Victorian ethos, leading to the Jazz Age of the 1920s with its sultry, exotic tunes, free-spiritedness, and a greater willingness to question those in power. Storyville, New Orleans' famous red-light district, allowed prostitutes to work in the open and encouraged the development of jazz in brothels' clubs.

At Newcomb College in Uptown New Orleans, women, leaving the confines of the home, entered higher education in greater numbers. With this reform-minded culture under way, more women entered the work force and volunteer circles, leading to a push for voting rights.

The United States' entry into World War I quickly changed some of these aspects of New Orleans life. A federal act prohibiting red-light districts near bases shut down Storyville and ended the careers of some of the characters that made it famous—or infamous—such as Tom Anderson, Lulu White, and Hilma Burt. Jazz musicians, having no place to perform, started moving to more African American–friendly cities such as Chicago and New York City, where the Harlem Renaissance was in full swing.

The 1920s brought additional hardships to New Orleans with the disastrous Flood of 1927, at the time considered the worst natural disaster in United States history. Only a short time later, the Great Depression hit the nation, and New Orleans felt the punch. Yet, one leader would rise during the 1920s and 1930s who would not only change the political climate of the state but the nation as well, Huey Long.

Although many things changed in New Orleans and in the rest of the country during this time, much stayed the same. French Quarter architecture remained relatively untouched as immigrants and bohemians flocked to the Quarter with its old-world charm. The Works Progress Administration (WPA) programs of the 1930s and 1940s brought photographers and

writers to the South to document this fading world. Specifically, through the Farm Security Administration, some of the most talented photographers of their generation came to New Orleans and fell in love with the city's culture, architecture, and people. Walker Evans, Ben Shahn, Frances Benjamin Johnston, and Joseph Woodson "Pops" Whitesell made New Orleans their home for a time.

Racist Jim Crow policies reinforced their grip. African Americans saw their rights and the advances they had made in previous generations further wither away. Segregation's hold on the city forced many black New Orleanians to the back of the streetcar, and it would be another generation before significant gains would be made.

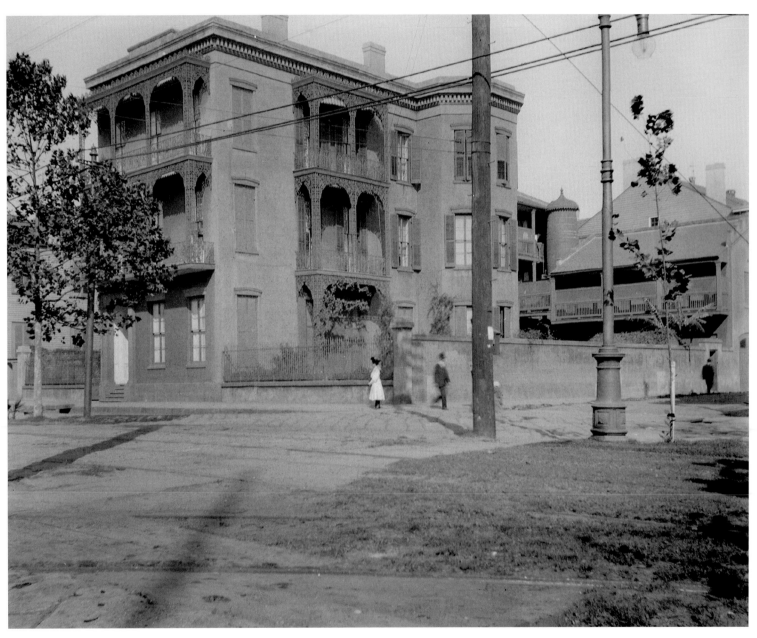

The firm of Little and Middlemiss built the Whann-Bohn House in 1859 for Captain William Whann at a cost of $18,750. The Greek Revival townhouse, located between Bourbon and Royal streets, represented the finest in luxury for this time. Apart from the artistry in its carpentry and accoutrements, it featured hot and cold running water, wine rooms and storerooms, and a 5,000-gallon cistern.

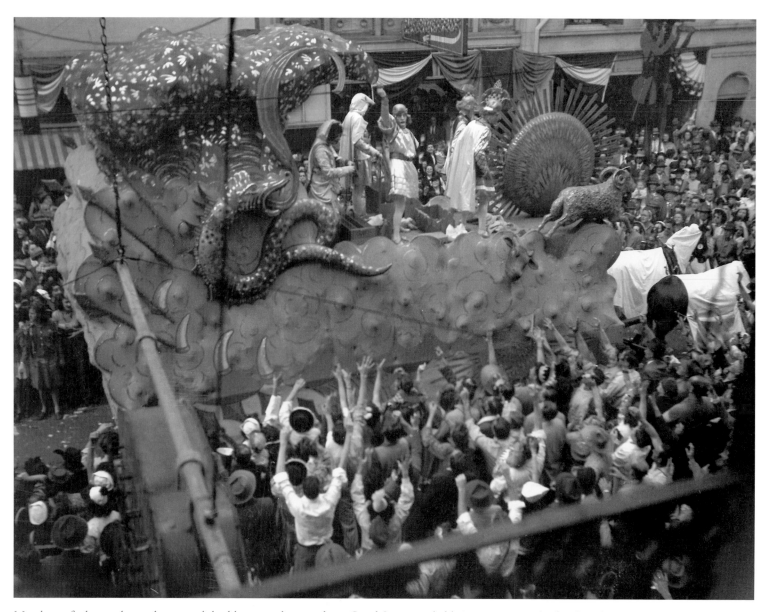

Members of a krewe dump throws and doubloons to the crowds on Canal Street, probably in response to the familiar shout, "Throw me somethin' mister!" Notice that the horses pulling the floats are also costumed. As with today, securing a prime location on Mardi Gras Day on Canal Street is a proud feat, something to tell your grandchildren!

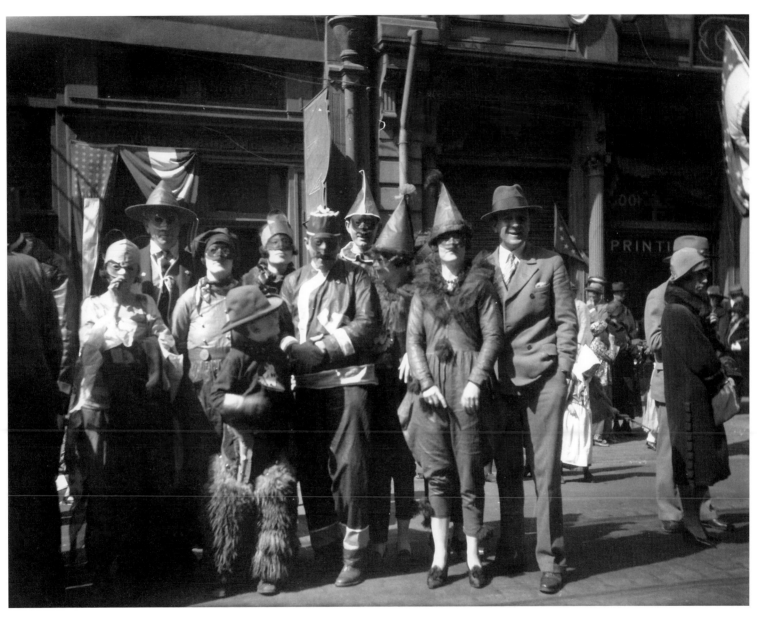

Young and old alike revel in this day and their costumes. Costumes run the gamut with everything from little boys dressed up as cowboys to young men in devil costumes. Normally, women were frowned upon when they masked, but as this image showed, not many women cared. Mardi Gras day is the one day in the year that people can forget their origins and social backgrounds and transform themselves into new characters and a new reality, if only for a short time.

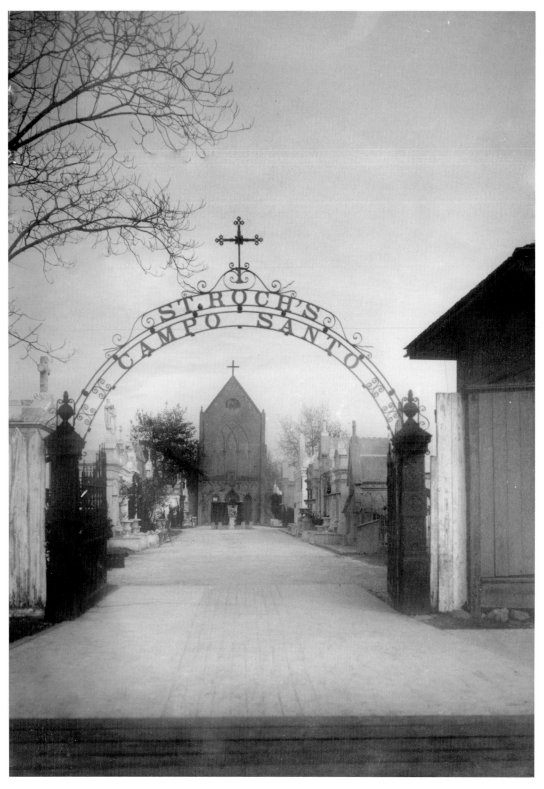

Germans immigrated en masse to New Orleans starting in the 1830s and settled in the Marigny and Bywater areas around St. Ferdinand Street. Saint Roch Chapel, constructed in Gothic style, evolved into the epicenter of the German community during the 1870s. When Father Thevis built the shrine, he called the spot "Campo Santo," or "Holy Acre." He now lies buried in the chapel near the altar.

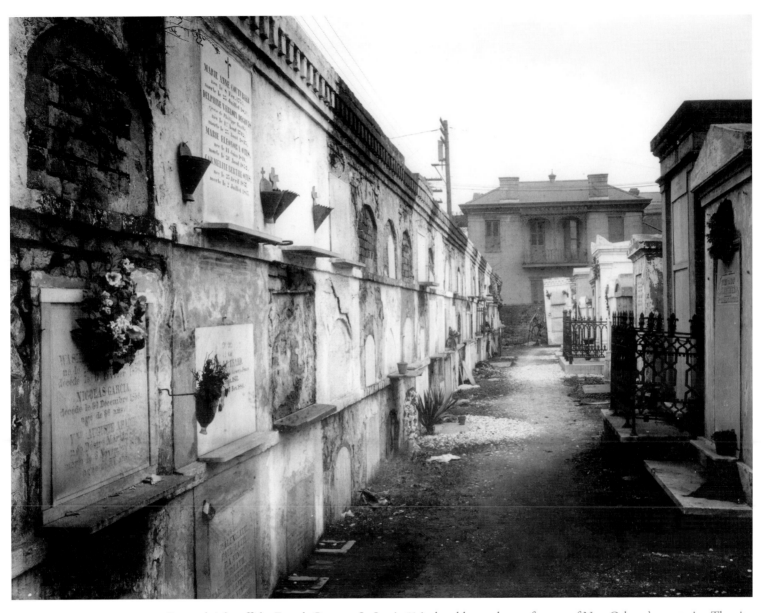

Located right off the French Quarter, St. Louis #1 is the oldest and most famous of New Orleans' cemeteries. The city established it in 1789, and both Catholics and Protestants used the space until the Protestant Girod Street Cemetery was built in 1820. Some of the more famous citizens buried here are sugar-industry pioneer Etienne Bore, chess champion Paul Morphy, and voodoo queen Marie Laveau. Various benevolent societies, such as the Italian Mutual Benevolent Society, also have tombs located there.

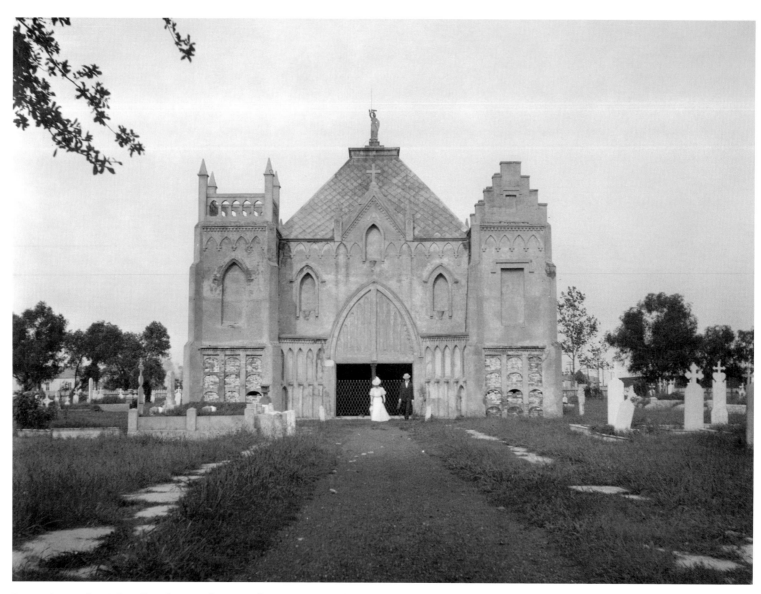

In reaction to the 1868 yellow fever epidemic, Father Peter Leonard Thevis, a German priest, and his parishioners prayed to Saint Roch, the patron saint of epidemics, to keep them from harm. They also promised to build a chapel in his honor. According to the legend, the congregation did not lose one member. The construction on St. Roch Chapel was completed in 1876. For years, the faithful have left behind artificial limbs and crutches, testifying to the miracles of this dearly beloved saint.

Made of granite and first built in 1837, St. Paul's Church was destroyed in a fire in 1854. A second building was erected shortly afterward and was also destroyed by fire, in 1893. During the 1950s, the congregation moved because of construction of the Mississippi River bridge. They settled on Canal Boulevard in Lakeview, taking many of their architectural gems with them, including hand-carved cypress pews, a brass lectern, and their stained glass masterpiece, the Ascension window.

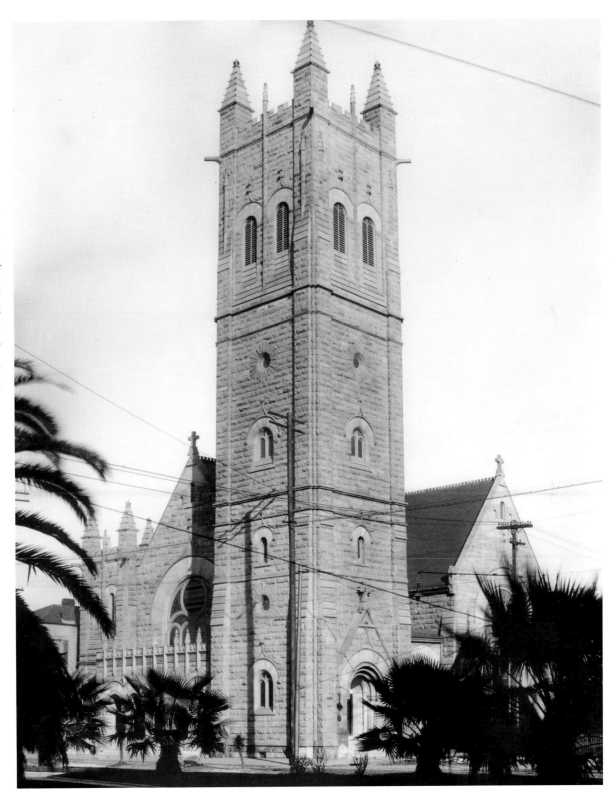

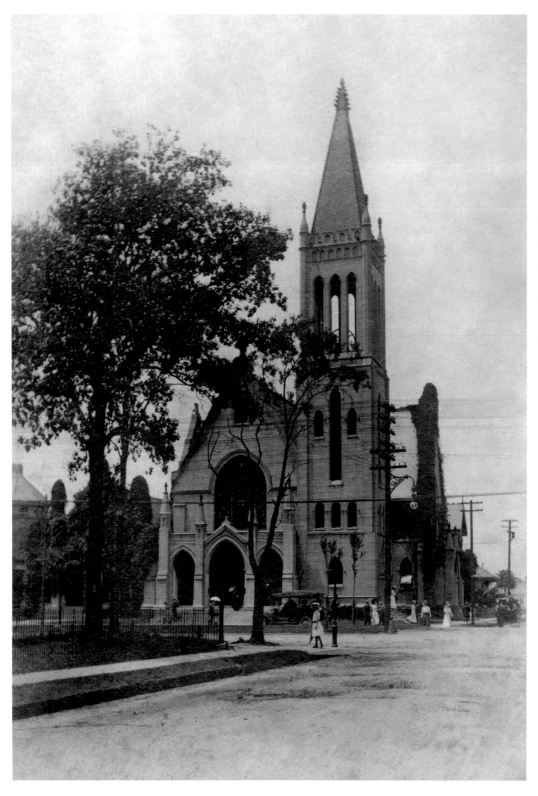

The oldest Protestant church in the entire Louisiana Purchase Territory is Christ Church Cathedral. Fifty-three Protestants of various denominations established this congregation in 1803. Philander Chase served as its first minister. After first being located on Canal Street for over eighty years, the congregation became too large and they decided to build a new church on St. Charles Avenue. The cornerstone for their new home was laid in 1886. Lawrence B. Valk of New York designed this Gothic-styled building.

From the earliest of colonial times, Reformist Jews settled in New Orleans but remained a relatively small population until the Louisiana Purchase. Yet, it was not until the 1820s when the first Jewish congregation, Gates of Mercy, was established. Temple Sinai, founded in 1871, served as the city's first Reform congregation and was composed mainly of German and Alsatian Jews. This Byzantine structure served until 1928 when the congregation moved to St. Charles Avenue.

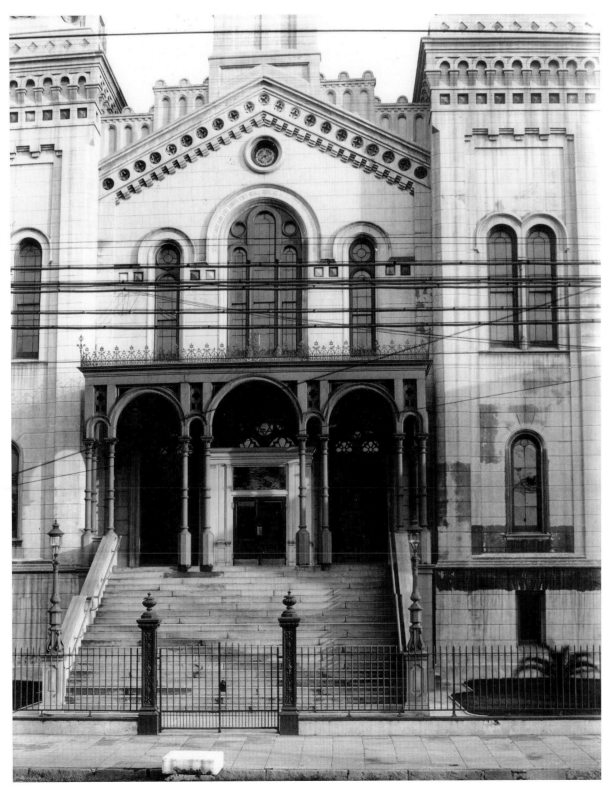

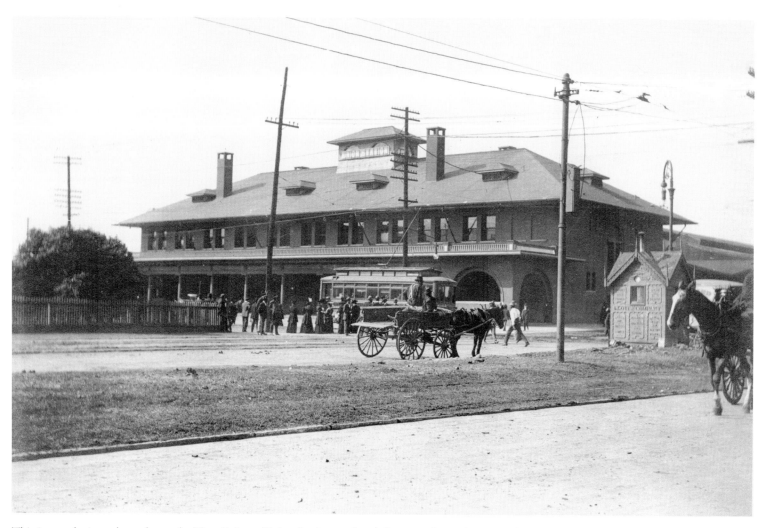

This image depicts a busy day at the New Orleans Union Station on South Rampart Street (now Loyola Avenue). In its early days, the station primarily served the Illinois Central Railroad. Prominent Chicago architect Louis Sullivan designed the building with Frank Lloyd Wright as his head draftsman. It opened June 1, 1892. By the 1940s, this station served thirteen passenger trains. The station was demolished in 1954 and replaced with the current New Orleans Union Passenger Terminal.

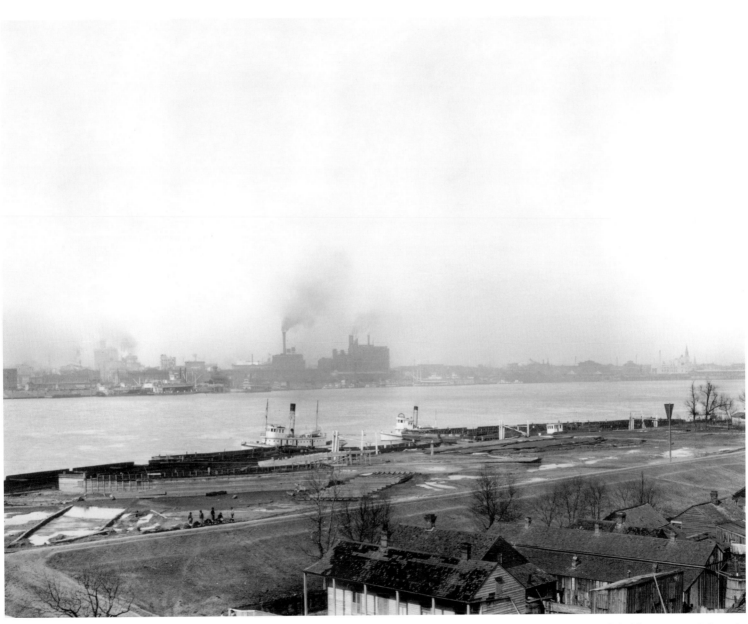

This remains a wonderful view of the increased industrialization that took hold over New Orleans in the early years of the twentieth century. This image, taken from the west bank of the Mississippi River shows the smokestacks of the Warehouse District to the left, the steamships sitting at the dock in the center, and the St. Louis Cathedral, the symbol of the city, to the right.

At the corner of Bourbon and Bienville streets stands the Old Absinthe House. Now illegal but making a comeback, absinthe, an anise-flavored spirit, is made with a form of wormwood that can produce psychotropic side effects. Built in 1798, the Absinthe House opened as a bar in 1826 until federal marshals closed it down during Prohibition. Some of the more famous brands produced in New Orleans were Green Opal, Milky Way, and Legendre.

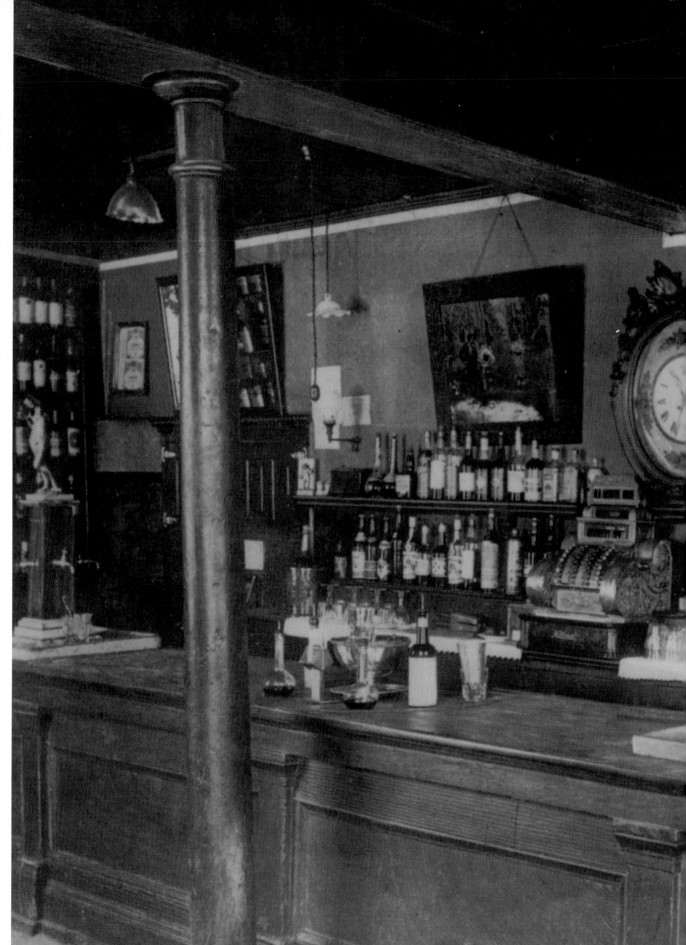

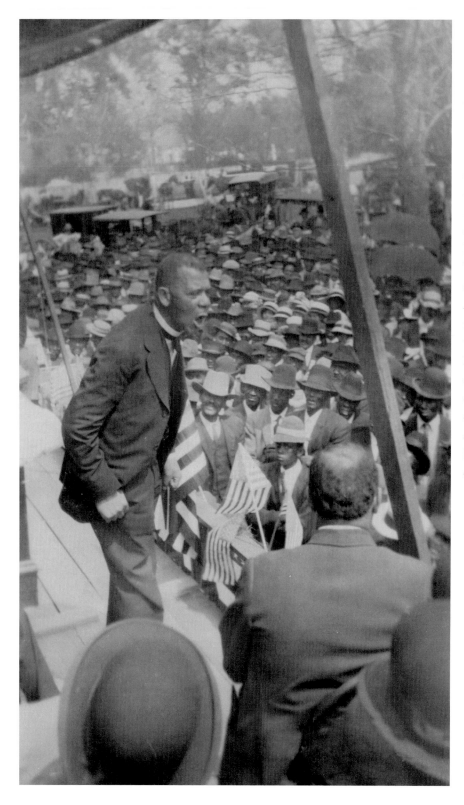

Booker T. Washington was a renowned proponent of academic and vocational training for African Americans. New Orleans native Arthur Bedou was his personal photographer, travelling the world to chronicle Washington's career. He captured this image of Washington addressing a crowd near New Orleans around 1912. Washington urged increased awareness of the plight of African American education in New Orleans. During this time, black students did not have access to public high schools, thus limiting their chances for achieving not only an education but also any sort of career. The first black high school in the city did not open until 1917.

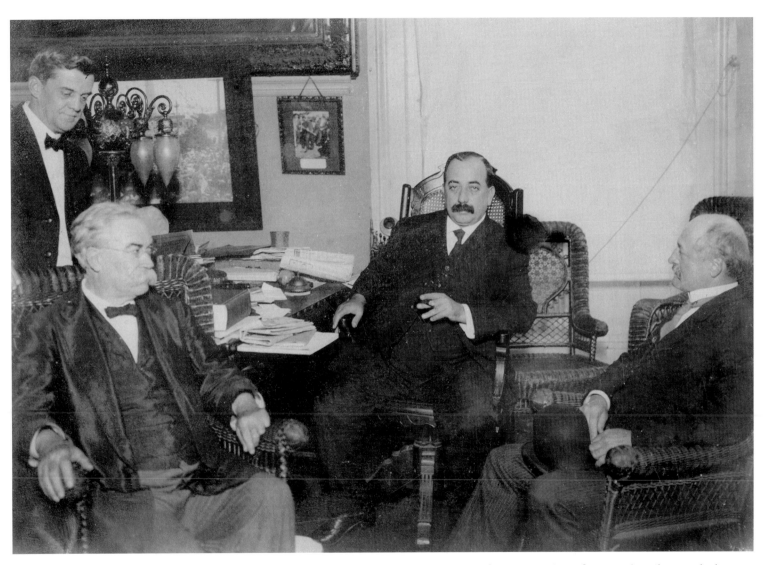

The mayoral administration of Martin Behrman (center, facing camera) ran from 1904 until 1921, the longest-running administration in the city's history. Born in New York City in 1864, his family moved to New Orleans shortly after his birth. Behrman was orphaned at the age of twelve. With little formal education, he rose through the ranks and ushered in an era of reform as mayor, with the expansion of the education system and increased modernization of the city's utilities.

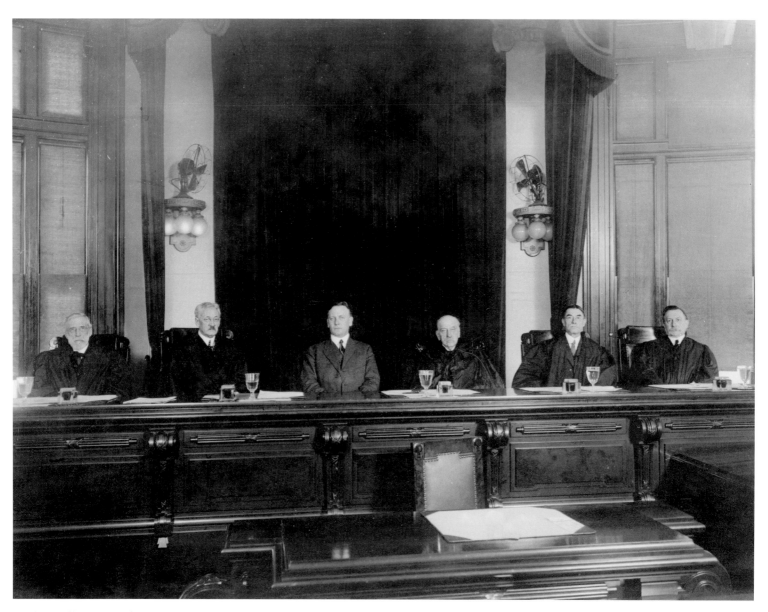

Luther Hall, governor from 1912 until 1916, is seated here with the justices of the Louisiana Supreme Court. They became embroiled in a controversy regarding African American education during this time. Southern University, originally located in New Orleans, contained the only high school for African Americans in the city. In 1912, Legislative Act 118 authorized the closing of Southern; there were plans to reopen it in Scotlandville, Louisiana. A group of New Orleans black activists, angry at the thought of losing their only high school, initiated a lawsuit against the closure. The Louisiana Supreme Court dismissed the case, and Southern opened in its new location in 1914.

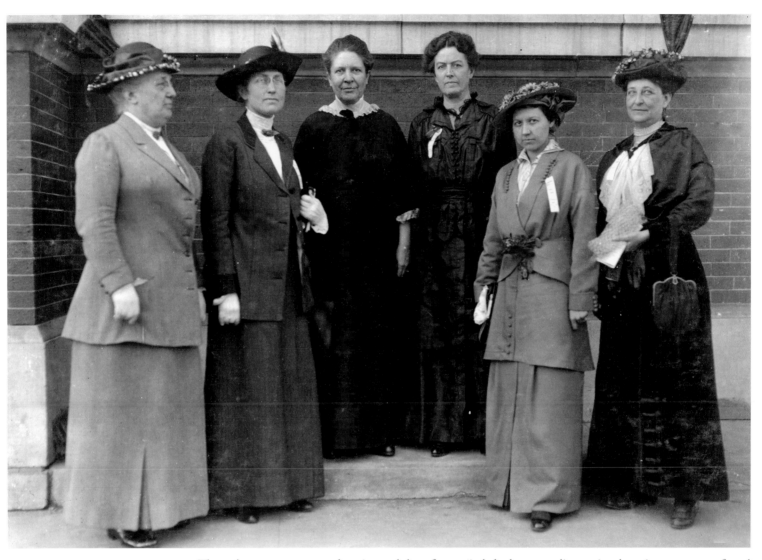

Through greater access to education and the reform-minded ethos pervading national sentiment, women found themselves entering the public sphere in greater numbers, joining the work force or progressive movements such as women's clubs. Here, a group of factory inspectors, including Jean Gordon of New Orleans (third from the right) and Martha Gould (far right), take a snapshot with colleagues in New Orleans.

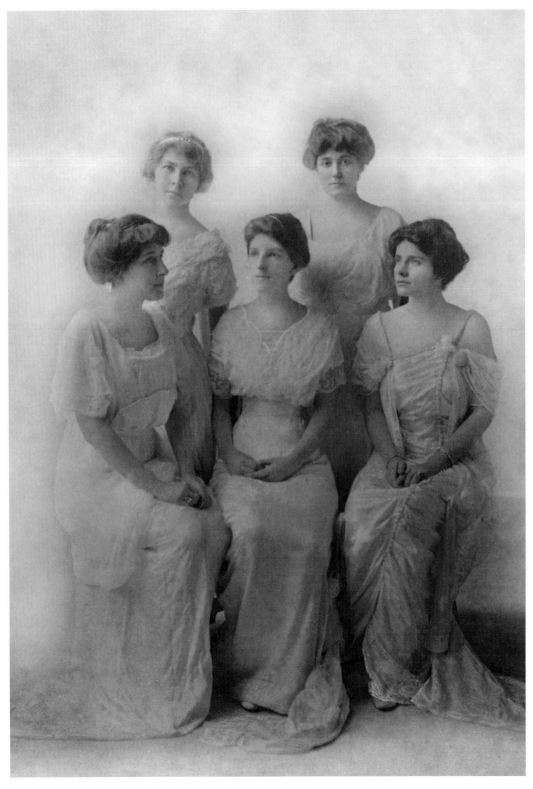

The New Orleans debutante season coincides with Carnival season. In addition to being presented to society, many of these young women also served as queens and maids of various krewes. In this image from the 1910–1911 season is Natalie Scott, seated to the far right. She graduated from Newcomb College and spent most of her adult life abroad in Europe and Mexico, working with children and befriending artists such as William Spratling.

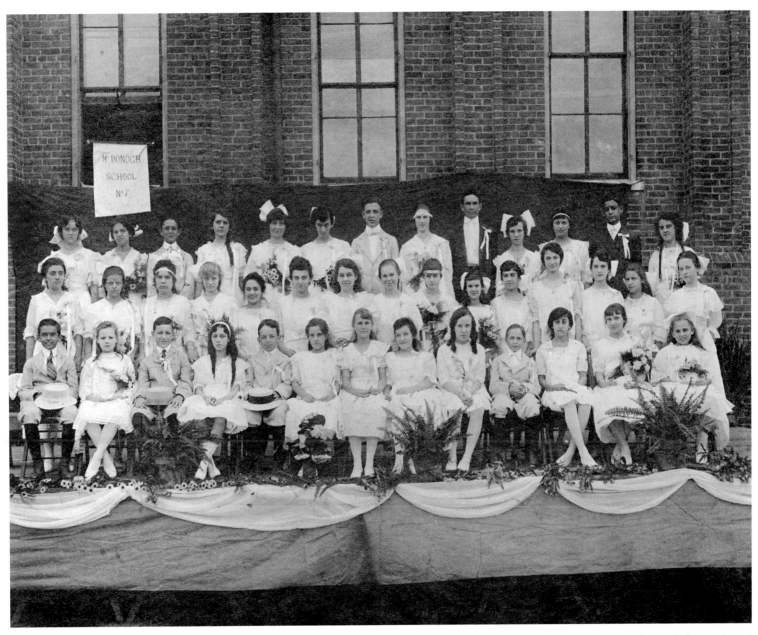

McDonogh #7 opened in 1877 in the 1100 block of Milan Street in Uptown New Orleans. The grammar school served white girls and boys. The two-story building had twenty classrooms and accommodated 1,096 pupils. The school still serves New Orleans' young people today and became a part of the Recovery School District following Hurricane Katrina.

While there was an increased access to education in New Orleans during the early twentieth century, many children could not attend as they had to help support their families. These seven- and nine-year-old children worked as newsboys. Other children worked in the markets of the city and performed other menial tasks as laborers. Addressing this community problem, the Orleans Parish School Board eventually opened night schools to accommodate the city's underclass.

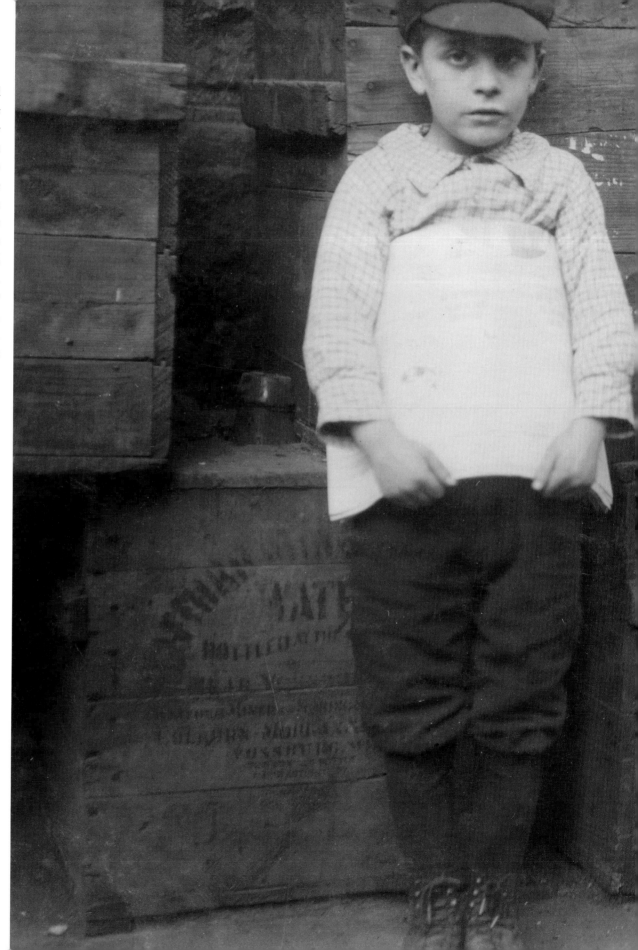

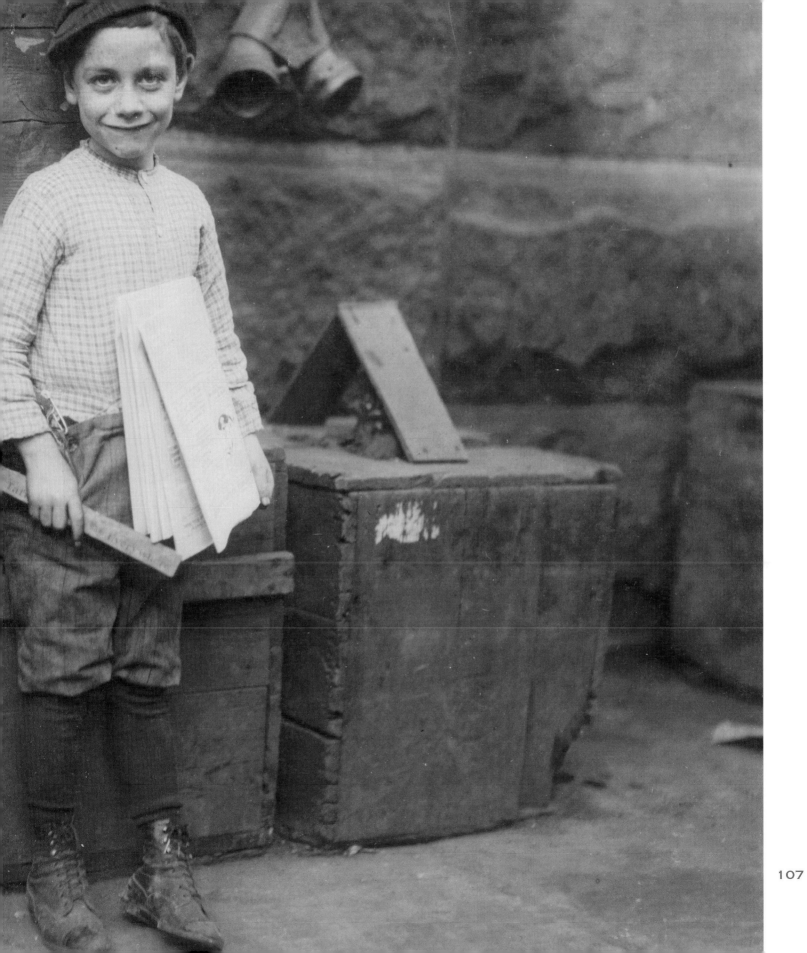

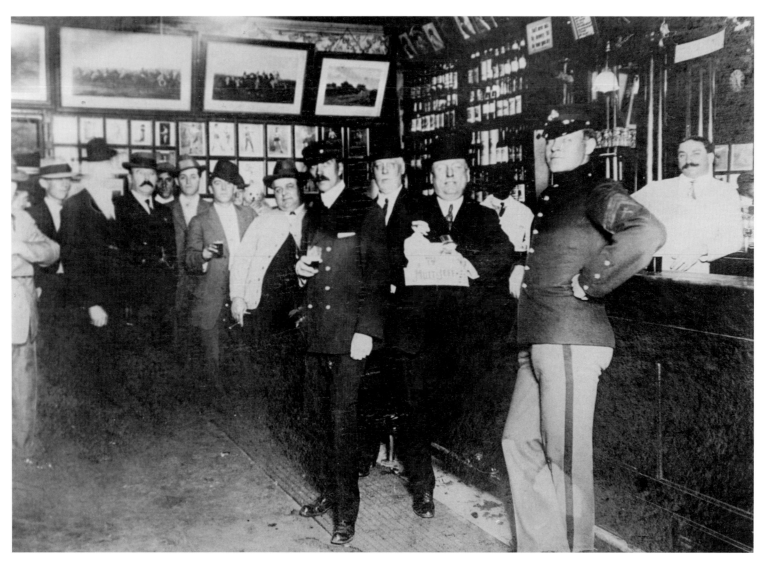

The block-long Terminal Saloon extended from Basin Street to Franklin Street, the heart of Storyville. New Orleans' recognized red-light district, Storyville began in 1898 and ended with a federal closure in 1917. During those twenty-odd years, it incubated the early stages of jazz with performances by such greats as Jelly Roll Morton and Buddy Bolden.

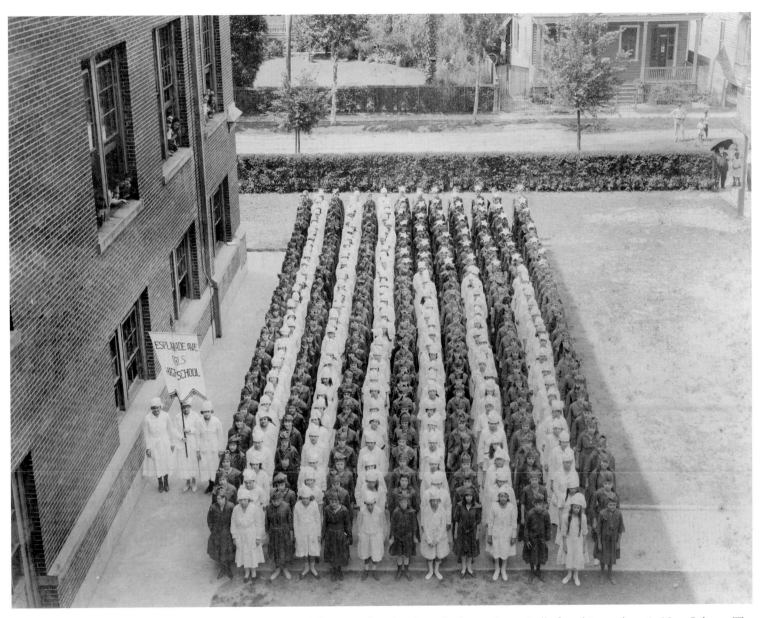

Under the administration of Mayor Martin Behrman, educational standards rose dramatically for white students in New Orleans. The Esplanade Avenue Girls High School was built in 1911 at a cost of $188,037 and served the young women of Esplanade Ridge. At a time when young women saw their mothers joining the workforce or volunteering their time in the spirit of progressive reform, they found that through increased access to education, they could eventually attend colleges such as Newcomb.

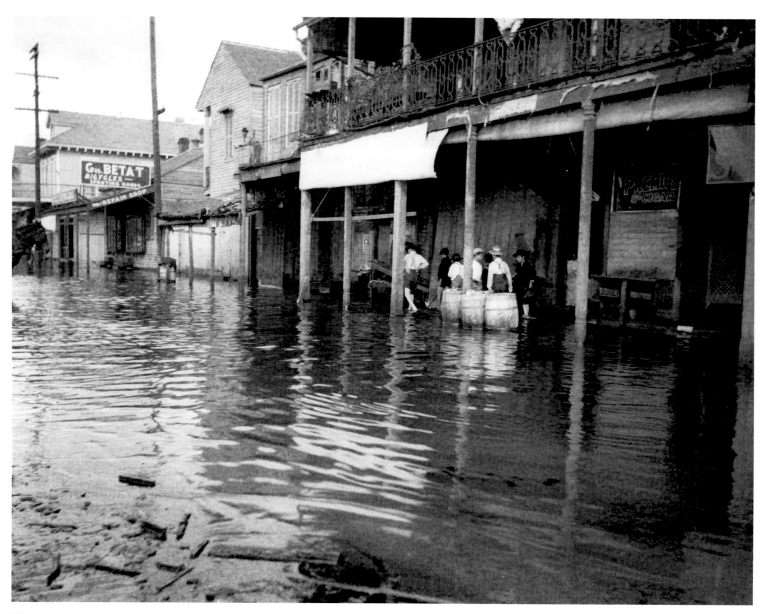

The Carondelet Canal, also known as the Old Basin Canal, was constructed in 1794 and filled in during the 1920s. It started at Bayou St. John, connected with Lake Pontchartrain, and reached the back part of the French Quarter and Treme, the oldest African American neighborhood in the United States. The lake often flooded the basin, inundating the streets around Claiborne, Orleans, and St. Peter.

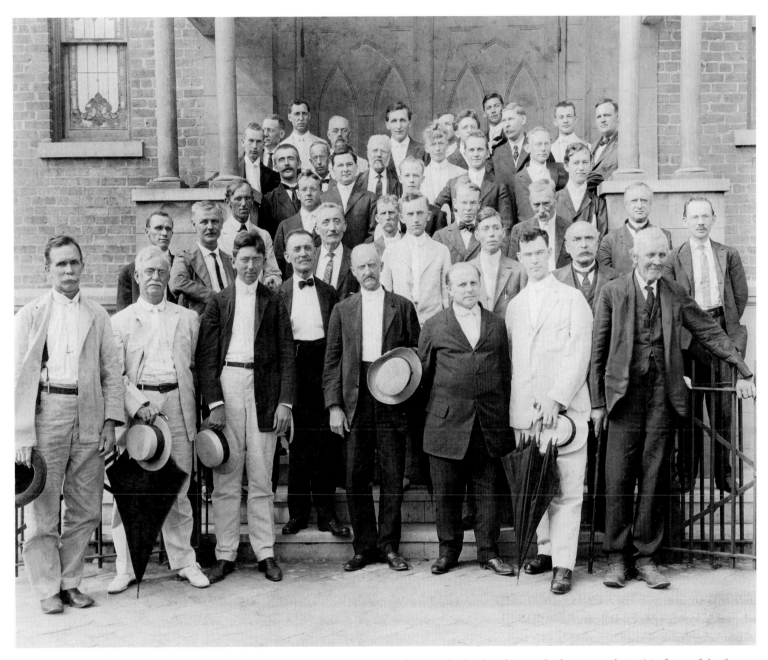

This meeting for local Lutheran clergy and schoolteachers took place around 1914 in front of the former St. John Lutheran Church on Prieur Street. Although New Orleans has mainly been a Catholic city since its inception, with the influx of German immigrants during the 1840s and 1850s the number of Protestants began to grow. St. John Church opened in 1852 and in 1924 moved to Canal Street in Mid-City New Orleans.

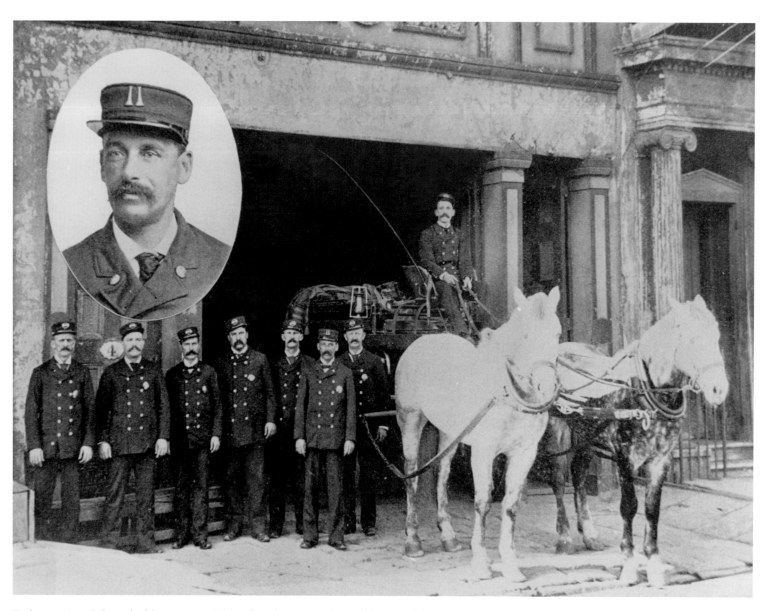

Early on, New Orleans had been susceptible to fires due to wooden buildings and their proximity to each other. In 1829, a group of men joined forces to start the city's first volunteer fire department, calling themselves the Firemen's Charitable Association. In 1891, the city officially established the New Orleans Fire Department. Improved building construction, such as brick and mortar structures, as well as access to improved water and sewerage systems aided local fire departments, such as this one, the Hook and Ladder No. 4.

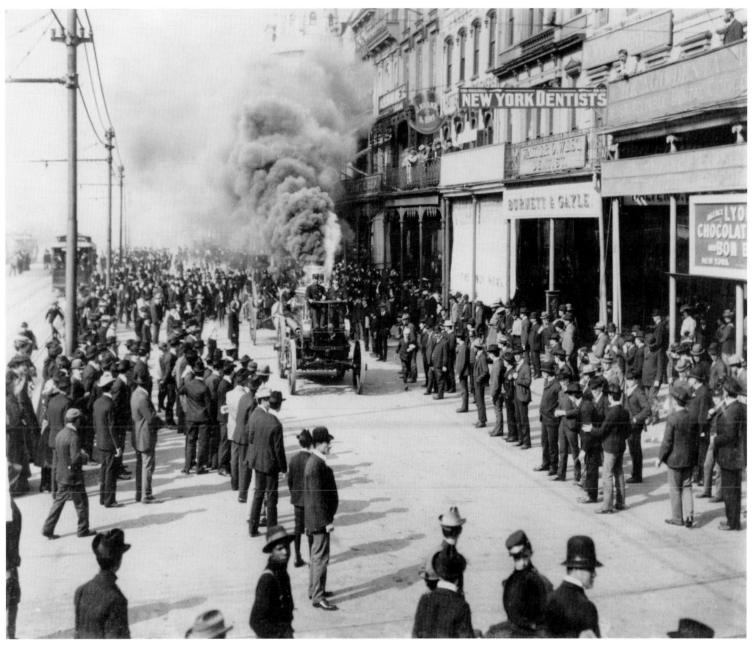

This is the first motorized fire engine marking its debut run down Canal Street early in the century. Although it probably produced more smoke than some of the fires that the New Orleans Fire Department extinguished, the transfer to motorization showed not only the necessity of upgrading the fire department with increased technology but also cut down the time required to reach fires. Louis Pujol served as Superintendent of the New Orleans Fire Department from 1911 until 1919.

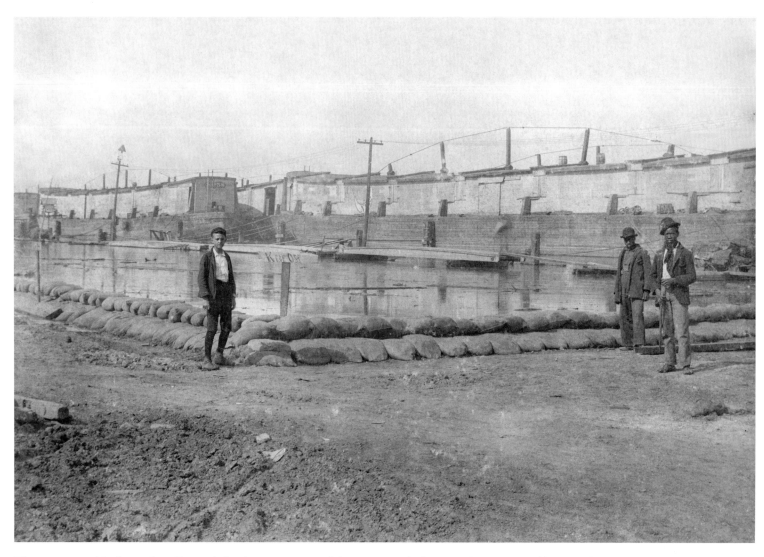

Three men stand in front of sandbags piled to keep water out of the streets. With the natural protection of levees and ridges throughout the city, New Orleans more often than not escaped flooding in the wealthier areas. Poorer areas rarely had such luck. Around 1910, in order to accommodate increased population and using technological advances such as A. Baldwin Wood's screw pump, outlying swampy areas were drained and developed. These neighborhoods were still highly susceptible to flooding.

Originally called back-of-town, Mid-City began to develop during the teens and twenties after the invention of the wood screw pump permitted former swamps to be drained for city development. This image from the corner of Salcedo and Canal streets shows some of this early development. Mainly, African Americans settled this area, considered a poorer area with not as much access to amenities such as schools and stores.

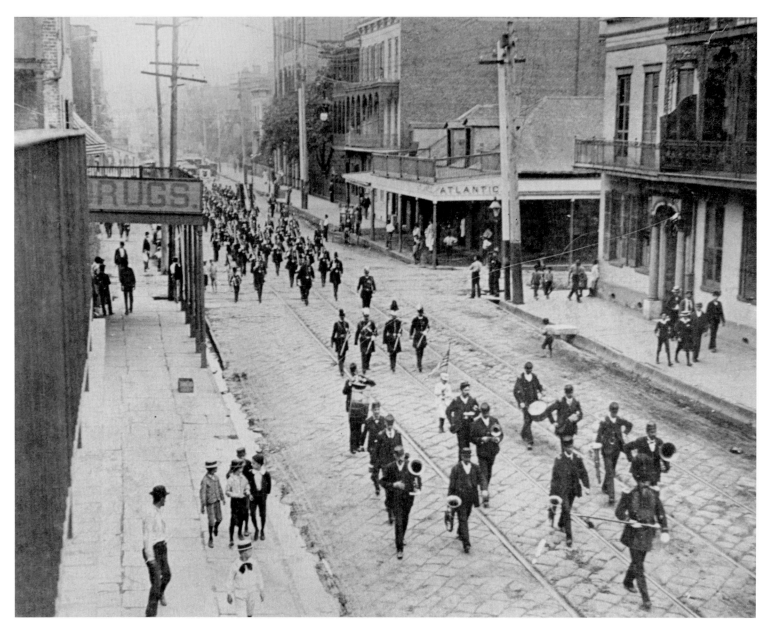

In an era of marching bands and civic pride, the Knights Templar parade from Camp to Girod streets, in the heart of the American sector of the city. New Orleans possesses a long history of Masonic activity, dating to the colonial period and encompassing white and black, French and Anglo lodges. Organized in 1793, the Union Perfect Lodge became the first Masonic order in the city.

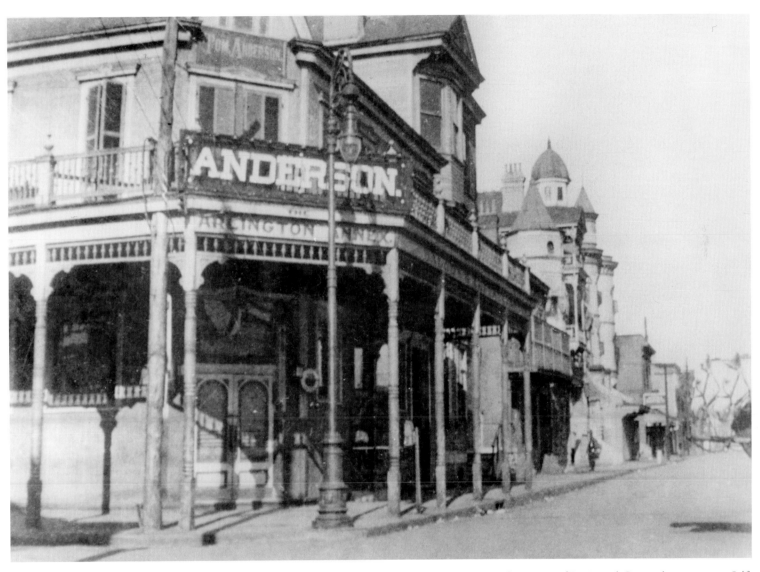

Tom Anderson opened Tom Anderson's Annex Café and Restaurant in 1901 at the corner of Basin and Customhouse streets. Self-proclaimed mayor of Storyville, Anderson became the political boss of the Fourth Ward, along with his longtime companion, Josie Arlington, one of the city's most infamous madams. Anderson also served in the Louisiana legislature from 1904 until 1920, where he was on the Ways and Means Committee and the Committee on Affairs of the City of New Orleans.

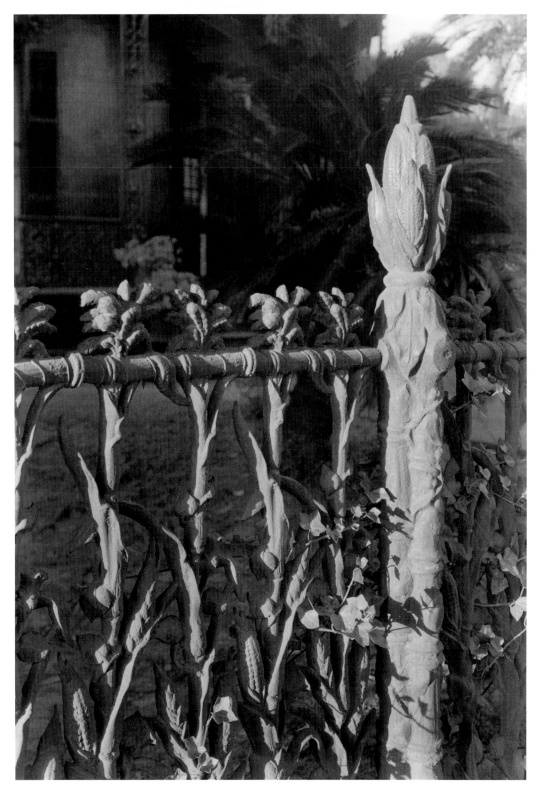

One of the most endearing facets of New Orleans' architecture concerns its embellishments. The motif of cast-iron cornstalk fences can be found throughout the city, such as this one at the Short-Favrot home on Fourth and Prytania streets. Wood and Miltenberger, the New Orleans branch of the Philadelphia foundry of Wood and Perot, created this charming embellishment.

Not much is known about Harry Johnson, pictured in this image with his sister Hazel Lea Johnson at an Elks function, except that he was an amateur photographer, a member of the Elks, and worked in sales for the majority of his career. He was born in 1879, died in 1962, and is buried in Greenwood Cemetery in Mid-City.

Josie Arlington, famous Storyville madam, gave a dinner party at her home on Esplanade Avenue to celebrate the engagement of John T. Brady and Anna Deubler, Arlington's niece. Some of the most prominent politicians in New Orleans, including Mayor Martin Behrman, former mayor Paul Capdevielle, and Tom Anderson attended this gathering. Arlington reigned as the most prominent madam in the city from the 1880s until her death in 1914.

Born in New Orleans in 1876, Toney Jackson worked in the brothels of New Orleans from 1891 until 1904, including establishments belonging to Hima Burts and Lulu White, prominent Storyville madams. By the time he was 15, Jackson was considered one of the top pianists in town. This picture documents the one engagement when Jackson performed with the Panama Trio (Carolyn Williams, Cora Green, and Florence Mills). Mills, the woman to the right, was one of the stars of the Harlem Renaissance whose career spanned vaudeville into the Jazz Age.

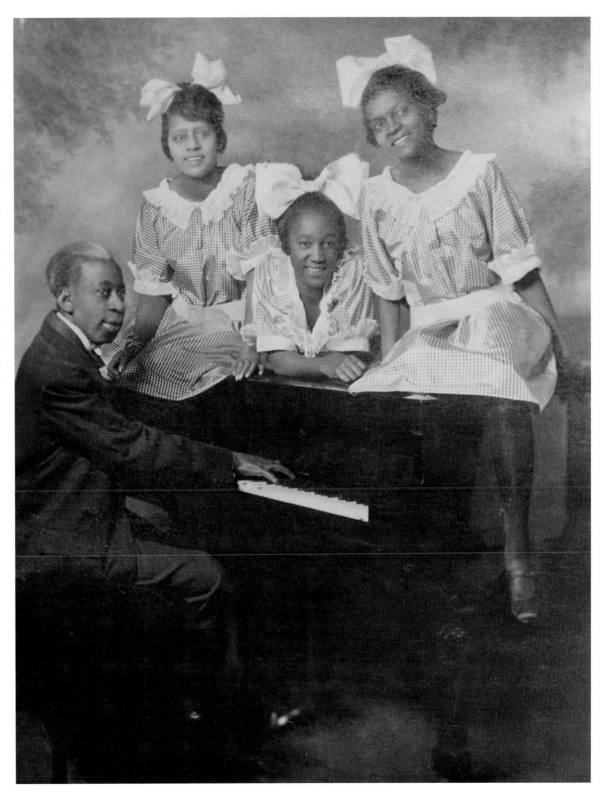

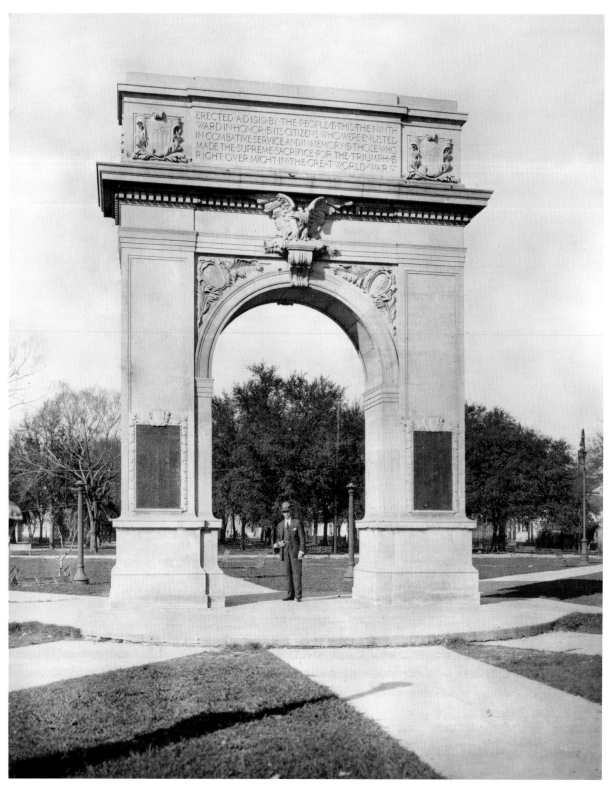

Erected to honor the more than 1,300 men and women from the Ninth Ward who served the United States during the First World War, this arch was completed in 1919. It is rumored to be the oldest World War I memorial in the United States. Weiblen Marble and Granite Company, along with their architect Charles Lawhon, built this memorial at McCarty Square.

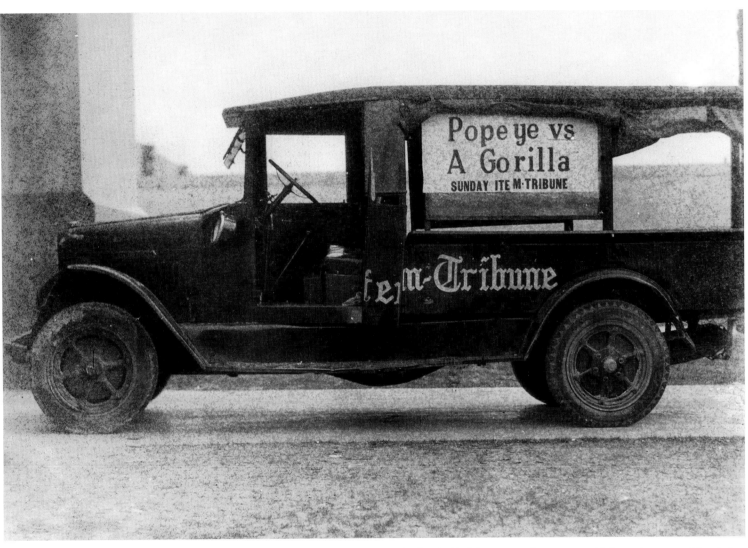

The *Item-Tribune* was a New Orleans-based newspaper during the first half of the twentieth century, with its main competition being the *Times-Picayune*. Journalists such as Howard K. Smith and Hodding Carter, as well as cartoonist John Churchill Chase, worked for this newspaper. Even renowned novelist William Faulkner wrote letters to its editor that can be found on its pages.

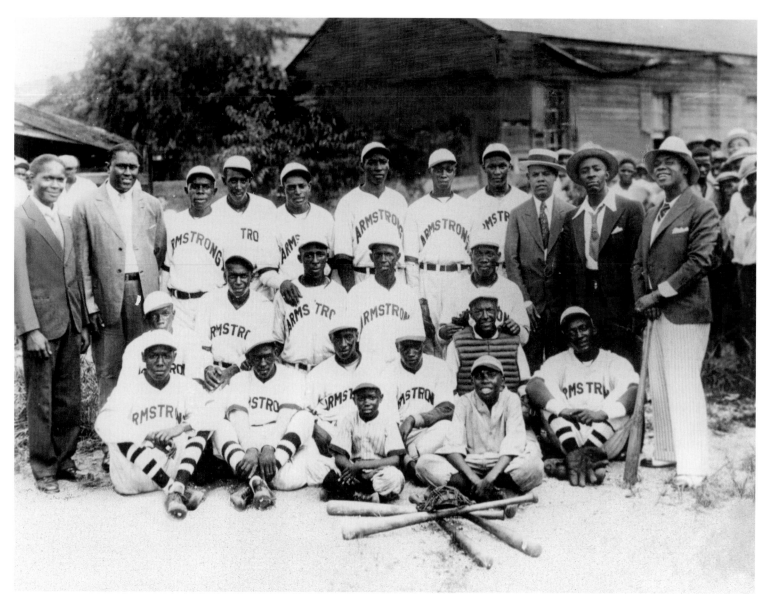

Jazz trumpeter Louis Armstrong was a huge fan of baseball and in 1931, he purchased the Secret Nine, an all-black, semi-pro baseball team. Born in August 1904, Armstrong is considered the most famous of New Orleans jazz musicians. He apprenticed under King Oliver and began his career in the Waif's Home band, playing drums and coronet at first. He travelled the world and recorded extensively, becoming the voice and the sound of New Orleans.

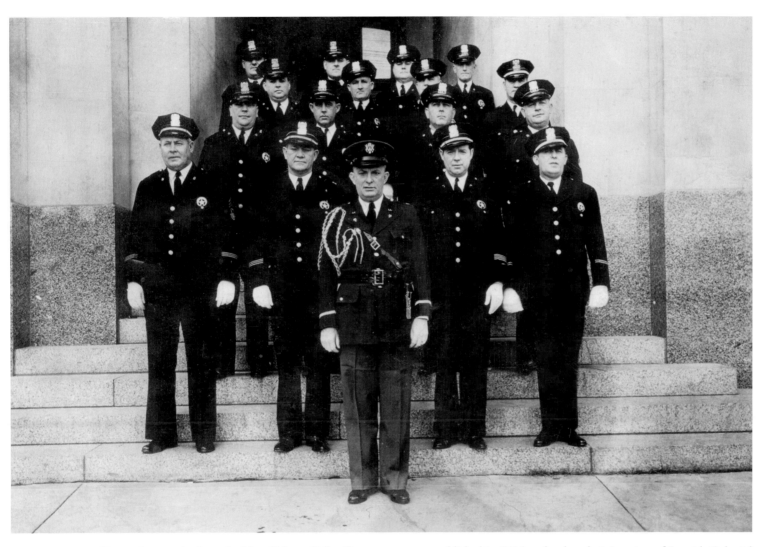

Due to increased crime, the New Orleans Police Department was established in 1796 under the administration of Spanish Colonial Governor, the Baron de Carondelet. The Louisiana Purchase, the Civil War, and various changes in administrative structure caused the department to constantly evolve. During the 1930s, George Reyer became Chief of Police, a new post. He is shown here in the front with his officers at police headquarters in 1939.

126

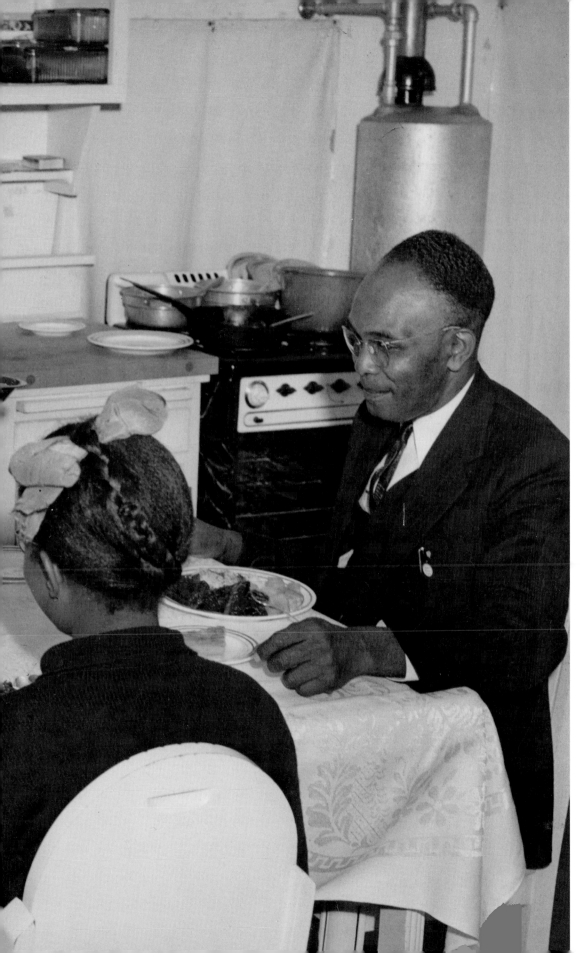

During the Depression, President Roosevelt committed to providing public housing for the urban poor and thus supported the passage of the U.S. Housing Act of 1937. The Housing Authority of New Orleans began a campaign during the 1930s, encouraging low-income families to move into housing developments. These low-density, garden-style apartment buildings housed low-income families for generations until Hurricane Katrina. The majority of these units have not reopened.

127

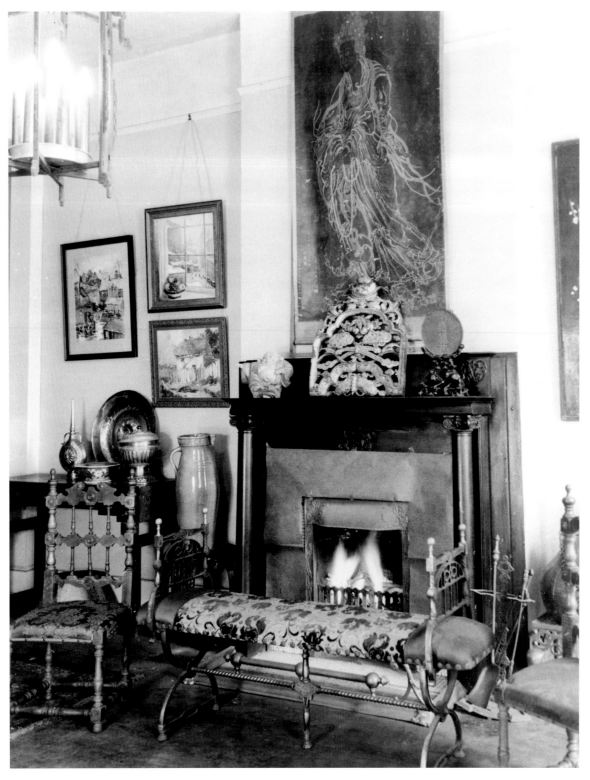

Frances Benjamin Johnston arrived in New Orleans during the 1930s under a contract from the state of Louisiana to photograph deteriorating plantations. Here, she captures the interior of her home on the 1100 block of Bourbon Street, which shows the detail of the fireplace and the high ceilings. Johnston's career spanned the first half of the twentieth century. She documented various U.S. presidents as the official White House photographer, but also captured many images of African American life in the South and architecture in Louisiana.

Originally located on St. Charles Avenue, between Union and Gravier streets, First Presbyterian Church is the city's second-oldest Protestant congregation. It was established in February 1818, and the cornerstone was laid in 1819, after a donation of a lot and $10,000 from the New Orleans City Council. The first church was destroyed by fire in 1854. In 1857, the new church opened with a seating capacity of 1,311 people and with the highest steeple in the city. The church remained at this location until the 1930s, when it moved to Jefferson and Claiborne avenues.

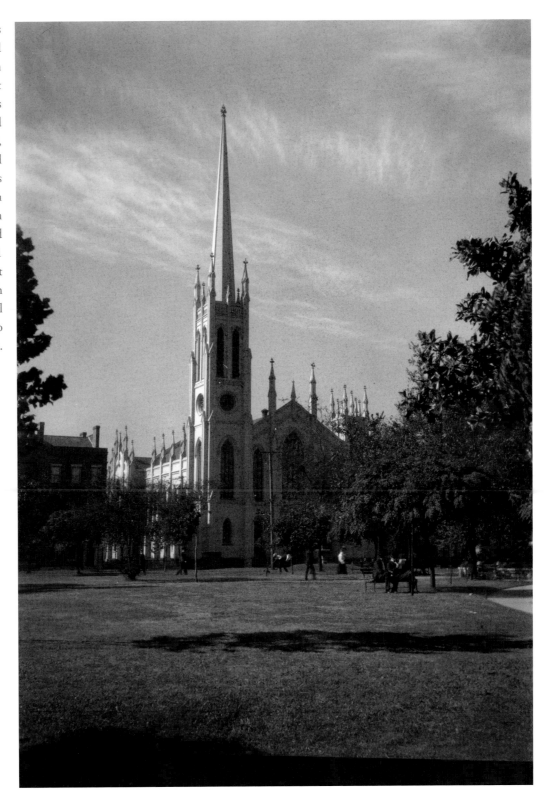

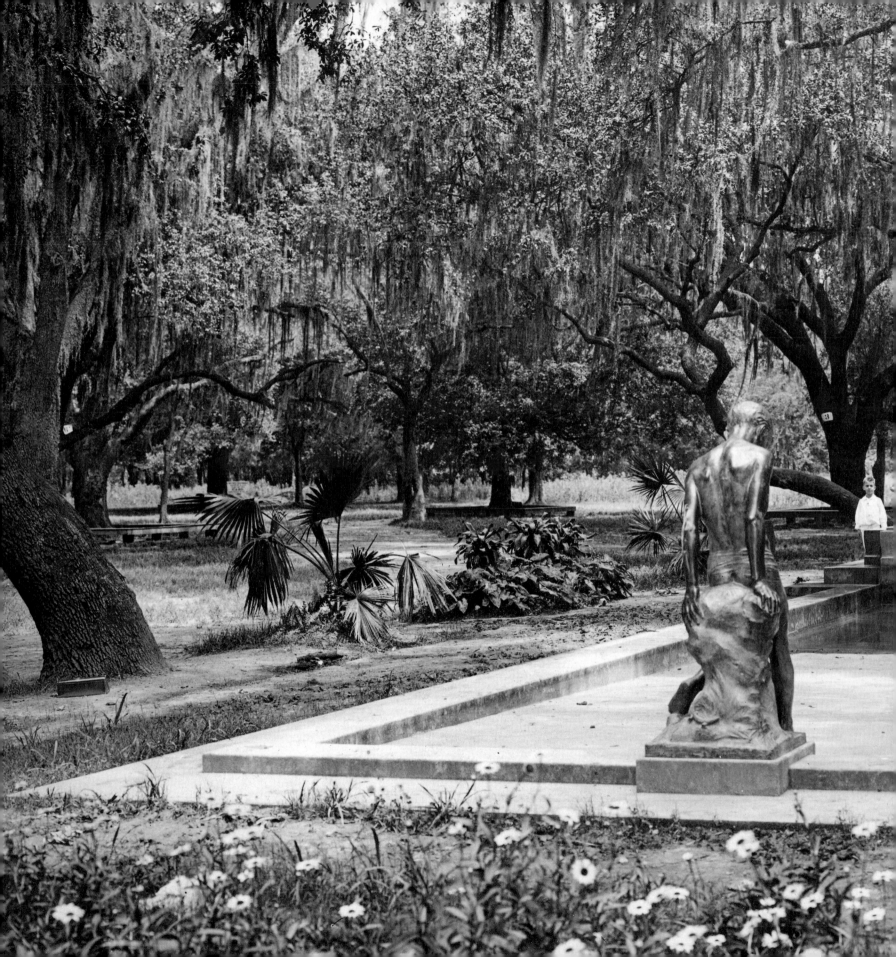

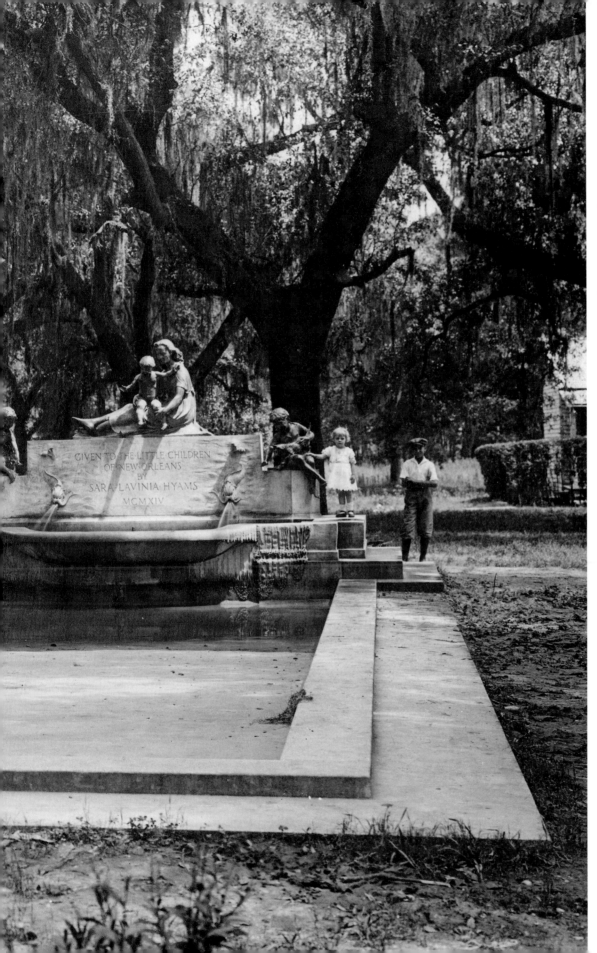

In 1915, Sara Lavinia Hyams bequeathed $30,000 to City Park and Audubon Park for beautification. In 1921, the Hyams Fountain and wading pool opened to the public next to a picnic area. Weiblen Marble and Granite supplied the work for the fountain, which has cooled off generations of New Orleanians for over eighty years.

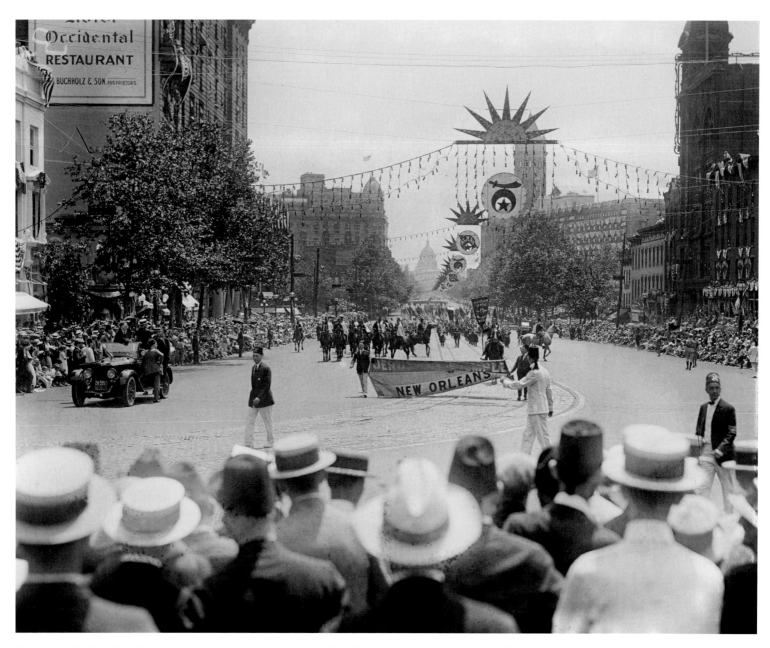

Always fond of parades, New Orleanians came out in large numbers for the Jerusalem Temple parade in June 1923. In 1916, the Ancient Order of the Nobles of the Mystic Shrine broke ground for the Temple on St. Charles Avenue. Architects Sam Stone, Jr., and Emile Weil, designed the Temple, which was built in 1919. This order possessed one of the largest memberships of any Shrine temple in the United States.

Using photography as an art, Arnold Genthe portrayed views of the city in a magical way. Here, he captured the Pontalba buildings from behind a gate at the Cabildo. The Baroness Micaela Almonester de Pontalba, daughter of philanthropist Don Adres Almonester y Roxas, commissioned the construction of the twin buildings, which flank the Cabildo and Presbytere, in 1848. The Pontalba family sold the buildings to Louisiana in 1927, which in turn gave them to the State Museum.

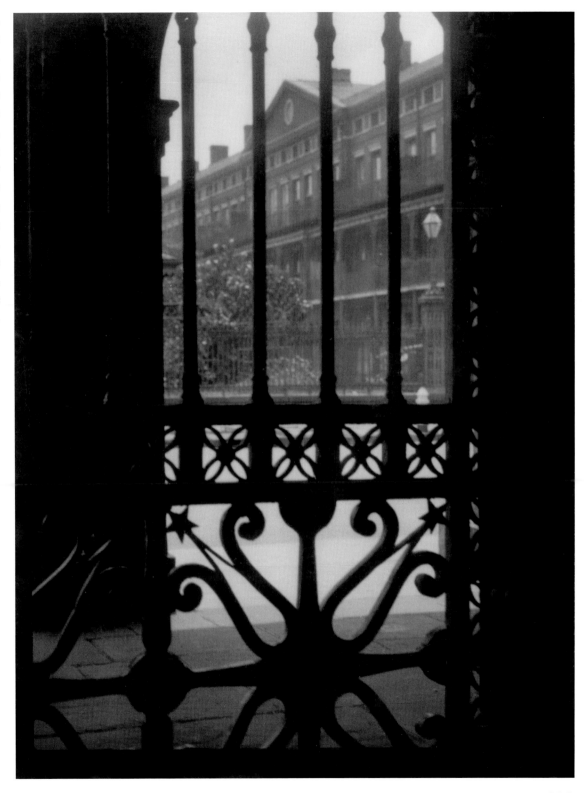

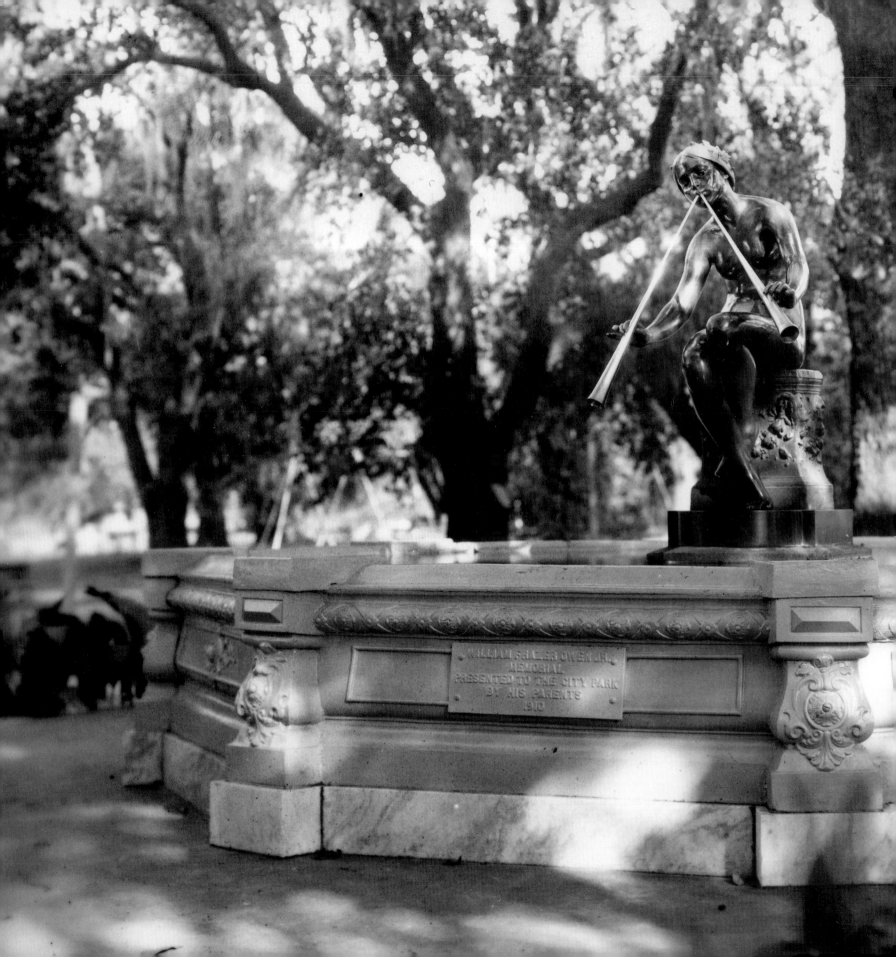

WILLIAM FRAZER OWEN JR.
MEMORIAL
PRESENTED TO THE CITY PARK
BY HIS PARENTS
1910

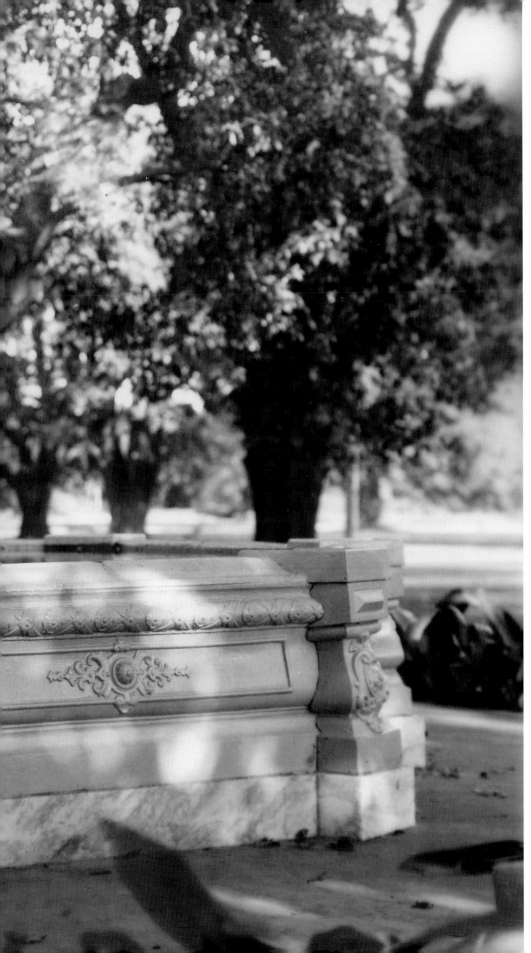

Chloe, the bronze nymph, was not the first statue here at the Owen Memorial Fountain in City Park. Mr. and Mrs. William Frazer Owen commissioned a work in 1910 to honor their son who had died prematurely. Titled *The Unfortunate Boot,* it depicted a little boy in overalls holding a boot from which water spouted. In 1929, park officials found this first statue destroyed and replaced it with *Chloe* in November of that year.

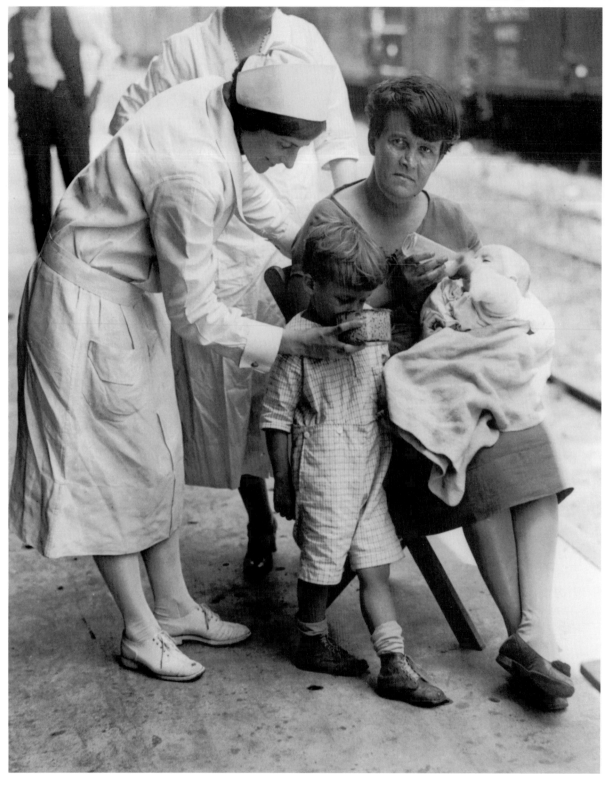

The Mississippi River Flood of 1927 wreaked havoc throughout Louisiana and Mississippi; many considered it the nation's worst natural disaster. While New Orleans was largely spared from the flooding, many refugees flocked to the city for aid. Here, Red Cross nurse Porter helps Mrs. D. P. Achen of Braithwaite, Louisiana, and her two children. Because of this disaster, the United States established the Flood Control Act of 1928, which initiated a period of infrastructure improvements, including the construction of levees, flood walls, spillways, and canals.

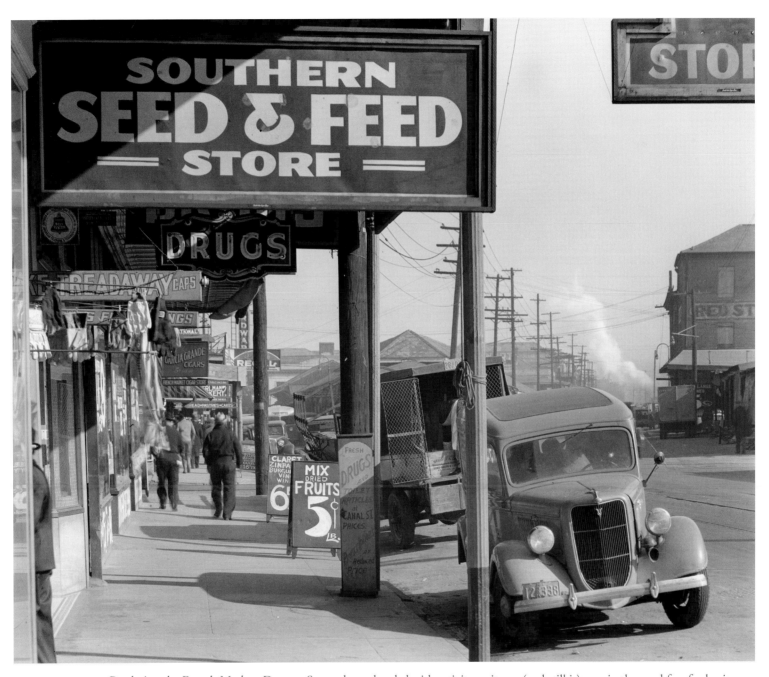

Bordering the French Market, Decatur Street always bustled with activity, as it was (and still is) a main thoroughfare for businesses in the Crescent City. In 1935, when this image was taken, photographer Walker Evans spent a bit of time in New Orleans, capturing the mood of the city and the outlying areas. He felt that he had not captured the Vieux Carre in its essence. Yet, with the images that he did produce, he left a legacy for generations on how the city looked during the Depression.

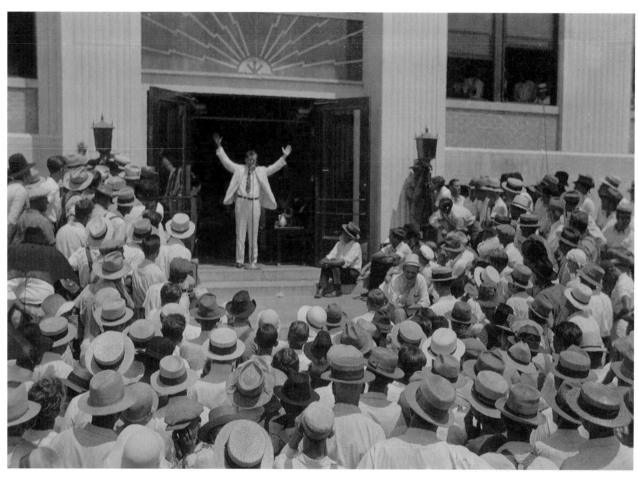

Considered the most powerful of Louisiana governors, Huey Pierce Long started his political career in Winfield, a rural area in north-central Louisiana. He implemented, during his service as governor and senator, unprecedented modernization in Louisiana, with upgrades to its infrastructure and free textbooks in public schools through his Share Our Wealth program. He was assassinated at the age of 42 in 1935.

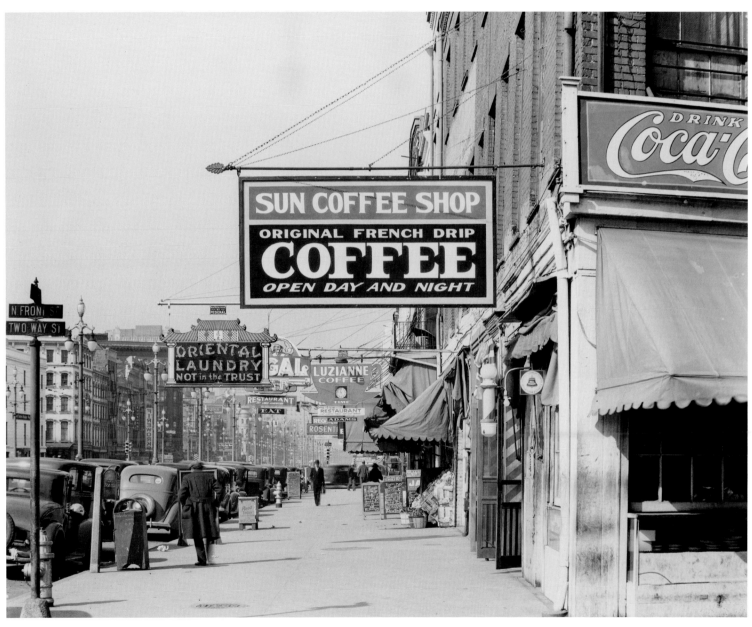

Walker Evans, known mainly for his photography of Depression-era, rural Alabama, also gives insight into New Orleans during this period. Evans arrived in New Orleans during the spring of 1935, under a contract for the Farm Security Administration, and his time here mingling with bohemian New Orleans changed his life forever. He later became the first photographer to receive a solo show at the Museum of Modern Art.

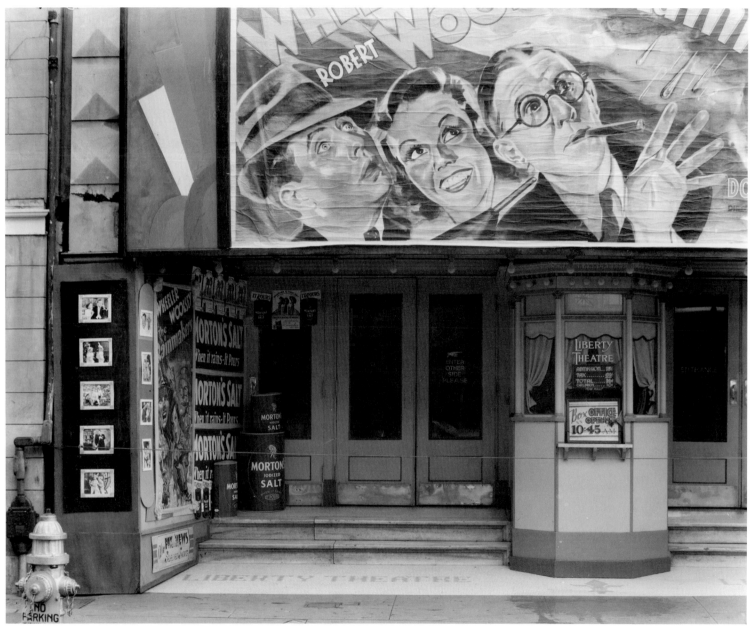

Movie theaters became extremely popular in New Orleans during the Depression. First, they provided entertainment at a cheap price. Second, and more importantly during the summer, they offered air conditioned, dark places to cool down. Here, Walker Evans shot the Liberty Theatre on St. Charles Street (today St. Charles Avenue) displaying an ad for a 1935 film starring the comedy team of Bert Wheeler and Robert Woolsey. Other movie houses were also located in the area. Notice the Morton Salt ads papering the wall on the left. The company tied in its famous slogan, "When it rains - It pours," with this movie, *The Rainmakers,* for a promotional campaign.

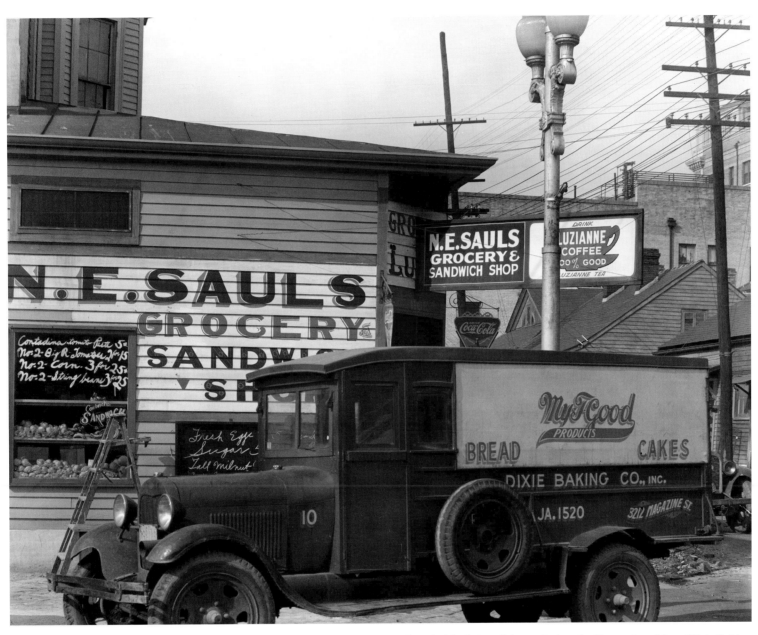

Photographer Walker Evans shows the proliferation of advertising taking hold of New Orleans during the Depression. Here, Dixie Baking Company advertises on its truck, and Luzianne Coffee hawks its wares on a building, near a Coca-Cola sign. William B. Reily, a grocer based in Monroe, Louisiana, started Luzianne Coffee in 1902 and saw an opportunity to open a coffee-roasting and grinding business in New Orleans. Today it is known primarily for its tea; Reily started that part of his business in 1932.

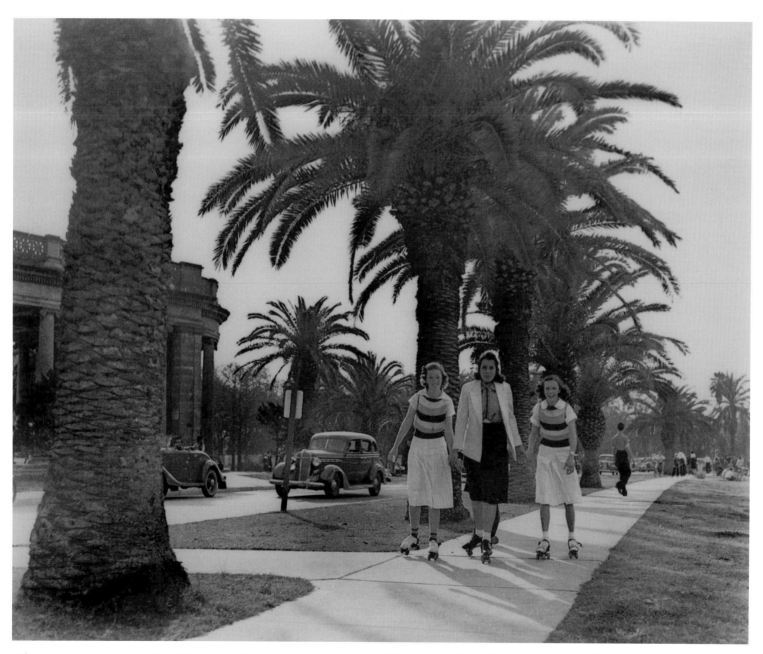

Palm trees are not native to New Orleans; the Jesuits first introduced them 200 years ago. Since then, palm trees have been a part of the city's landscape, from Canal Street up through City Park and over to Gentilly. Here, young girls skate through City Park, enjoying a beautiful afternoon. At one time, City Park had a skating rink, but it has been gone for generations.

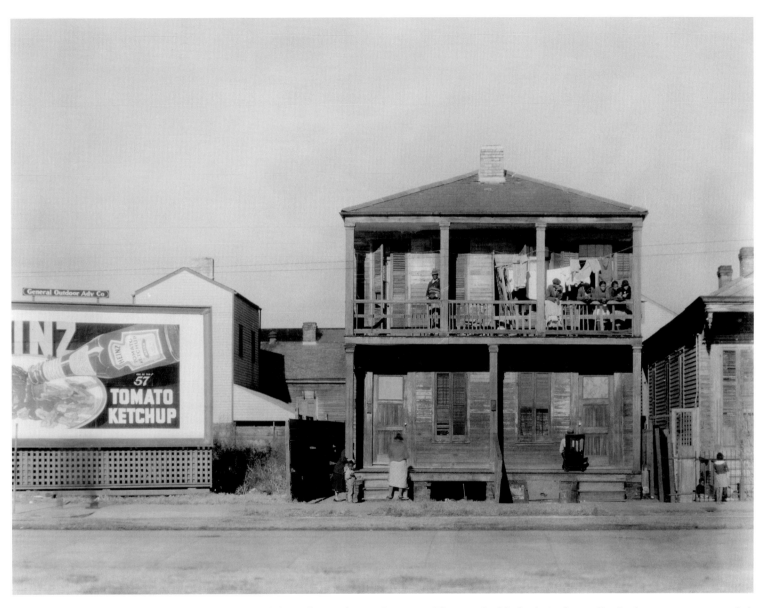

Many of the city's urban poor lived in squalid conditions during the 1930s. The poor had little choice but to live in dangerous, overcrowded, ramshackle buildings with few, if any amenities. Here, Walker Evans captured some of the conditions to which African Americans were subjected, next to an advertisement for Heinz Ketchup.

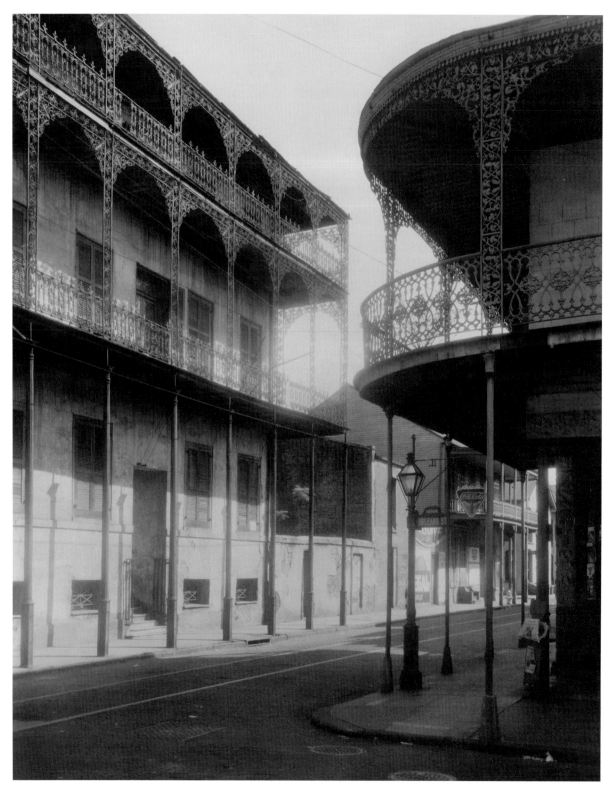

A popular "haunted house," the Gardette-Le Petre House, also known as the House of the Turk, stands on Dauphine at Orleans streets. Legend has it that a Turkish sultan arrived in New Orleans during the mid-nineteenth century and rented the house. The sultan brought his entourage with him, including his harem, armed guards, and treasure he had stolen from his brother. One day, a passerby noticed the gate unlocked and found carnage everywhere. Body parts were strewn around the house and blood oozed through the wooden floors. The only body that could be identified was that of the young sultan, who had been buried alive.

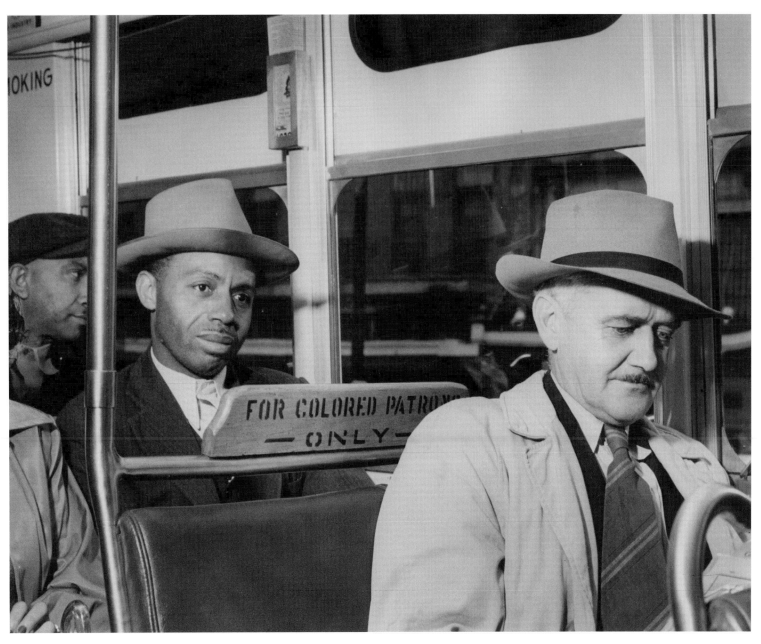

As a legacy of the Supreme Court case *Plessy v. Ferguson*, which legally sanctioned segregation in the United States, African Americans did not have their choice of public restrooms, stores to shop in, or seats on public transportation until the 1950s. The "For Colored Patrons Only" placard shown here could be moved to accommodate the number of white customers on the city's streetcars. Another Supreme Court case, *Brown v. Board of Education*, finally repealed Jim Crow.

Ben Shahn's images of people such as this old sailor sitting in Jackson Square impressed many critics. Born in Lithuania in 1898, Shahn's family immigrated to the United States when he was a child. Walker Evans recommended him for a position with the Farm Security Administration to document the American South. About his time in Louisiana, he later commented how Placquemines Parish struck him with the Italian community, who "made an environment that was just Italian . . . the architecture, the lemon groves, the orange groves and so on."

146

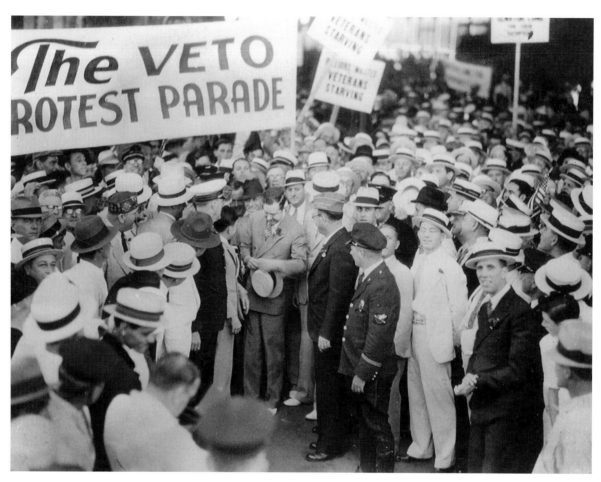

At a rally with veterans carrying signs stating that they were starving, Huey Long addresses a parade protesting President Herbert Hoover's veto of a bill expanding veterans' benefits. Long advocated benefits and health care for veterans who were hurting during the Great Depression. Many of the social reforms that Long championed eventually became domestic policy in the United States, including Social Security, veterans benefits, financial aid for college, the Works Progress Administration, food stamps, Medicare and Medicaid, housing assistance, the graduated income tax, and inheritance tax.

Today a popular nightclub with great music, 615 Toulouse Street possesses a storied history. Originally a theater, this building also housed a speakeasy during Prohibition. The front lobby consisted of a veterinary clinic that hid the club in the back. Today, people report seeing apparitions of a gangster, a lady in a white dress, and a musician who may have died there.

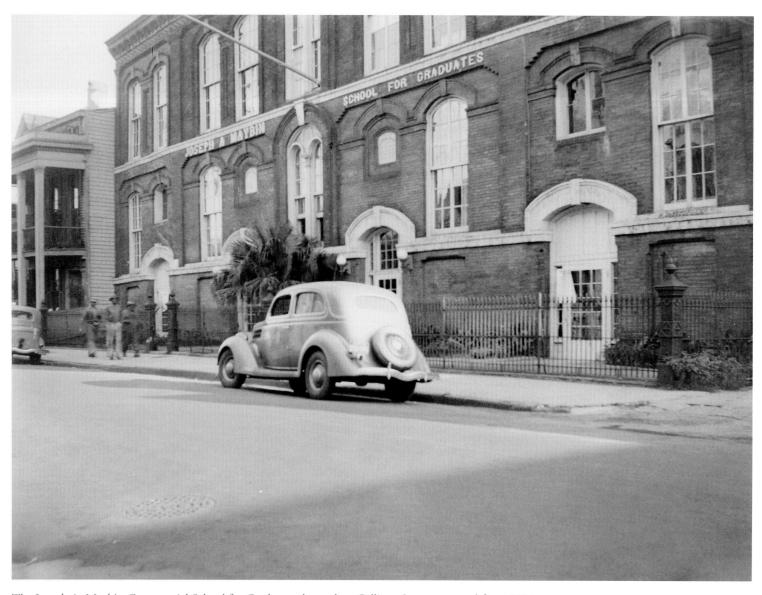

The Joseph A. Maybin Commercial School for Graduates, located on Calliope Street, operated from 1910 to 1951. The school offered advanced studies for business graduates. It was named after Philadelphia native and lawyer Joseph Maybin, who moved to New Orleans in 1817. A devout Presbyterian, Maybin also served as a chaplain in the Louisiana Militia during the Civil War.

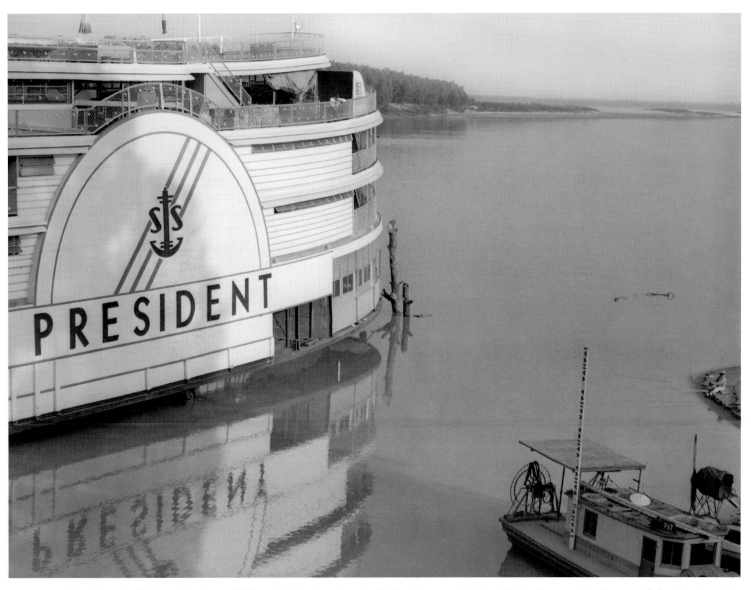

Listed on the National Register of Historical Landmarks, the SS *President* was built in 1924 and was originally named the *Cincinnati*. It ran from Cincinnati to Louisville, Kentucky. In 1934, the Streckfus Company purchased it, converted it into an excursion boat, and added a ballroom and a bandstand. By the end of World War II, New Orleans became the permanent home for the steamboat. In 1990, it was renovated into a casino and moved to Davenport, Iowa.

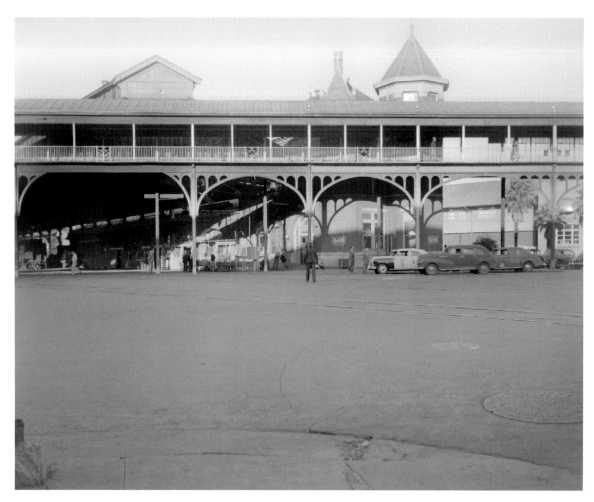

The Louisville and Nashville Railroad Company arrived in New Orleans during the 1880s, when it purchased the Pontchartrain Railroad Company. The L&N Station was located on the foot of Canal Street, across from the Algiers Ferry Landing. During the 1950s, the city merged all its railways and made them use the Union Passenger Terminal, thus making stations such as this one obsolete. The city demolished the L&N Station around 1954.

Julius Koch designed this structure located on St. Charles Avenue between Girod and Julia streets. Converted into the Washington Artillery Hall in 1880, the building held notable functions such as Rex balls, dances that featured jazz, and annual conventions of benevolent societies and professional societies. It also housed the Louisiana-based exhibits from the 1904 St. Louis World's Fair.

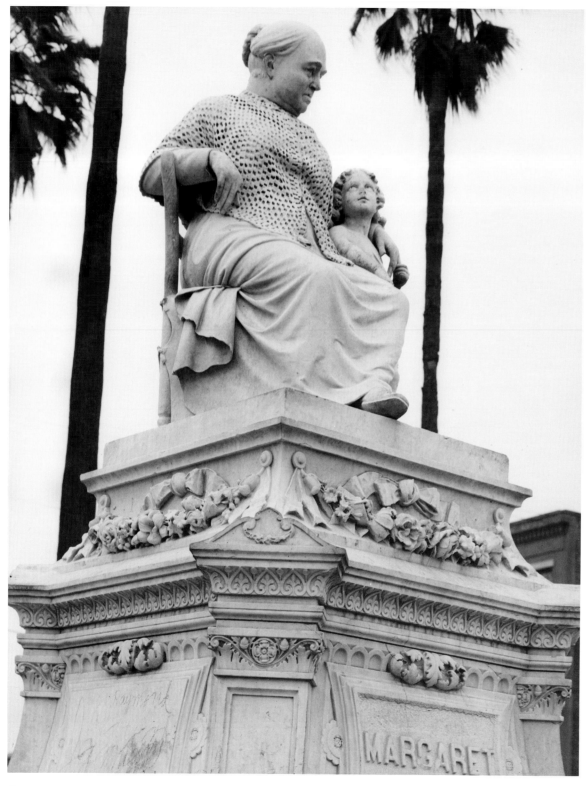

One of the most beloved characters from New Orleans history, Margaret Haughery came to the city as a young wife and mother in 1835. Shortly after their arrival, her family died in a yellow fever epidemic, leaving Margaret alone and destitute. She eventually opened her own dairy and bakery and gave the profits to local orphanages. When she died in 1882, the mayor of New Orleans and two Louisiana governors served as her pallbearers. Her statue, erected in 1884, was the first statue in the United States to honor a woman.

WORLD WAR II AND POSTWAR CHANGES

(1940–1969)

Once the United States entered World War II, the city of New Orleans would play an important role in the country's victory. Andrew Higgins, owner of Higgins Industries, designed the Higgins boat, otherwise known as a Landing Craft, Vehicle, Personnel (LCVP). Higgins modified his company's flat-bottomed swamp boat design to create the amphibious vehicle that carried troops ashore in every seaborne invasion America made during World War II. General Dwight D. Eisenhower credited this New Orleans-based company with a major role in winning the war for the United States.

When the war ended, New Orleans' city leaders reinstated Mardi Gras. Historically, during times of war (the Civil War, World War I, and World War II), the city canceled the Carnival season. Zulu, the city's oldest African American krewe, became more prominent during Carnival and started gaining more notoriety. In 1949, Louis Armstrong would return to the city to reign as the Big Shot, or king of Zulu. Within a decade, Carnival became the festival that many know today: throngs of tourists visiting the city; Zulu commanding as much respect as Rex and other traditional white krewes; and the various Mardi Gras Indian tribes settling scores—originally with street fights but now with competition for best costumes, chants, and so forth—and performing in the historically African American areas of the city.

During the postwar economic boom of the 1940s and 1950s, the city underwent subtle changes along with some dramatic ones. Although New Orleanians have always enjoyed a party, they found new haunts to visit, one being the Blue Room at the Roosevelt Hotel. Most people knew of the Roosevelt's reputation as one of the nicest hotels in the city, complete with a radio station and famous nightclubs. The Blue Room for decades remained one of the finest nightclubs in the city. Old standbys such as Lafitte's Blacksmith Shop, with its legends and ambience, remained favorites.

Other landmarks, particularly in black New Orleans, would fall victim to urbanization and modernization. With federal projects pervasive throughout the United States, as well as increased consumerism, the automobile increasingly replaced the rail system. The city underwent a construction bonanza with the building of the new city hall, the Louisiana Supreme Court, and the New Orleans Public Library. All reflected modern trends in architecture. The Union Passenger Terminal replaced the Frank Lloyd Wright building on Loyola Avenue, and the city demolished many of the old passenger stations

downtown. Buses started replacing streetcars, as many thought the latter were outdated. The largest project of all, the building of the Pontchartrain Expressway, ripped through and destroyed historically black neighborhoods.

The one event that marked the 1960s for many locals was Hurricane Betsy, which lashed the Louisiana and Mississippi Gulf Coast in 1965. This storm sported a price tag of over $1 billion, the first disaster to cost this much. After that, the Army Corps of Engineers reconfirmed its commitment to the New Orleans area and initiated projects to build and sustain levees, canals, and other innovations to help New Orleans survive the next big storm.

Marion Post Wolcott, working for the Farm Security Administration during the 1930s and 1940s, takes a snapshot of New Orleanians sitting on a stoop. Many New Orleans residents made a natural pastime of stoop-sitting, especially in days before air conditioning. It encouraged neighborliness and helped fight crime.

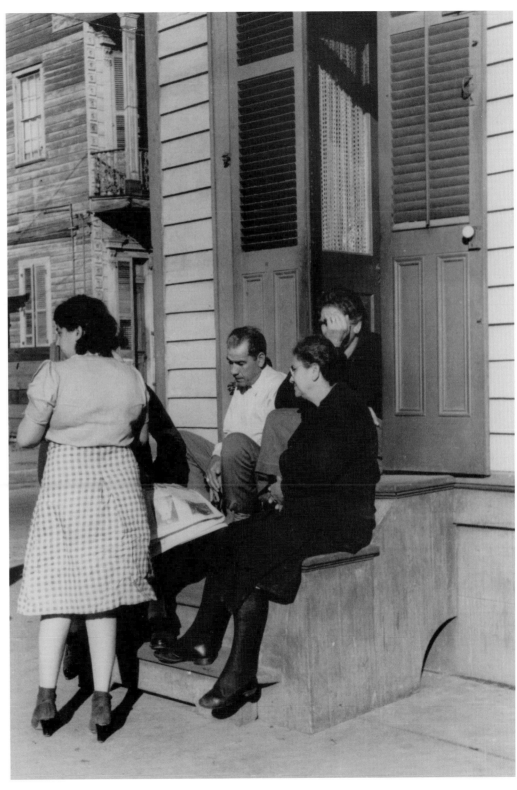

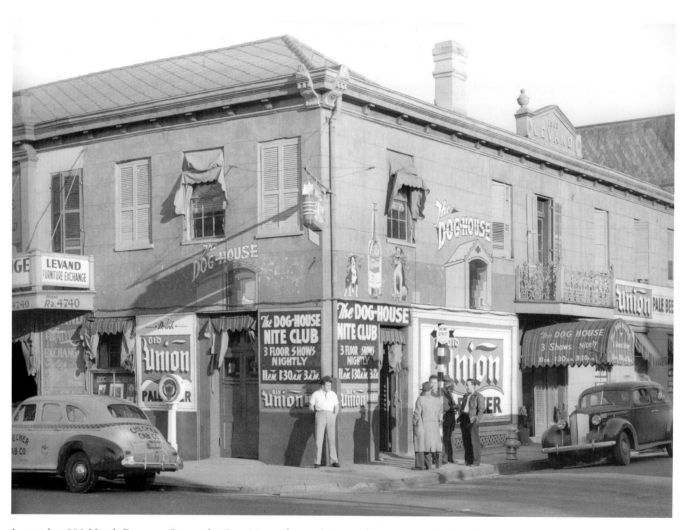

Located at 300 North Rampart Street, the Dog-House featured jazz performances and a floor show. It stayed open until 4:00 AM nightly. The owner referred to it as a high-class place for middle-class folks, where they could find freedom for the "body and soul."

The African American
Zulu Social Aid and
Pleasure Club marched
for the first time in 1909
and the organization
received its first charter
in 1916. Here, the Zulu
king arrives on New
Basin Canal, a part of its
original route. The king
originally wore a lard can
for a crown and a banana
stalk for a scepter, and
the krewe members
sported black face
mimicking white society.
In the 1940s, Zulu
became more prominent
in the annual celebration.

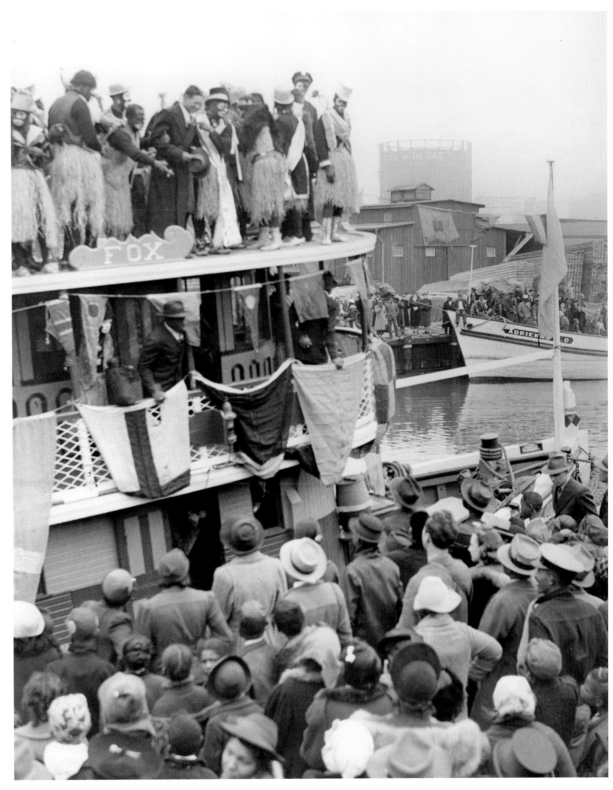

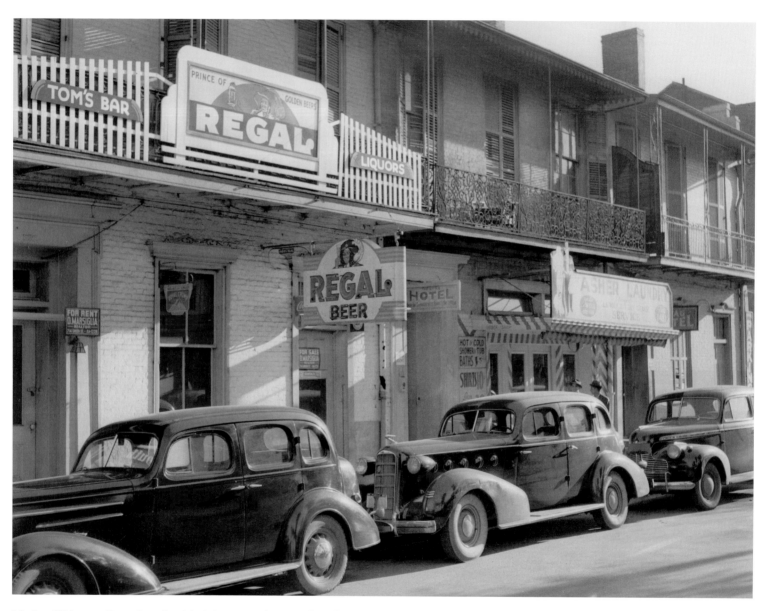

Marion Wolcott, a Farm Security Administration photographer, shot Tom's Bar covered with advertisements for Regal Beer, a locally produced brew during this time. The American Brewing Company of New Orleans owned the Regal brewery, and the beer was considered a mainstay product during the first half of the twentieth century. Their brewery was located on Bourbon Street, the site of today's Royal Sonesta Hotel.

Marion Post Wolcott, known for her images of the Islenos community in Louisiana, preferred to illustrate the harsh realism of life. Yet, at times her images showed much humor, like this Oldsmobile advertisement sandwiched between an ad for masses at St. Patrick's Church and an ad listing times for St. Jude novenas.

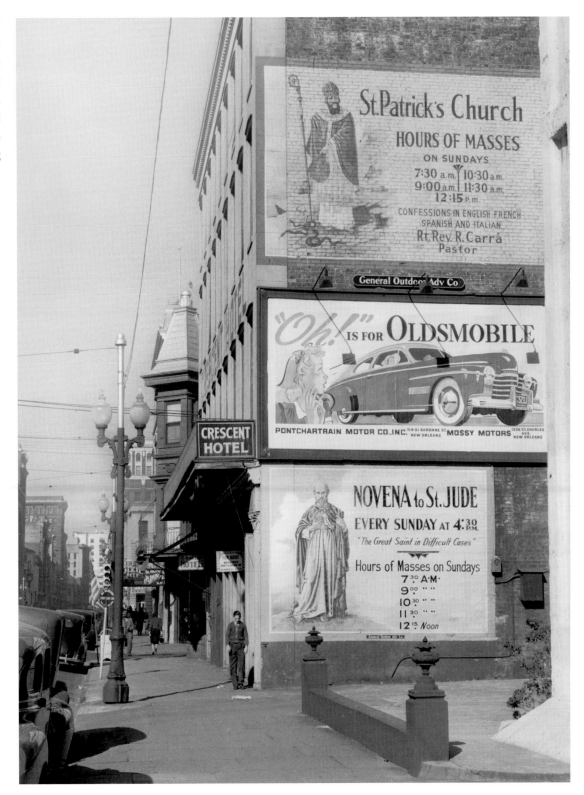

161

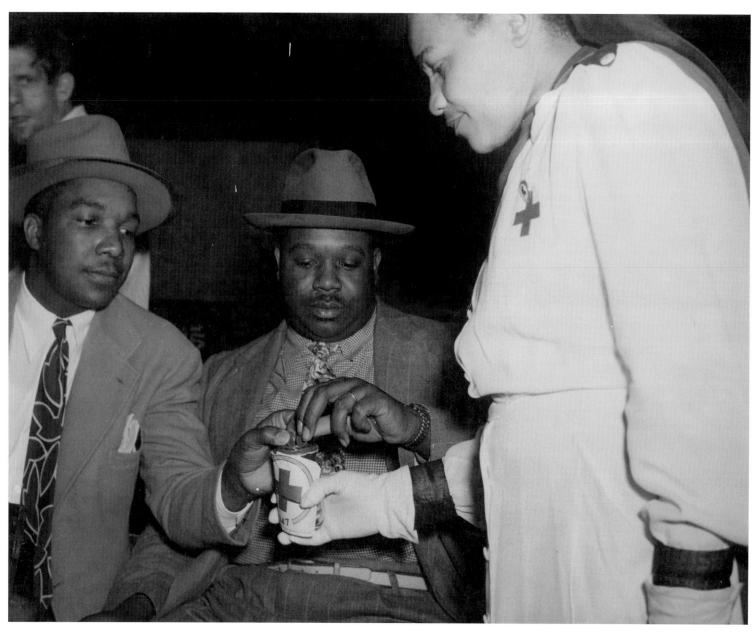

Here, a Red Cross worker receives donations from a couple of men. On the national level, the Red Cross decided to encourage African American participation and integrated its national headquarters. They also worked with a number of prominent African Americans and organizations such as the Olympian Jesse Thomas. By 1943, they started staffing African Americans throughout their chapters.

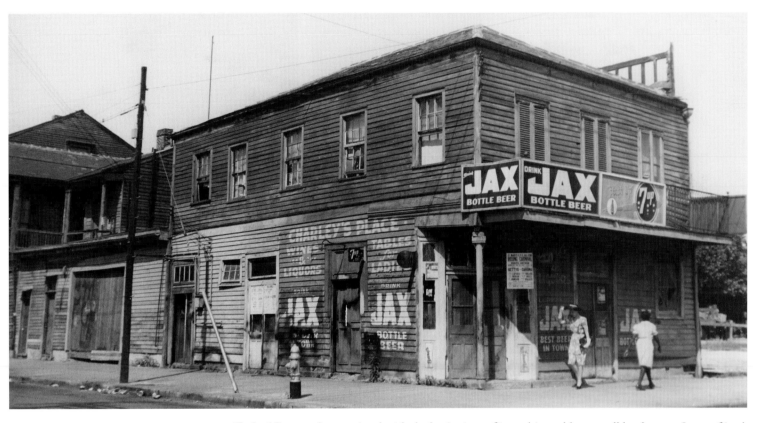

If a building can be associated with the beginnings of jazz, this could very well be the one. Some of jazz's pioneers, Kid Ory, King Oliver, Freddie Keppard, and Sidney Bechet, to name a few, all performed at Pete Lala's Café in Storyville on Iberville at Marais streets. During its existence, Storyville employed fifty musicians who worked at the various bars, brothels, and mansions.

During the war, buses and streetcars displayed signs for shoppers to go home early so that defense workers could have seats on public transportation. Here, Higgins workers flash "V for Victory" signs as they finish their day at the shipyard at 4:00 P.M. Although Higgins Industry employed a sizable work force at its height during the war, the company lost the majority of its business and closed in the 1960s.

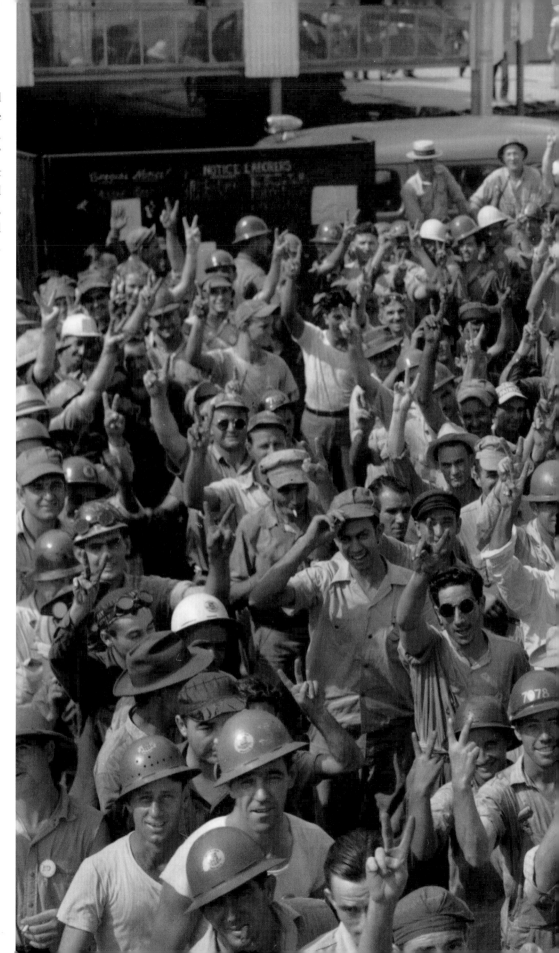

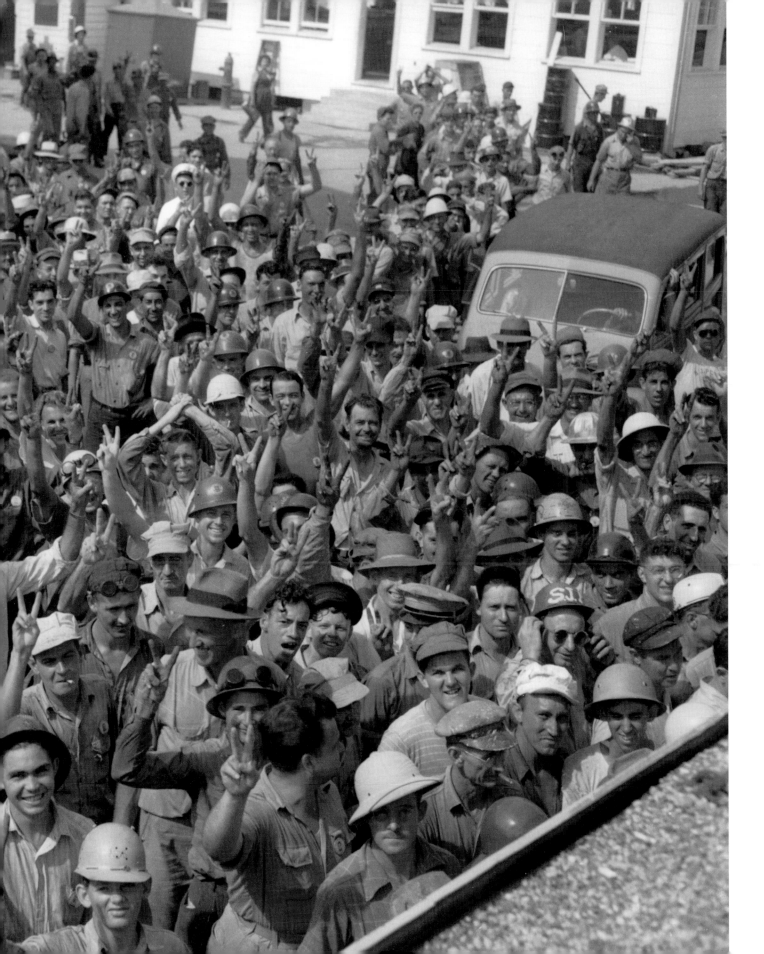

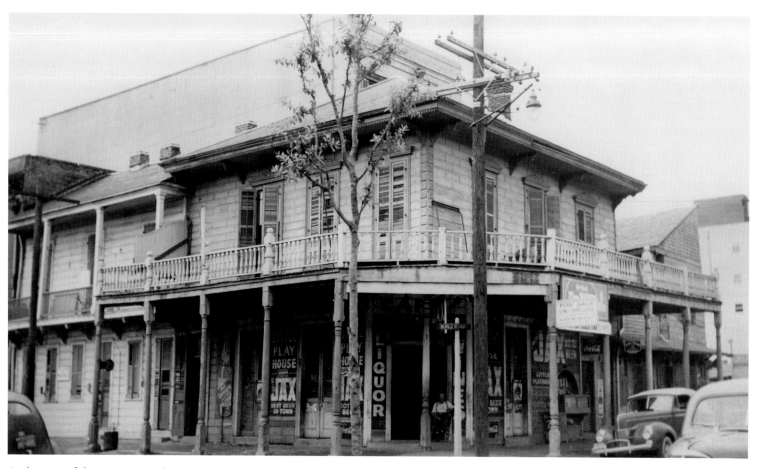

At the turn of the century, jazz legend Toney Jackson performed at Frank Early's My Place Saloon and wrote the hit "Pretty Baby" there. Another jazz prodigy who performed there was Professor Manuel Manetta, who was known for his ability to play both trumpet and trombone simultaneously. To the left of the building stand cribs that lower-class prostitutes used to ply their trade.

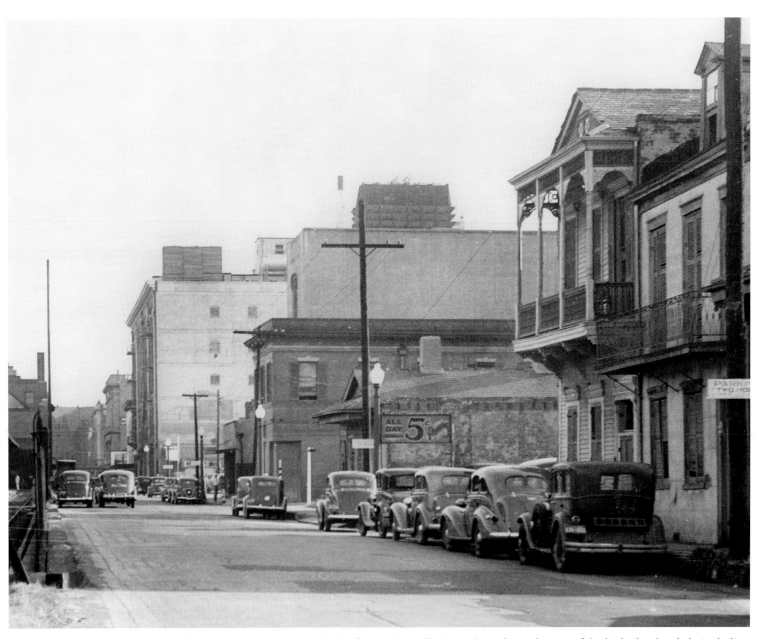

One of the most prominent strips in the former Storyville, Basin Street housed many of the high-class brothels, including Willie Piazza's establishment, Hilma Burt's place, and Mahogany Hall. It was at Hilma Burt's brothel where Jelly Roll Morton received his first musical start in Storyville. After Storyville's closure, Basin Street was renamed North Saratoga Street, and later the Iberville Housing Development replaced the majority of the street.

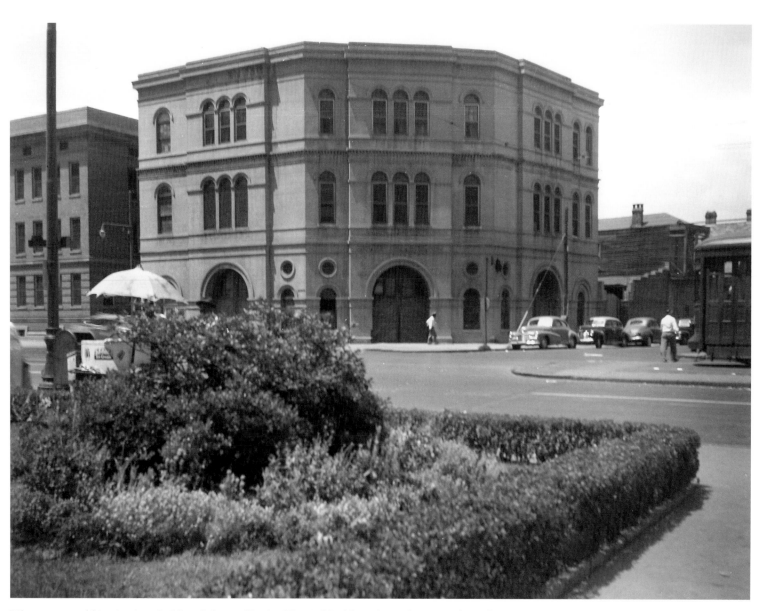

Like so many old institutions in New Orleans, Charity Hospital had been located in a number of areas throughout the city. In 1832, it moved to its last location on Tulane Avenue. One hundred years later, Charity prided itself on its history and its technological advances. By the late 1930s, the hospital held a capacity of 1,800 patients, employed 160 nurses, and contracted the services of seventeen resident interns, as well as a large staff of physicians and surgeons. Its budget exceeded $1.5 million.

During the war years, slogans such as "He who relaxes is helping the Axis" could be found at the shipyards throughout the South. A Coast Guard sentry stands watch over a patrol torpedo (PT) boat under construction at a shipyard. Higgins was also involved in designs for these fast attack boats.

169

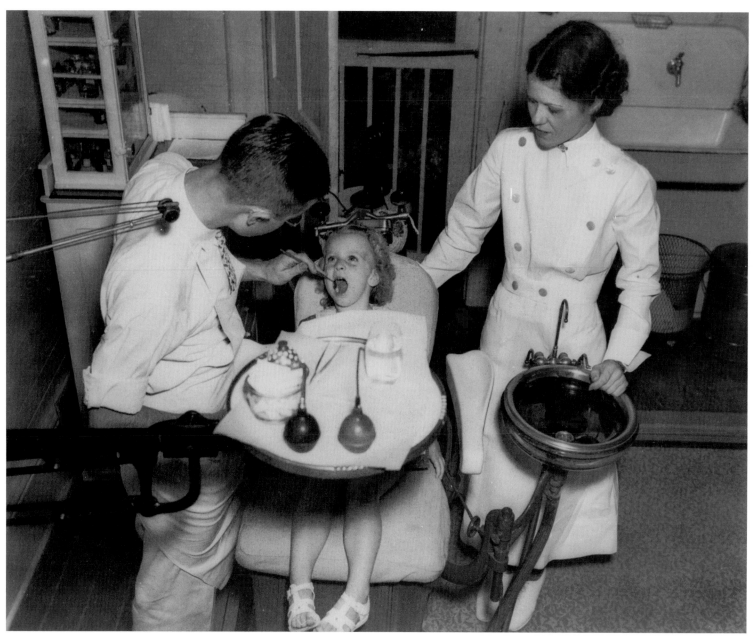

Health and welfare issues became a civil defense concern during the war years, and the federal government encouraged visits to the doctor and dentist. Here, a child visits the dentist for her checkup.

Tennessee Williams made this streetcar famous in his play, *Streetcar Named Desire*. The New Orleans Railway and Light Company started the Desire line in 1920. It ceased operation in 1948 when the city replaced the streetcar with a bus. Here, Henry Lacour who spent his career as a streetcar conductor, takes the No. 832 out for its final run.

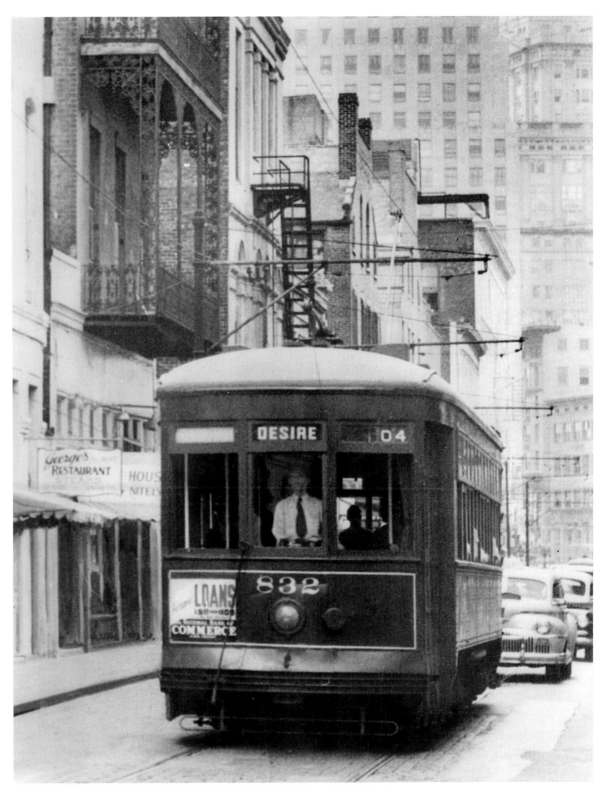

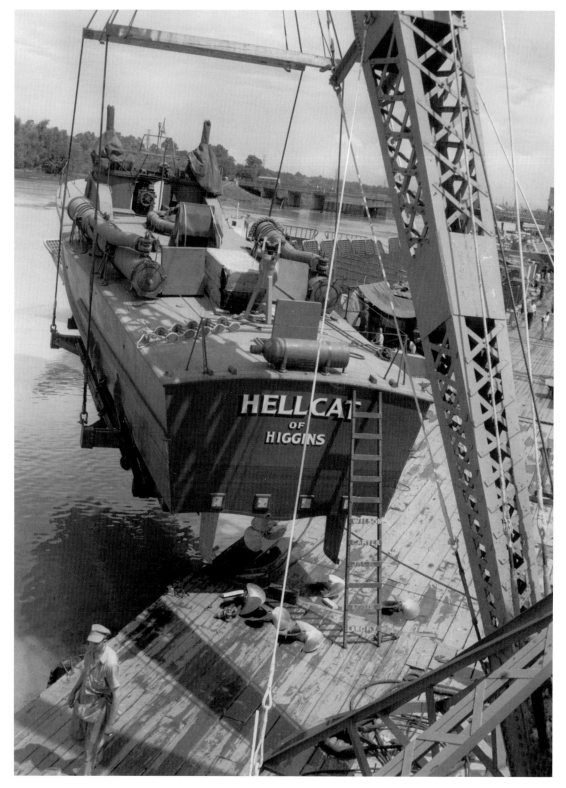

In 1943, Higgins Industries, based in New Orleans, built USS *PT-564*, an experimental 70-foot torpedo boat otherwise known as the *Hellcat*. It was based in Miami, Florida, and served along the East Coast of the U.S. It was taken out of service in 1946 and sold in 1948. Andrew Higgins, owner of Higgins Industries, received much acclaim from General (later President) Dwight D. Eisenhower.

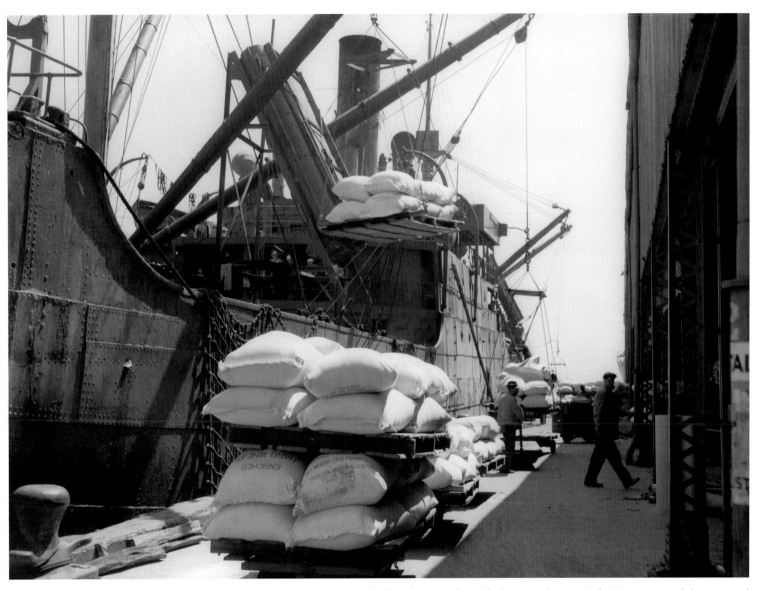

John Vachon (1914–1975) started off in photography with the Farm Security Administration and documented rural life during the Depression as well as World War II. Eventually, he worked for the United Nations and *Look* magazine. Here, he records a ship being loaded with goods at the Poydras Street dock.

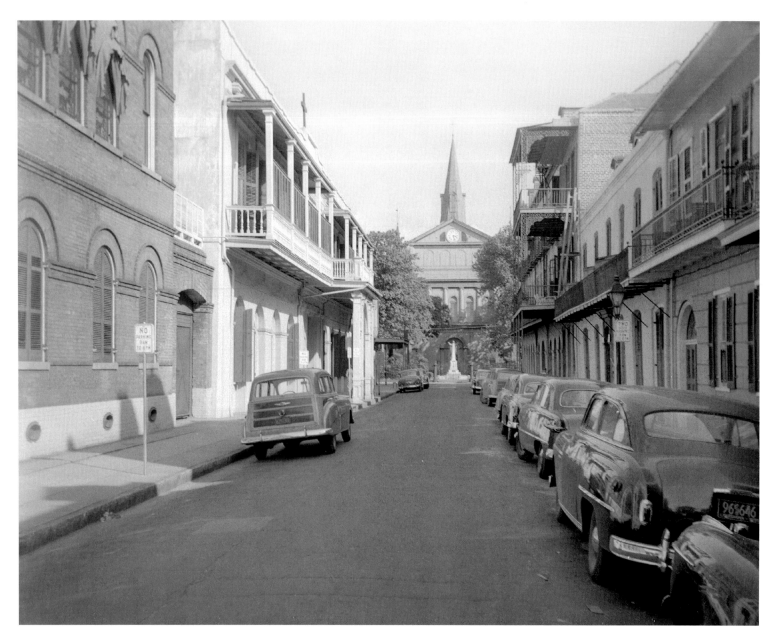

This is a back view of St. Anthony's Garden located behind the St. Louis Cathedral. In 1831, the city purchased strips of land behind the church and closed off that part of the street. In 1848, the trustees of the church received these strips of land, enclosed the area with a cast-iron gate, and have used it as a garden ever since. New Orleans is the only city in the country where the most prominent landmark is a church.

This image marks the return of Carnival on St. Charles Avenue in New Orleans following World War II. Only three times in New Orleans history have city leaders canceled the event: the Civil War, World War I, and World War II. Rex's theme that year was Myths of Starry Hosts.

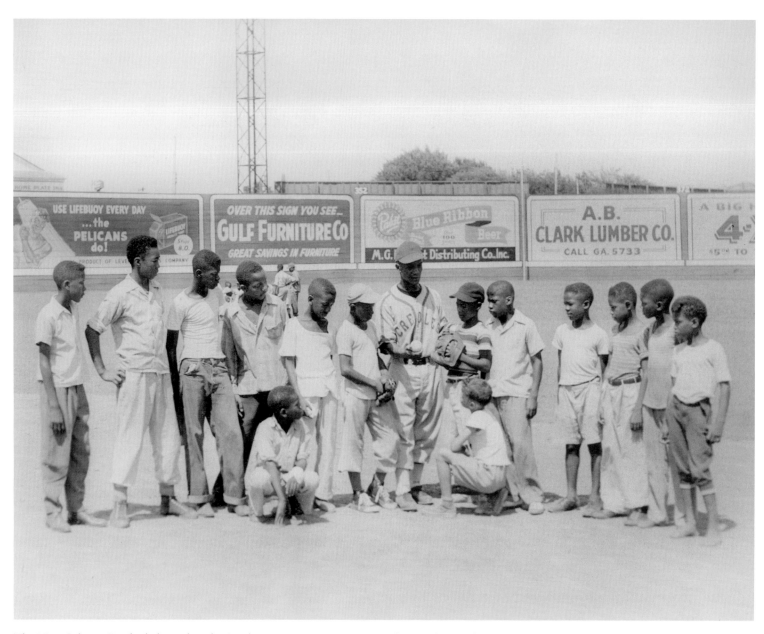

The New Orleans Creoles belonged to the Southern Negro Leagues, a minor league, during the 1940s. Here, a baseball player conducts a workshop at Pelican Stadium in 1947. The New Orleans Creoles shared the stadium with the Pelicans, another minor league team. Pelican Stadium, also known as Heinemann Park located in Mid-City, hosted the New Orleans Pelicans from 1911 until 1957.

This group of politicians, known as the "Long Leaders" due to their support of Governor Earl Long, boards a Louisville and Nashville train for the Kentucky Derby in 1950. George Reyer, Superintendent of the New Orleans Police Department (right-hand door, bottom step) waves to the photographer, as does another New Orleanian, Guy D'Antonio (second to the right, standing in the foreground) who served in the Louisiana Senate during this time.

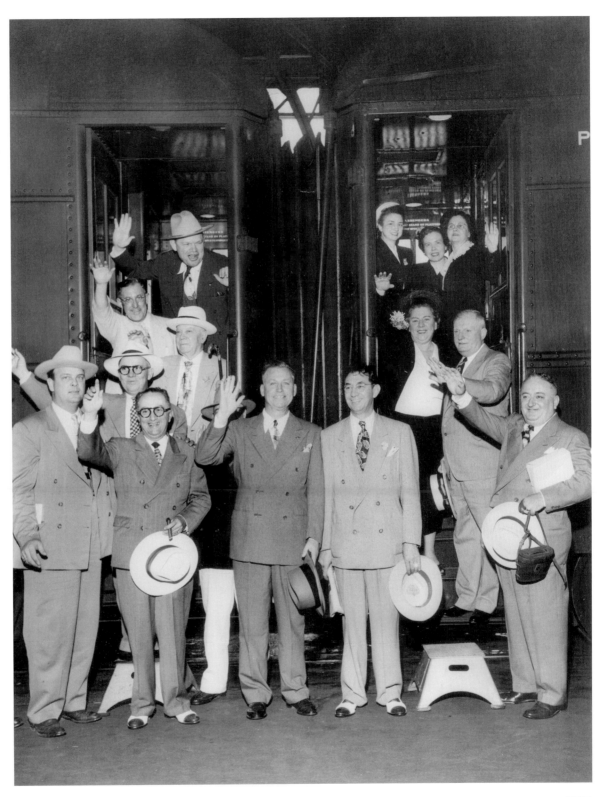

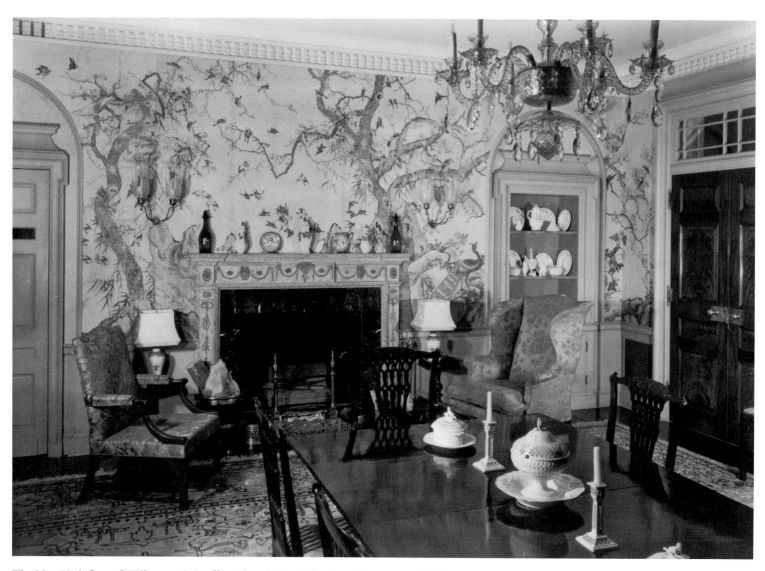

The New York firm of William and Geoffrey Platt designed the Stern home at 11 Garden Lane in Metairie, an outlying suburb of the city. Edgar Bloom Stern spent his career as a powerful cotton broker and Edith Rosenwald Stern was the daughter of Julius Rosenwald of Sears, Roebuck & Company, Chicago. Both devoted much of their time to the community and their charity funded a number of notable institutions such as Dillard University and Longue Vue House and Gardens in Metairie.

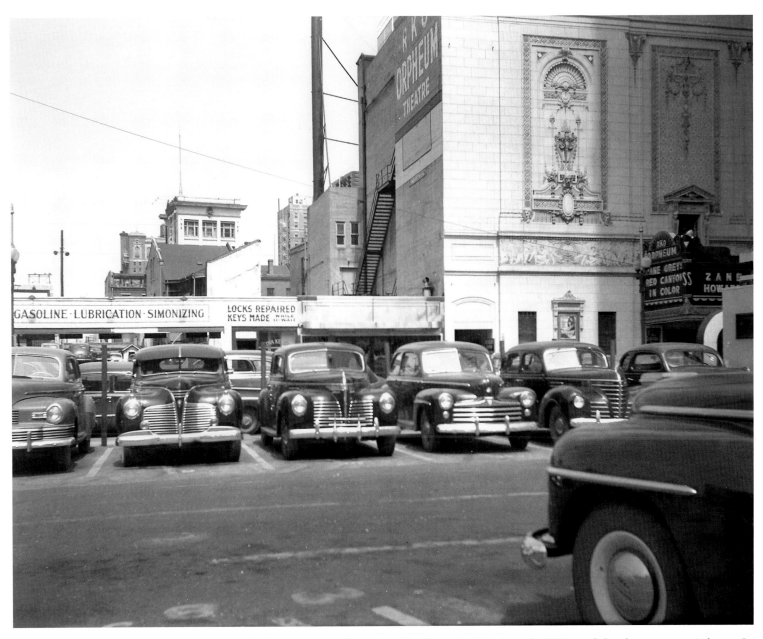

The Orpheum Theatre opened its doors in 1918, featured vaudeville acts during the early 1920s, and then became a movie house. In the 1970s, the building was scheduled for demolition. Instead of destroying this Beaux Arts–styled building that seated 1,800, heavy renovations went into it, and it reopened in 1989 as the home of the Louisiana Philharmonic Orchestra, the only full-time, professional orchestra in the Gulf South. The building received heavy damage during Hurricane Katrina and is still awaiting renovations.

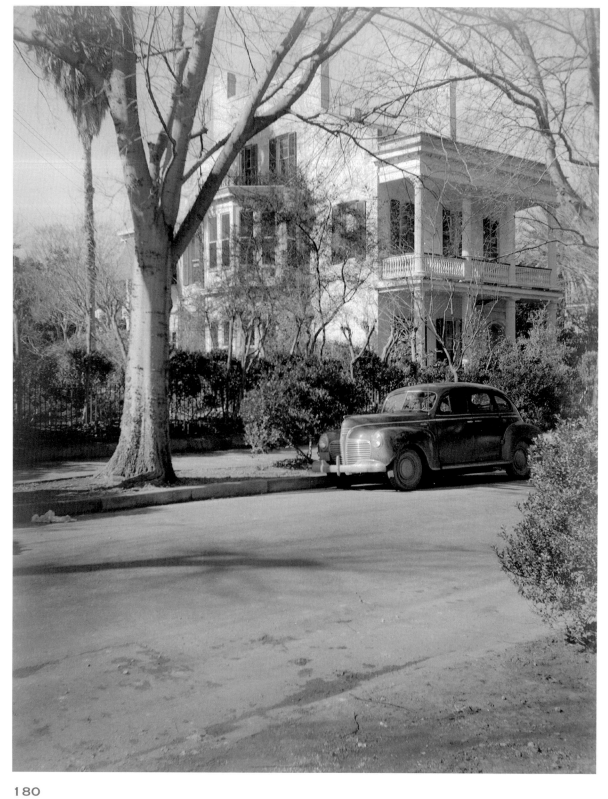

The beauty and elegance of homes in the Garden District is reflected in this 1951 image of the D. W. Pipes residence at 1238 Phillip Street.

Frances Benjamin Johnston and Joseph Woodson "Pops" Whitesell were fixtures of bohemian New Orleans from the 1920s until their deaths in the 1950s. Both famed photographers, Johnston started her career in Washington, D.C., and became the first female photographer of the White House. Whitesell came to New Orleans during World War I and by the 1940s was one of the ten most prominent salon photographers in the world.

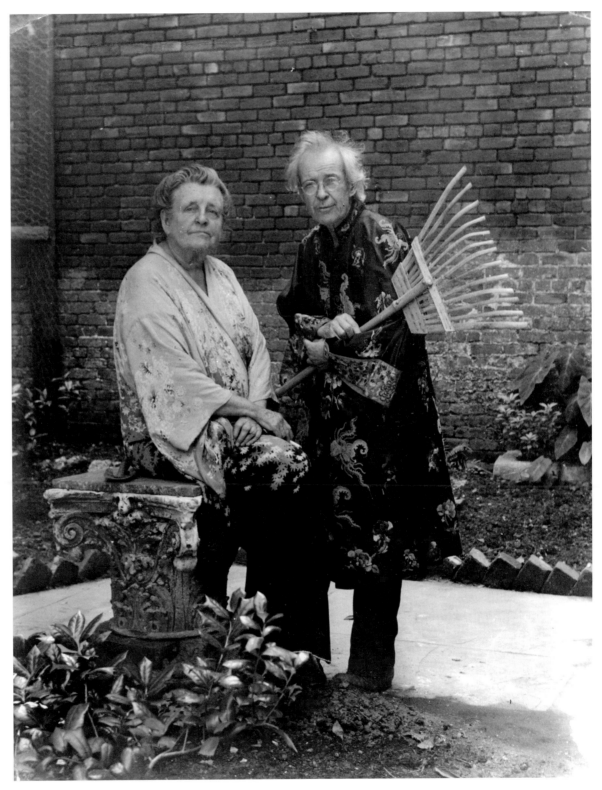

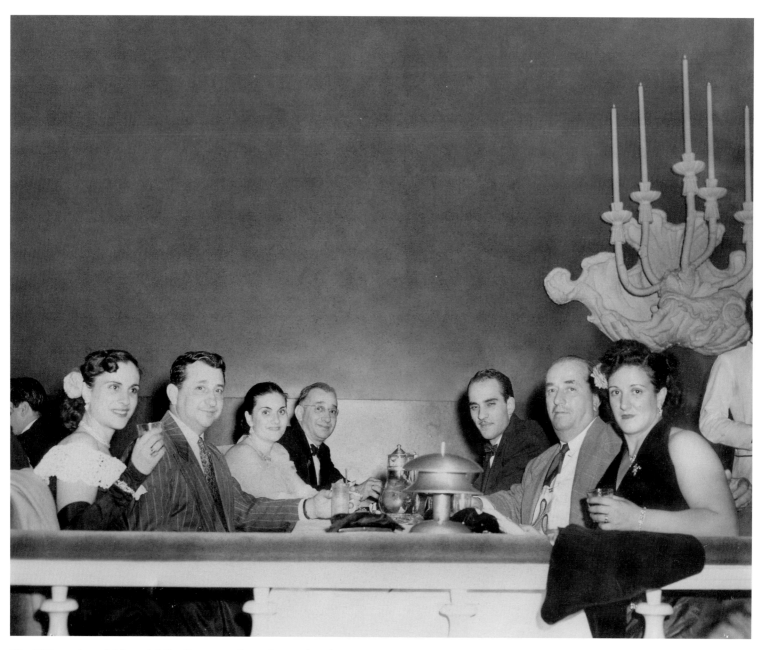

The D'Antonio and Morettini families enjoy themselves at the Blue Room in the Roosevelt Hotel on Baronne Street. Opened in 1935, the Blue Room remained one of the swankiest nightclubs in the city during the 1940s and 1950s. With the house band led by Leon Kelner, musical sensations such as Louis Prima, Marlene Dietrich, Ethel Merman, and Jimmy Durante entertained their fans.

This image marks the kindergarten graduation in 1954 at the Florida Housing Development. Following the Housing Act of 1937, housing developments expanded throughout the United States to meet the needs of impoverished families. The Florida development opened in 1946 and housed 500 units. It served many families in New Orleans until the late 1990s, when it underwent major renovations. Today, the fate of many developments such as these is uncertain with the rebuilding efforts that are taking place in New Orleans.

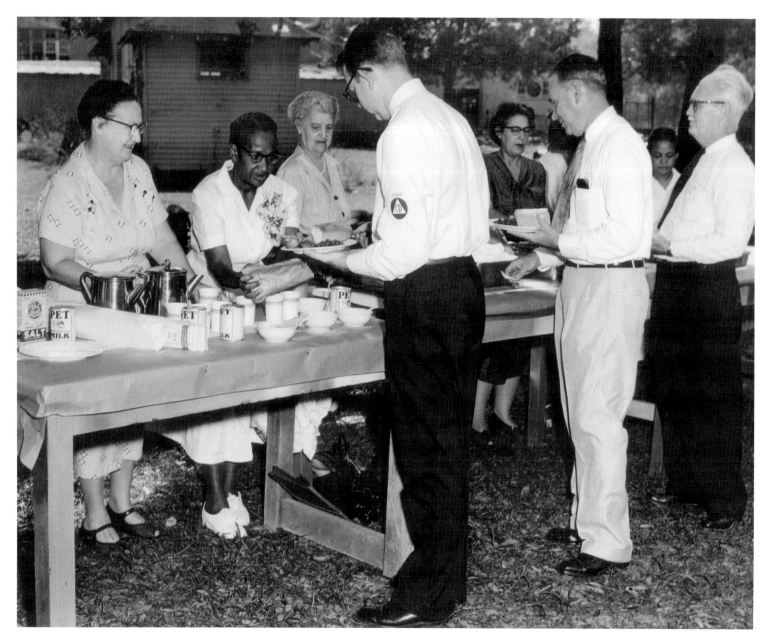

The Volunteer Civil Defense Workers prepared and served this "disaster meal" to CD members at Delgado Trades School as a part of a tour of the New Orleans Civil Defense operations. Delgado Community College is the state's oldest and largest community college. It opened its doors in 1921 with the purpose of educating boys and young men to the vocational trades. Today, the school, open to both sexes, is nationally known for its nursing program.

During the Cold War, Americans throughout the country sought ways to protect themselves. Here, Colonel J. T. Knight, Jr., Chief of Attack Warning Section of New Orleans Civil Defense, and Paul Ristroph, Director of New Orleans Civil Defense, test an air raid siren. This type of mechanical siren was produced from the 1950s until the 1980s.

Alexander Allison took this shot from his office in New Orleans' new city hall built in 1957. He spent the majority of his career as a civil engineer for the Sewerage and Water Board of New Orleans. The current city hall opened in spring of 1957 under the administration of Mayor deLesseps Morrison and was the signature building among a group of modernistic buildings that lined Loyola Avenue, which included the Union Passenger Terminal, the Louisiana Supreme Court, and the New Orleans Public Library.

Business leader James Holtry, Pontchartrain Park golf pro Joe Bartholomew, Mayor deLesseps Morrison, and Herbert Jahncke, President of the Parkways and Parks Commission, commemorate the dedication of the Lake Pontchartrain Golf Course house at Pontchartrain Park. This golf course was the only one of its kind available to black New Orleans during Segregation. Joe Bartholomew designed and built this golf course, in addition to City Park #1 and City Park #2.

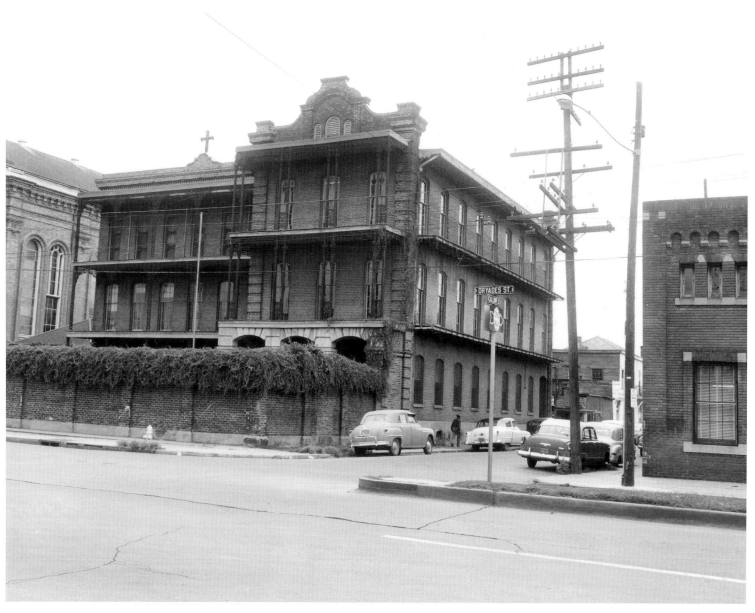

In 1860, Domenican nuns arrived from Ireland to teach girls in a heavily Irish area of New Orleans. In time, they accepted male students as well, and the Archdiocese of New Orleans opened St. John Baptist Parochial School on the corner of Dryades and Calliope streets. This image was taken shortly before the school was demolished to make way for the Pontchartrain Expressway.

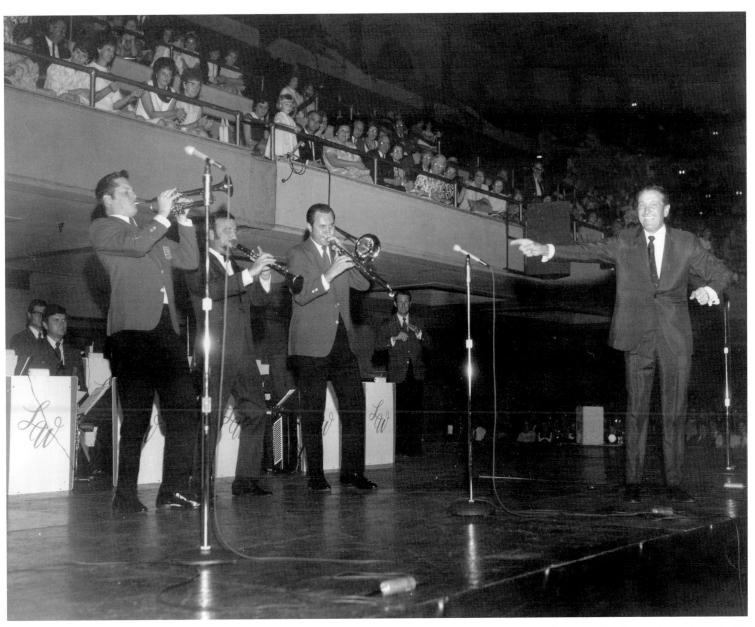

Bandleader Lawrence Welk wowed fans at the Municipal Auditorium in 1958. Local clarinetist Pete Fountain performed with Welk's band from 1957 until 1959. Here, he is seen in the center of the trio behind Welk. In addition to his long, storied musical career, Pete Fountain is also known for his Half Fast Walking Club that parades in the French Quarter on Mardi Gras Day.

In 1954, Edgar Stern's Pontchartrain Park Homes outlined the plans for this former swamp located in Gentilly, the first suburb built for middle-class African Americans in New Orleans. It boasted a ten-acre park that featured a stadium, tennis courts, and a playground. The neighborhood also produced a variety of civic leaders such as mayors Dutch and Marc Morial. Southern University of New Orleans, a historically African American university, stands across the street from this neighborhood.

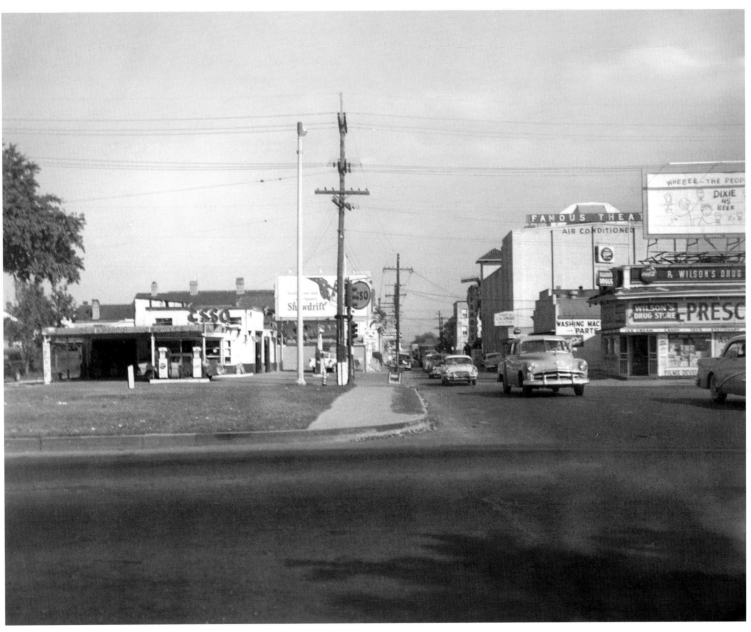

Up to the 1950s, Claiborne Avenue had gained prominence as the African American commercial center in New Orleans. When city leaders received federal aid to build the Pontchartrain Expressway, the interstate that runs right on the edge of the French Quarter, they decided to demolish this area to make room for the highway. Today, murals on the pillars under the expressway depict and remember the once-vibrant neighborhood.

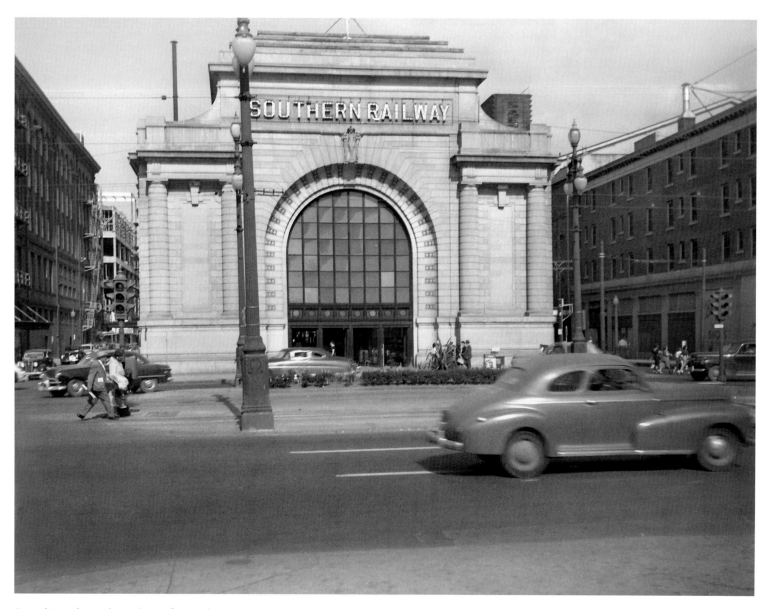

Daniel Burnham, the architect for Washington D.C.'s Union Station, designed the Southern Railroad Terminal in 1908. Located on Canal Street, this station served the Southern Railway, the New Orleans and Northeastern Railroad Company, and the New Orleans Terminal Company. Like other passenger terminals in the city, this station also fell victim to the city's consolidation in the 1950s. The Beaux Arts–styled building was demolished in 1954.

Tulane University's campus reflects the great variety of New Orleans' flora and fauna, with its palm trees and oak trees among its parklike setting. Established in 1834 as the publicly funded Medical College of Louisiana, Tulane is the city's oldest university. Known for its law and medical schools, the university has trained generations of New Orleans residents as well as those from out of state. It is the only university in the country that went from being a public university to a private one.

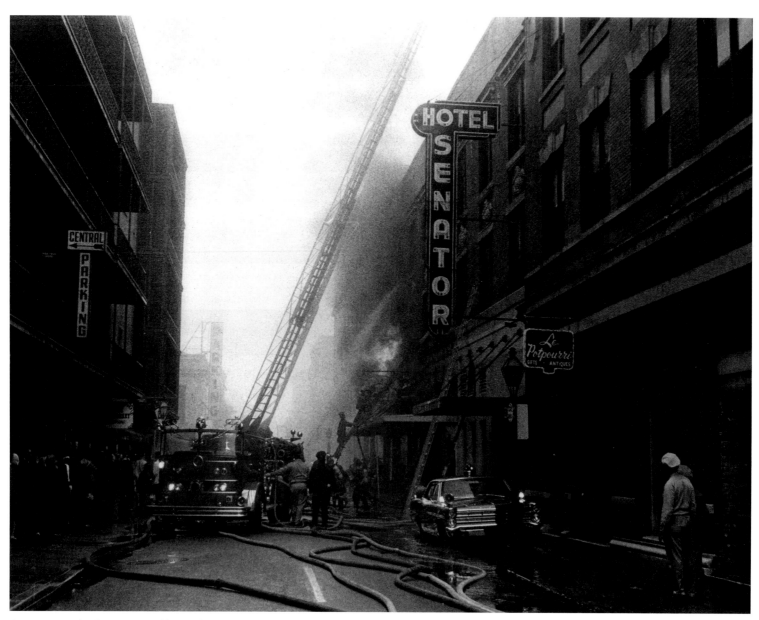

At one time, the Senator Hotel housed 125 rooms and boasted air conditioning. Lee Harvey Oswald, the accused assassin of President John F. Kennedy, and his mother lived at this hotel for some time. By the time this fire destroyed the hotel on Dauphine Street, it had been abandoned for a number of years. Three firefighters received injuries while battling this blaze.

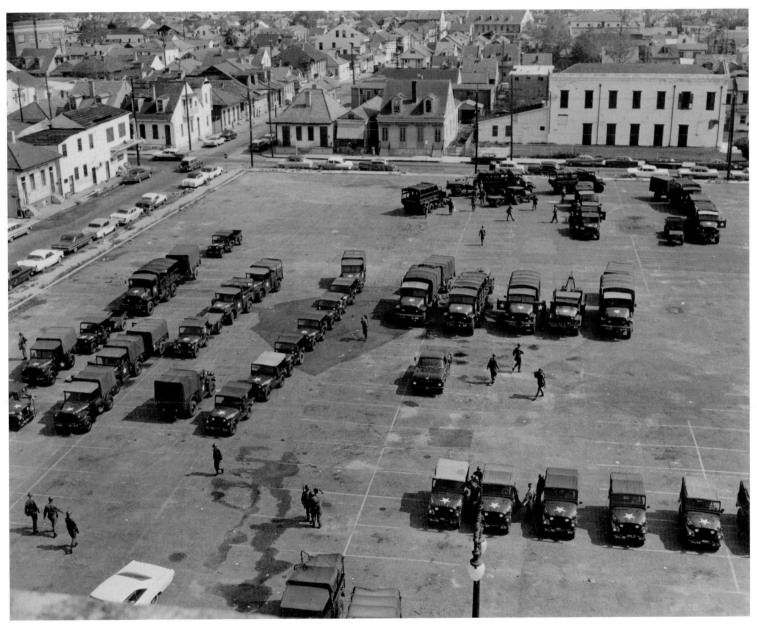

Hurricane Betsy slammed into Louisiana in September 1965 and was considered the country's worst natural disaster up to that time, costing over $1 billion. Here, National Guard troops set up a staging point to aid New Orleanians in distress. Because of Betsy's destruction, the U.S. Army Corps of Engineers established its Hurricane Protection Program, which included building better levees to withstand a strong Category 3 storm.

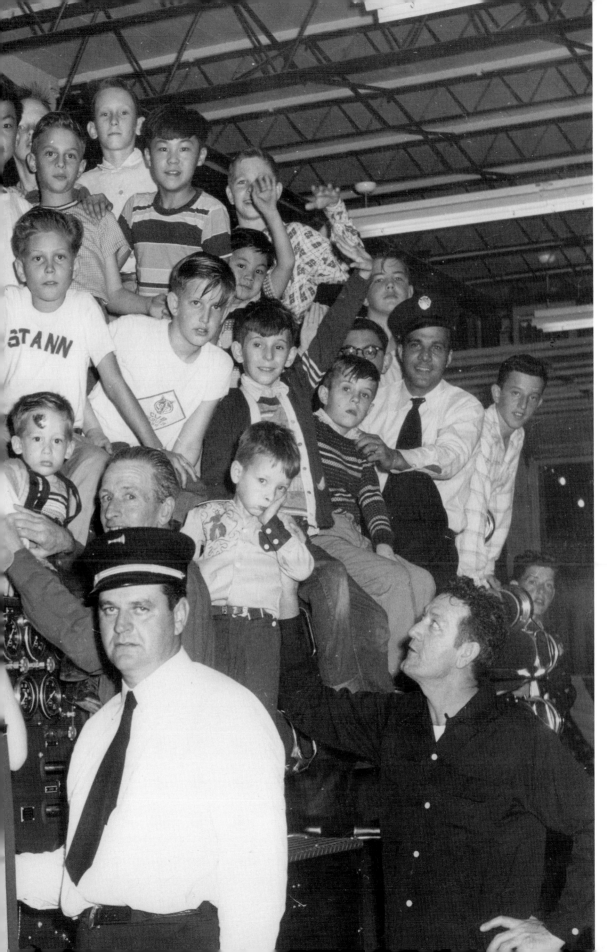

A part of the New Orleans Fire Department's community outreach program concerned teaching children about fire prevention and reaction. Here, members of the fire department allow boys to spend time on one of its trucks, testing the lights and sirens.

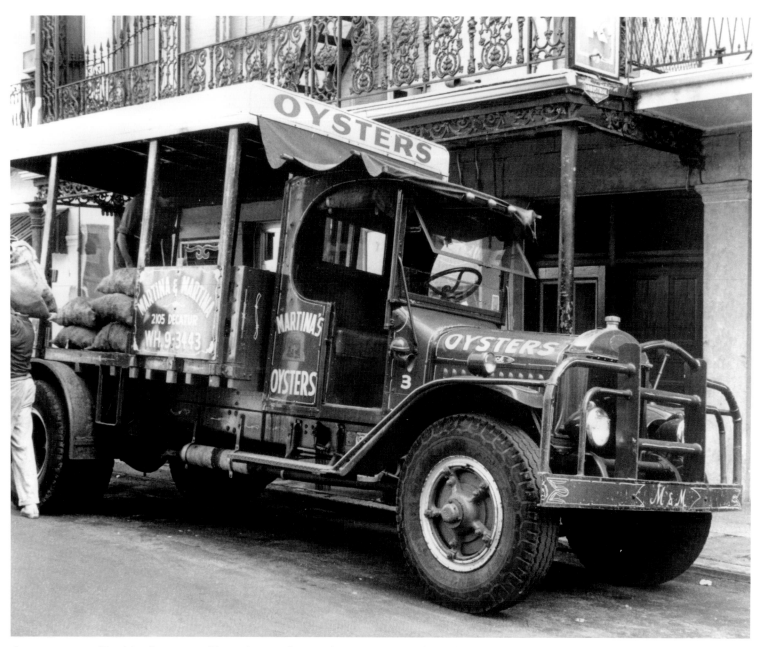

Oysters are one of Louisiana's most notable products and currently constitute an industry that supports over 10,000 jobs. More than one-third of the nation's oysters come from Louisiana. Here, Martina and Martina, who served the New Orleans area for over one hundred years, deliver oysters in the French Quarter.

Mardi Gras Indians—actually African Americans in regalia—date back to the nineteenth century and represent the bonds forged between blacks and American Indians when runaway slaves found haven among the native tribes. The structure of the Mardi Gras Indians is based on various tribes based along ward lines in the city. The hierarchy of these tribes includes the Big Chief and the Spy Boy, among others. All their costumes are hand-sewn and can take nearly a year to create.

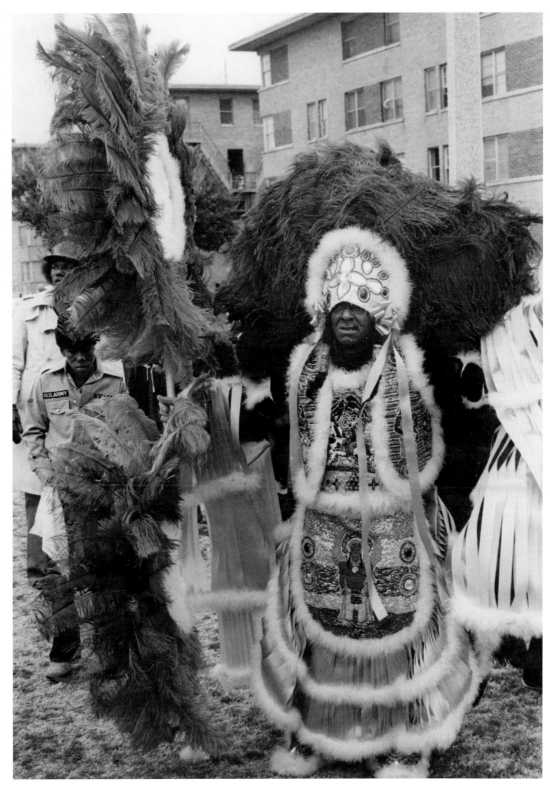

NOTES ON THE PHOTOGRAPHS

These notes, listed by page number, attempt to include all aspects known of the photographs. Each of the photographs is identified by the page number, photograph's title or description, photographer and collection, archives, and call or box number when applicable. Although every attempt was made to collect all available data, in some cases complete data was unavailable due to the age and condition of some of the photographs and records.

II **MARDI GRAS**
Special Collections, Tulane University

VI **FIREMEN TRAINING**
Louisiana Division/City Archives
New Orleans Public Library

X **REYNES HOUSE**
Louisiana Division/City Archives
New Orleans Public Library

2 **ST. LOUIS CATHEDRAL AND PRESBYTERE**
Louisiana Division/City Archives
New Orleans Public Library

3 **ST. LOUIS CATHEDRAL INTERIOR**
Louisiana Division/City Archives
New Orleans Public Library

4 **CATHEDRAL ALLEY**
Louisiana Division/City Archives
New Orleans Public Library

5 **OLD EXCHANGE ALLEY**
Louisiana Division/City Archives
New Orleans Public Library

6 **FOUR BOYS**
Louisiana Division/City Archives
New Orleans Public Library

7 **LALAURIE HOUSE**
Louisiana Division/City Archives
New Orleans Public Library

8 **SAENGER HALLE**
Louisiana Division/City Archives
New Orleans Public Library

9 **ST. CHARLES STREET**
Louisiana Division/City Archives
New Orleans Public Library

10 **JOCKEY CLUB**
Louisiana Division/City Archives
New Orleans Public Library

11 **GALLIER HALL**
Louisiana Division/City Archives
New Orleans Public Library

12 **LIVE OAK, AUDUBON PARK**
Louisiana Division/City Archives
New Orleans Public Library

13 **CHARLES JANVIER**
Special Collections, Tulane University

14 **PLOWING GROUND**
Louisiana Division/City Archives
New Orleans Public Library

15 **CURING MOSS**
Louisiana Division/City Archives
New Orleans Public Library

16 **PICKING COTTON**
Louisiana Division/City Archives
New Orleans Public Library

17 **SUGAR BARRELS**
Louisiana Division/City Archives
New Orleans Public Library

18 **BANANA ELEVATOR**
Louisiana Division/City Archives
New Orleans Public Library

19 **STEAMSHIP**
Louisiana Division/City Archives
New Orleans Public Library

20 **FRENCH MARKET**
Louisiana Division/City Archives
New Orleans Public Library

21 **LEVEE**
Louisiana Division/City Archives
New Orleans Public Library

22 **WAREHOUSE DISTRICT**
Louisiana Division/City Archives
New Orleans Public Library

24 **JEFFERSON DAVIS' FUNERAL**
Library of Congress
LC-USZ62-61347

25 **DOMESTIC WORKER**
Louisiana Division/City Archives
New Orleans Public Library

26 **"EDWARD RICHARDSON" INTERIOR**
Louisiana Division/City Archives
New Orleans Public Library

28 **DECK OF STEAMBOAT "MOMUS"**
Louisiana Division/City Archives
New Orleans Public Library

29 **ALLEN SCHOOL**
Louisiana Division/City Archives
New Orleans Public Library

30 **NEW ORLEANS PUBLIC LIBRARY**
Louisiana Division/City Archives
New Orleans Public Library

31 **McKINLEY'S VISIT**
Library of Congress
LC-USZ62-98368